"Situating practice firmly at the heart of her discourse, Dr. Harris unpacks the creative process from a composer's perspective, revealing valuable insights which challenge traditional media hierarchies and elaborate nuanced understandings of audiovisual composition. This text will be of importance to students, fellow composers and audiovisualogists, providing a desperately needed injection of new perspectives into the topic."

Andrew Knight-Hill, University of Greenwich, London

"Harris courageously crafts transdisciplinary inroads into difficult territory, providing teachers, composers, students and theorists multi-perspectival approaches to a broad range of audiovisual practice and identifying and challenging limits of current language and conceptions."

Bret Battey, De Montfort University, Leicester

Composing Audiovisually

What does the Coen Brothers' *Barton Fink* have in common with Norman McLaren's *Synchromy*? Or with audiovisual sculpture? Or contemporary music video? *Composing Audiovisually* interrogates how the relationship between the audiovisual media in these works, and our interaction with them, might allow us to develop mechanisms for talking about and understanding our experience of audiovisual media across a broad range of modes. Presenting close readings of audiovisual artefacts, conversations with artists, consideration of contemporary pedagogy and a detailed conceptual and theoretical framework that considers the nature of contemporary audiovisual experience, this book attempts to address gaps in our discourse on audiovisual modes, and offers possible starting points for future, genuinely transdisciplinary thinking in the field.

Louise Harris is an audiovisual composer and Senior Lecturer in Sonic and Audiovisual Practices at the University of Glasgow. In her creative work, she specialises in the creation and exploration of audiovisual relationships utilising electronic music, recorded sound and computer-generated visual environments in fixed media, performance and large-scale installation contexts.

Sound Design

Series Editor: Michael Filimowicz

The Sound Design series takes a comprehensive and multidisciplinary view of the field of sound design across linear, interactive and embedded media and design contexts. Today's sound designers might work in film and video, installation and performance, auditory displays and interface design, electroacoustic composition and software applications, and beyond. These forms and practices continuously cross-pollinate and produce an ever-changing array of technologies and techniques for audiences and users, which the series aims to represent and foster.

Sound and Image
Aesthetics and Practices
Edited by Andrew Knight-Hill

Sound Inventions
Selected Articles from Experimental Musical Instruments
Edited by Bart Hopkin and Sudhu Tewari

Doing Research in Sound Design
Edited by Michael Filimowicz

Sound for Moving Pictures
The Four Sound Areas
Neil Hillman

Composing Audiovisually
Perspectives on Audiovisual Practices and Relationships
Louise Harris

For more information about this series, please visit: www.routledge.com/Sound-Design/book-series/SDS

Composing Audiovisually

Perspectives on Audiovisual Practices
and Relationships

Louise Harris

Routledge
Taylor & Francis Group

LONDON AND NEW YORK

First published 2022
by Routledge
2 Park Square, Milton Park, Abingdon, Oxon OX14 4RN

and by Routledge
605 Third Avenue, New York, NY 10158

Routledge is an imprint of the Taylor & Francis Group, an informa business

British Library Cataloguing-in-Publication Data
A catalogue record for this book is available from the British Library

Library of Congress Cataloging-in-Publication Data
A catalog record has been requested for this book

ISBN: 978-0-367-34692-8 (hbk)
ISBN: 978-0-367-34691-1 (pbk)
ISBN: 978-0-429-32717-9 (ebk)

Typeset in Bembo
by codeMantra

For Rich, who tolerates my nonsense on a daily basis, and for my parents, to whom I owe everything.

For Rich, who tolerates my nonsense on a daily basis,
and for my parents, to whom I owe everything.

Contents

Illustrations

Figures

Tables

Introduction

First, welcome. If you're reading this, the chances are that you have some kind of interest in how sound and image interact with one another, and how we, as human beings, experience that interaction. Your interest might be perceptual, philosophical, phenomenological, emotional, physical, academic, spiritual… and that interest might be borne out of a preoccupation with visual music, narrative film, music video, video games, installation art, expanded cinema, mixed media performance or all (or none!) of the above. I fervently hope that there will be something contained in this book that might help you to navigate your experience of composing, thinking, teaching, analysing or understanding our encounters with audiovisual experience across a range of modes, and that in interrogating that understanding we can contribute to each other's development as an, albeit somewhat diffuse, learning community and community of practice (Lave and Wenger, 1991).

As I write this introduction, the idea of a 'diffuse' community of practice is perhaps even more resonant than it was when I set out on this project. It is the 17th of March 2020 – the second day of the cancellation of face-to-face teaching at the higher education institution where I work, and the early stages of what will likely become a complete lockdown in the UK at large due to the Coronavirus pandemic. At the moment, large gatherings are discouraged, non-essential travel is prohibited and those over 70 years of age and with pre-existing health conditions are being advised not to leave their homes at all. This is a very strange time for the world – a time no one had really expected or been preparing for, and certainly a time in which writing a book about how we understand and experience audiovisual work feels somewhat unnecessary and frivolous. However, the ethos underpinning this book is one of developing shared knowledge and understanding, and I do believe this can fruitfully take place even under the very peculiar circumstances we currently find ourselves; further, I feel that making and engaging with art, even under the current circumstances, is fundamental to what makes us human. The following volume is therefore approached from this perspective – with the hope that, ultimately, it may be of use.

The genesis for this book stems from my earliest attempts to contextualise and understand my own creative practice, initially as a PhD student and

later as an academic based within music in higher education institutions in the UK. Completing a portfolio of audiovisual compositions as a doctoral student at Sheffield University, I felt frustrated and somewhat disillusioned by the lack of available discourse on the field of audiovisual composition in which I was attempting to situate myself; the landmark publication in the field, Chion's *Audio-Vision: Sound on Screen* (1994), was already 15 years old at this point and was still relatively heavily focused on the role of sound in narrative film. Other publications have begun to emerge in recent years, such as Carvalho and Lund's significant volume, *The Audiovisual Breakthrough* (2015), but although enormously illuminating the text primarily attempts definitions of various forms of live audiovisual practices as opposed to interrogating the nature of audiovisual experience itself. I have long been looking for a volume which allowed me to understand my response to music video in the same terms as, for example, my response to the interplay of sound and image in narrative film, or my experience of an interactive audiovisual installation, but sadly not been able to find one, and had hoped that such a volume might also allow me to better understand my own audiovisual compositional practice. This volume is an attempt to fill that gap.

It is important, however, to state upfront what this book *is not*, just as clearly as what it *is*. First, I have not read or experienced **everything** that is potentially relevant to the approaches I present and advocate for in this volume. That would not be possible, and the number of suggestions of readings to engage with that came out of the questionnaires associated with this book is completely overwhelming (and, I might add, absolutely amazing!). I have, throughout my career, and in preparation for this volume, read widely – and tried to read outside of what might broadly be conceived as the Western canonical texts on both audiovisual work and audio and visual modes in isolation – but I cannot claim universal knowledge nor universal truth. Instead, this book presents an attempt at an intersectional and interdisciplinary approach – possibilities, suggestions – for encountering audiovisual works and attempting to understand and situate our responses to them. It is a place for me to interrogate my *own* work and my *own* thinking on how I, and others, approach composing audiovisually, for those experiences to be drawn into how I teach, and how we might explore and position our individual and collective responses to audiovisual experience.

It is also important to consider who this book is *for*, as this very much informs the shape of discussion in subsequent sections. First, it is intended for the broad community of practice engaged with audiovisual work – not necessarily in specific modes and media, or from a particular perspective or discipline, but for those who are broadly interested in how we encounter works that involve both sonic and visual elements. This community will include both those that make audiovisual work, either individually or collaboratively, and also those who already write about audiovisual experience or who are interested in doing so. The difficulty with this comprehensive readership is that each member of this community will no doubt approach the text

from their own disciplinary, aesthetic, conceptual, philosophical and, indeed, personal experiential perspectives and preoccupations, and consequently the way the discussion is approached here may not entirely resonate with its full readership. This is inevitable, and is to some extent accounted for through acknowledging:

A: the relatively specific focus of this book means that it can only account for particular things. It attempts intersectional, interdisciplinary discussion, but this will necessarily be limited by the brevity which is required for a volume of this size and, of course, by the interests and contexts of the author.

B: that although it will attempt to engage with a broad range of disciplinary, aesthetic, conceptual, philosophical, phenomenological etc.... perspectives, one could write an entire volume on each of the articles and books referenced in this volume and still not have a complete picture of the broader context surrounding our enquiry. The perspectives utilised and ideas cited are necessarily selective and, in many cases, distilled to the fundamental aspects that are of resonance to the discussion at hand. This volume is about beginning transdisciplinary conversations around audio-visual experience, not providing definitive answers.

The book is intended for those who teach audiovisual practices, specifically within a higher education context (though much of what is suggested could also be adapted to secondary school level), and attempts to offer some practical advice on how to approach developing a curriculum and how to encourage in-depth and rigorous engagement with, and development of, audiovisual work. The pedagogical ideas offered here primarily refer to teaching which is, at least in part, practice-based (and, ideally, research-led), but many of the exercises suggested are also appropriate to purely theoretical courses.

It is also important here to acknowledge the potential shortcomings of the discourse presented here. First, it is written primarily by one person – an able-bodied, privileged, European white woman from a middle-class background who has had every educational – indeed every social and societal – advantage, outside of being born a woman (and indeed, there are numerous aspects of this book that are shaped and informed by this experience, some of which will be discussed later in context). Consequently, this is the central perspective of this book and it is necessarily shaped and formed by those fundamental characteristics – acknowledgement of which might allow me, to some extent, to account for them and understand the preconceptions and proclivities they bring to the volume. It draws from a particular disciplinary background and much as it attempts to step outside and away from being rooted solely in that background the weight of nearly 30 years of personal study in the field will render this somewhat difficult. It is an able-bodied per-spective, and therefore cannot account for (and would not try to) individual audiovisual experience for those whose sensory encounters with the world

are not from that privileged position. It is a white, European perspective, and therefore cannot account for (and would not try to) individual audiovisual experience outside of that heritage. It, deliberately, does not attempt discussion from a particular political perspective (that is for another volume), and is not an actively feminist encounter (the author herself is a feminist, though not a feminist scholar). What it does advocate for throughout, though, is the importance of the self in encountering the ideas and works in this volume, and the importance of interrogating personal experiences, contexts and preconceptions in exploring our responses to audiovisual work. So, whilst it is written from one specific, personal perspective, it also actively advocates for frameworks and mechanisms of engagement that specifically foreground the role of the self and the importance of personal context and experience.

Presented in three sections, this book attempts the following:

Section 1 – *Thinking audiovisually* – deals with some of the relevant contextual background for this work. It considers how encountering audiovisual work is theorised, introducing and dissecting relevant texts, and presents a brief survey of current thinking and approaches to audiovisual work. It presents and analyses responses to an open-ended questionnaire developed as part of this research, alongside a series of interviews with contemporary artists, sound designers, directors and collaborators, investigating how they think about developing audiovisual work. It also makes suggestions concerning what it means to 'think audiovisually' in the context of both making and experiencing audiovisual work.

Section 2 – *Composing audiovisually* – presents my reflections on, and understandings of, my own audiovisual compositional processes and how these have developed over the past decade. It explores what I consider to be the fundamental elements of Audiovisual Composition, presenting the building blocks with regard to sound and visual morphologies, relationships and terminologies, clearly linked to examples from my own practice and to the pedagogy of audiovisual work more broadly.

Section 3 – *Analysing audiovisually* – builds on the first two sections to present a potential framework for understanding audiovisual experience across a range of modes. It does this through a close reading of a range of audiovisual artefacts, applying the proposed analytical framework to examples from narrative film, visual music, artist film, audiovisual installation and music video.

I will begin, though, with a consideration of the title of the book itself – what it means, and what it *might* mean in framing the book as a whole. This book is approached with the understanding that the way language frames the ideas presented here *matters*, and indeed that the words, phrases and terminology utilised to describe and explain specific things are essential in communicating and understanding the nature of those things themselves.

Consequently, the best starting point for this volume is a discussion, definition and clarification of the terms 'composition' and 'audiovisual' in isolation, followed by a discussion of what the term 'composing audiovisually' itself might mean, both to myself and what it might mean for others. This should establish a starting point for the subsequent discussions in this volume.

First, 'Composition'. What does this term really *mean*, in the context of this book?

If we begin with the etymology of the word composition itself, we can trace it back to the Latin – componere ('put together'), through 14th-century Old French – composicion ('action of combining'). As an academic working within the music subject area of a Russell Group HEI, having been classically trained as a flautist and having studied at three other Russell Group HEIs throughout my academic career, the term 'composing' has historically meant something *very specific*. If we look through the *New Grove Dictionary of Music and Musicians* for guidance, we are offered the following as a definition:

> **The activity or process of creating music, and the product of such activity.** The term belongs to a large class of English nouns derived from the participial stems of Latin verbs (here composit-, from compo- nere: 'put together') followed by the suffix -io/-ionem. Etymologically, the primary senses of 'composition' are 'the condition of being com- posed' and 'the action of composing'. Since the 16th century the English word and its cognates in other languages have been applied to **pieces of music that remain recognizable in different performances as well as to the action of making new pieces.** Both the creation and the interpretation of compositions in this restrictive sense are commonly distinguished from improvisation, in which decisive aspects of compo- sition occur during performance. The distinction hinges on what per- formers are expected to do in various situations and on how they prepare themselves to meet such expectations.
>
> (Blum, 2012, para. 1, emphasis mine)

However, as this book concerns not only the act of composing with music and sound, we also need to look for the usage of the word in other fields. Grove Art doesn't offer a similar definition for composition as it applies to visual art, but Tate online offers the following:

> Although in a general sense **any piece of music or writing, painting or sculpture, can be referred to as a composition**, the term usually refers to the arrangement of elements within a work of art. An artist **ar- ranges the different elements of an artwork so as to bring them into a relationship satisfactory to them** and, it is hoped, the viewer.
>
> (Tate Online, 2020, para. 3)

We also see the term utilised in dance, usually as a foundational element in choreography, and in some cases interchangeably with the term choreography itself (Smith–Autard, 2000).

If we expand our search further, to incorporate other areas that have a specific understanding of 'composition' in their disciplinary context, we can look into fields such as mathematics, chemistry and computer science. Within mathematics, the term appears (amongst other places) in the context of composition relations – in which a new relation arises from two given relations, and in *function composition*, in which an operation takes two functions and produces a further, composite function. Within chemistry, we see the terms *chemical composition* related to mixtures and substances, specifically the way in which elements or components are combined to constitute an end product. Within computer science, function composition allows the combination of simple functions to produce more complex ones.

Fundamentally, across all of these fields and disciplines the term typically involves combining, arranging, putting together and creating from component parts in a range of ways – the context in each case might be different but the ultimate goal, with regard to the ethos of the process at least, is largely consistent. Consequently, the term *composition* in this book will be understood broadly to mean combining or putting together, with *Composing* understood in this volume as 'the process of creating, arranging and combining elements – of putting things together'. However, it is also clear that the way in which the term composition is used, both within and outside music, can refer to both the *process* of composition and the *product* of that act of composing. Consequently, the definition in this case can be broadened to 'the act of creating, arranging and combining elements – of putting things together – and the work that results from this act'. Interestingly, particularly within the sciences, composition often refers to the combining of existing things to create an other, new, thing; this is an idea that will be revisited extensively in later sections of the book, and is perhaps even more apt in our interdisciplinary compositional context than when applied to a single art form.

To continue exploring the title through defining the term *audiovisual*, this is a little trickier and more nebulous, with no readily applicable definition across fields and contexts and, indeed, no particular consensus as to the format of the word. The term is variously hyphenated or not, dependent on the source, and is very often applied primarily to the technology or equipment utilised to mediate audiovisual experience, rather than to the experience itself. Indeed, in the questionnaire on audiovisual practices that forms the basis of later chapters in this book, respondents were asked specifically about both whether or not they used the term and, if so, in what format. Some responded that they found it to be an 'old' or 'dated' term, or that in their specific language (French being referenced at least twice) it usually referred to a technical department, rather than an artistic practice.

The Oxford English Dictionary (OED) has the term hyphenated at present, with the following definition: "**Of, relating to, or involving both**

sight and sound; esp. (of educational equipment or material) using both visual images and sound in order to aid understanding" (OED Online, 2020).

The relative newness of this term (OED cites initial appearances in print to the early part of the 20th century) alongside its nebulousness in application and format presents a potential problem here – a lack of clarity over what the term really *means*. However, viewed in a prudential light this is perhaps an opportunity – to take ownership over the term and define it for this purpose and context. I have always described myself as an audiovisual composer, as opposed to a sound and visual artist or a mixed media/multimedia/hybrid media/intermedia artist because, fundamentally, I believe my work to be about the composition and combination of sounds and images within a single artwork (albeit variously manifested) and for both the sound and image within the work to be an essential and integral part of both the conception and perception or reception of the work, that there be no sense of media hierarchy in how the perceptual components of the work exist together. The term audiovisual, for me, affords this sense of cohesion and unity – notwithstanding the necessarily linear syntax of the word in putting 'audio' first, the word itself is one I have adopted as being representative of engaging with sound and image on a level playing field. Consequently, within the context of this book, the term audiovisual will be understood to mean 'specifically engaging both sight and hearing simultaneously'.

All of the above being said, I offer the following subtitle to this volume as a whole:

> *Composing Audiovisually*: An exploration of the processes, products and experiences of creating, arranging and combining sonic and visual materials.

The next section, Thinking audiovisually, begins this exploration through setting out the ethos of the book in more detail, and positioning it within relevant theoretical and conceptual contexts.

Section 1

Thinking audiovisually

This section deals with some of the relevant contextual background for this book. It introduces and dissects some relevant texts, and presents a brief survey of current thinking and approaches to audiovisual modes from a range of disciplinary perspectives. It also presents and summarises the thinking of contemporary artists, sound designers, directors and collaborators, through responses to an open-ended questionnaire and a series of semi-structured interviews.

However, before getting into any of these areas in detail it is important to lay out what the ethos of this book is and how it informs the chapters that follow. As I have discussed earlier in the introduction, the language we use here *matters*, and the use of the term 'audiovisual' is important in both clearly defining the work being addressed and describing the holism of the approach to addressing work involving both sounds and images. Indeed, what is being sought here are ways of interrogating and exploring our understanding of audiovisual experience without attempting to bracket particular works or practices into specific disciplinary boundaries or reductive terms. That is not to say that this cannot be a useful way of encountering audiovisual works, but for the purpose of this volume these aesthetic, conceptual, theoretical, disciplinary or simply genre-based categorizations' will, where possible, be side-stepped, to allow consideration of a work and our response to it through other means.

As an example, an immediate question in approaching this volume might be "why use the term 'audiovisual composition' and not something like 'visual music'?". This is a question I have been asked on more than one occasion, and indeed my own audiovisual work has historically been described as visual music (though not, it must be said, by me). It is perhaps best to begin here by first addressing why I don't use the term in describing my own work, before considering why the term 'audiovisual composition' is being utilised here rather than a more specific term such as visual music.

Having spent some considerable time in my career exploring the history and practices broadly associated with visual music, there is little doubt that much of the work I do both draws heavily from and is closely related to, in ethos and practical development, some visual music practices both contemporary and historical. However, the principal element I react against in the term

itself is the use of the word 'music', as I do not really consider the auditory component of my work to be specifically musical.

This might seem like a peculiar acknowledgement for an academic working within music higher education, but in avoiding the term I am attempting to step around the baggage it brings with it. Whether intentional or not, describing a work as *music* involves evoking a large number of expectations and preconceptions, many of which I don't feel are particularly useful in encountering my work. In describing my pieces as audiovisual compositions, I am attempting to define them as being works in which auditory and visual elements have been combined (usually in a temporal form), but beyond that I am attempting to remove any particular preconceptions associated with the terminology I use to define my work. Each of the strands of my audiovisual practice, and indeed each of the works I compose, is different – in how they are developed, the processes and materials they use, their compositional ethos, their structure, form, texture, timbre, colour, shape, rhythm, etc. – the one thing that unites them is that I describe them as being audiovisual compositions. This is the reason why I don't use the term visual music, as I fundamentally don't consider them to be so, and I don't want audiences to approach them as such.

It might be useful here to reflect on an example I encountered in recent years whilst working on both conceptualising my own compositional ideas – specifically those related to algorithmic aleatoricism (Harris, 2020) – and simultaneously developing another (as yet unfinished) research project on the history of the single-shot music video. Exploring the work of OK Go, whose music videos often feature single-shot or apparently single-shot compositions, I became intrigued by the tale of Mario, the Echo Park gander (who the band dubbed 'Orange Bill') who inserted himself into the video for *End Love* and became quite a prominent feature. The video itself is a single-shot, 18-hour take which uses time-lapse techniques in both compression and expansion to allow the band to perform to the song in the park, including at one point spending the night in sleeping bags and awakening intermittently to lip sync. Mario was a gander familiar to regulars of Echo Park, who tended to prefer the company of people to that of other geese. Having initially been quite territorial with the band during the practice run for the shoot several days earlier, including (anecdotally) biting one of the band members, Mario eventually seemed to almost adopt the band and appears frequently throughout the single-shot take – including spending quite a lot of time sitting at the band's feet or circling them as they perform their elongated dance moves with other park goers.

The intrusion of Mario felt, intuitively, somewhat familiar and sympathetic to the ways in which I had been seeking to structure my own audiovisual work through algorithmic aleatoricism. For me, this process was about both controlling and not controlling elements of my work – of allowing it to be defined in fundamentals – in this case, algorithmically – but having some of the fine details left to chance. The extraordinary control that OK Go have

historically demonstrated in their music video work, often involving elaborate visual environments that are constructed or deconstructed as the works progress, finds resonance in the processes I utilise in writing algorithms to tightly control certain aspects of my work. The intrusion of Mario, then, in this video is the aleatoric element; though not specifically sought, as it was in my own work, this element of unpredictability fundamentally shaped and altered the trajectory of the work itself. Though the outcomes of the work and, indeed, the works themselves might be somewhat different, there were elements of the audiovisual construction that were nonetheless related and felt, intuitively, similar. This recognition of similarities in process resonates with my understanding of audiovisual modes more broadly; that the separation or categorisation of audiovisual works into specific genres or 'types' might be useful in some ways – in addressing, for example, the historical or technological contexts that facilitated them – but might also push us towards overlooking points of correspondence or commonality between audiovisual modes that could impact on our interpretation of them.

Fundamentally therefore, in this volume I am seeking to address works that involve the combination of auditory and visual elements across a range of practices and modes, yet not limited to being from within one particular designation such as visual music. In Section 3 – Analysing Audiovisually – I will further break down the broad heading of audiovisual composition into specific categories or modes in order to facilitate the close analytical reading of a number of examples, but these categories will be functional and descriptive of the mode of the work, i.e. live performance, installation, music video, rather than genre-based or relating to the work's aesthetic or conceptual underpinnings. Within each of these categories it would, of course, be possible to further subdivide these modes into disciplinary boundaries, but that is beyond the remit and, bluntly, interest of this volume at the present moment.

Approaching this volume in this way may be, in itself, potentially problematic. In attempting such a broad and holistic approach to audiovisual work – in trying to speak across a very wide range of modes, practices and artists – I run the risk of revealing nothing meaningful about any of them; as a mentor of mine has often said, "when everything is important, nothing is". Indeed, there are audiovisual works that might be difficult to account for, or more complex to encounter, under the frameworks that will be developed in each subsequent section of this book; narrative film and theatre, for example, and the relative weightings of their sensory components might pose problems that are insurmountable for this particular volume, and the expansive nature of existing discourse relating to their audiovisual experience might render an attempt to add anything to the discourse somewhat fruitless. Nonetheless, what is perhaps most important here is the endeavour, an attempt to reconsider how we encounter audiovisual work outside of disciplinary, aesthetic, conceptual, theoretical, historical or modal boundaries which, even if not successful in this volume, might ultimately provoke the kind of discourse that will allow us to continue this conversation in fruitful directions.

1 Discourse on audiovisual experience

As I have described in the introduction, the impetus for writing this volume comes from a number of areas, one of which is the relatively limited discourse in the field of audiovisual practice outside of specific disciplinary boundaries. The following chapter will provide a brief summary and consideration of some relevant discourse, both positioned from the perspective of addressing 'audiovisual practices', broadly defined, and from discipline-specific perspectives that might have a bearing on how we encounter audiovisual work. It will consider a number of the 'key texts' exposed through the questionnaire, specifically those by authors who were cited by numerous of the questionnaire respondents. It will also consider branches of philosophical, phenomenological and perceptual theoretical thinking that might be relevant to this volume, or which are often referenced by authors writing on audiovisual practice when addressing either their own practice or that of others.

Texts that attempt to deal with the multisensory nature of audiovisual experience within the context of various art forms have become increasingly prevalent, particularly in the last 10–20 years or so, as the term has gained currency within arts practices and academic settings. Whilst the majority of these are still situated within particular disciplinary brackets (the recent 'Sound Image' collected edition (Knight-Hill, 2020b) and, indeed, this publication will appear as part of Routledge's 'Sound Design' series, for example), I will begin with the open access publication, *The Audiovisual Breakthrough*, which both through the way in which the text is constructed and the fact of its open access ethos is one text that has effectively spoken across disciplinary boundaries.

Perhaps the most succinct way of explaining the central ethos of the text is to directly quote the introduction to the book from its host website:

> Visual music, expanded cinema, live cinema, VJing, live audiovisual performance—these are concepts enough to create some confusion in the wide realm of today's artistic audiovisual production. While each of these concepts is widely propagated and suggestive of its own line of history and shared practices, they are not as yet sufficiently defined for theoretical debate and clear practical use. To untangle this confusion was

the aim of our project, The Audiovisual Breakthrough, which brought together six international researchers to solve the problem in a collaborative effort. This book is the result. Its main purpose is to make the entangled complexities of the field manageable by putting forth and elaborating on definitions for the five main concepts named above. The theoretical texts are complemented by the design of the book, a graphic take on audiovisuality that includes visualizations of the results from an international survey among the practitioners in the field of audiovisual (art) practices. This book is addressed to artists, curators, researchers, students, and teachers within these practices, and to anyone working at their intersection with other fields of knowledge.

(Carvalho and Lund, 2015, para. 1)

This succinct exposition is a neat encapsulation of what the book does, drawing from a range of authors from different backgrounds and fields of expertise to offer both definitions of the terms visual music, expanded cinema, live cinema, VJing and live audiovisual performance and a summary of their conceptual and aesthetic underpinnings in an attempt to situate and codify some of this practice. This it does extremely well, and the volume is an essential introduction to a range of live artistic audiovisual practices (indeed, it is required reading on a number of the UG and PG courses I teach). Crucially, it does not attempt to establish a canon of practices or practitioners, beyond pointing to examples where they are fruitful for discussion, but is more interested in the societally mediated constructs developing and supporting the practices it describes and explores. However, it does focus primarily on live practice; this is not necessarily a failing, particularly as Lund's previous publications on visual music deal extensively with some other modes of fixed audiovisual work, as we will see shortly.

The 'graphic take on audiovisuality' (Carvalho and Lund, 2015) the book presents is also highly effective, particularly in foregrounding specific perspectives from survey respondents and also in creating an engaging and, at times, disruptive (in a good way) reading experience (one thing to note, though, is that because of the various text orientations, often from one page to the next, this is much more effectively realised in print form than in the slightly rigid pdf offered online).

One slight disappointment to this volume is that, despite setting out in the introduction that the concepts explored in the book will "form an intricate web of audiovisual relations centered around four main characteristics that play a crucial role in our definitional work: liveness, intermediality, performativity and cinematicity" (Carvalho and Lund, 2015, p. 16) these four characteristics, though variously explored by the book's authors, are not returned to or summarised after the chapters themselves. This feels like a missed opportunity, particularly in a volume aimed, in part, at disambiguation.

Having already referenced Lund's other publication on visual music, this might be a useful volume to consider next. Published in 2008 in collaboration

with Holger Lund, as an accompaniment to Fluctuating Images 2007–2008 visual music project, *Audio.Visual: on Visual Music and Related Media* is a collection of academic articles, shorter essays, imagery and an accompanying DVD that explores the expanded definition of visual music from a range of perspectives and practices, ranging from short artist film to music video, VJing and sound games. Visually, its presentation has a lot in common with the subsequent Fluctuating Images publication referenced above, and the close ties between practice and discourse advocated in that volume find precedent here, through a really effective integration of theoretical ideas with practical examples. The ethos of the book and the issues it problematises are, again, perhaps best exemplified by Holger Lund's description in its editorial:

> Contemporary visual music thus seems to be characterised by substantial diversity as is evidenced, in fact, by this volume's broad assortment of contributions, some of which directly contradict each other... not only different methods of discussion, but also various desiderata emerge, for example there is no standard terminology for the field of audiovisual creation.
>
> (Lund, 2009 p. 11)

Crucially here, and indeed of central concern to the volume you are reading now, is the notion that there is no standard terminology for the field of audiovisual creation. The closest approximation, and indeed the terminology referenced most readily in the questionnaire disseminated as background research for this volume, might be those proposed by Chion in *Audio-Vision* (Chion, 1994), but I will come on to these later in this chapter. Outside of this, the lack of a stable discourse in the broad field of audiovisual practices is acknowledged and addressed in *Audio.Vision* to some extent; however, as with the Audiovisual Breakthrough there is no summary to the book, and no specific conclusions offered, around terminology or indeed the term visual music as applied to the practices addressed in the book. The reader can take what they find most useful from the volume – which is, in itself, quite refreshing – but the series of diverse and, as the editors acknowledge, often contradictory perspectives in many ways poses more questions than the volume can answer.

 Nonetheless, there are some theoretical and conceptual concerns unpicked in the book which are specifically relevant to this volume; indeed, almost all of the chapters express ideas around the interplay of sound and image that resonate with the ideas in this volume and those put forward by participants in the questionnaire. As an example, Matthias Weiss's chapter on the in-differentiability of music video and video music, though potentially a little reductive with respect to the history and indeed contemporary practice of both visual music and music video as forms, interrogates why the two are considered to be fundamentally different even though this difference is somewhat problematic to qualify. Through a series of examples, he argues that, whilst often conceptualised independent of one another, the two are

fundamentally linked through the act of "combining music and the filmic image as inextricably as possible" (Weiss, 2008, p. 100).

The Thames and Hudson art volume, Visual Music (2005), an accompaniment to the exhibition of the same name at the Museum of Modern Art in Los Angeles, is worth pointing to here while we are on the topic of visual music more broadly. Whilst considering only at a relatively surface level the aesthetic, theoretic and conceptual concerns of the medium as a whole, the volume provides quite a detailed historical account of the notion of visual music as it relates to fine art practice and provides some interesting insight into key moments and practitioners from that particular tradition and related traditions. It also provides some interesting indications of what that particular institution considers to be the beginnings of a 'canon' of works and practitioners in visual music.

For a complete history, and contemporary consideration, of visual music as both a practice and an ethos, the most comprehensive resource I have encountered is Maura McDonnell's PhD thesis (2020), *Finding Visual Music in Its 20th Century History*. This incredibly detailed and rigorous study of visual music and the traditions it draws from provides an essential overview of the field, interrogating practices, artists and theoretical and conceptual groundings in really significant depth and detail. Of particular note are McDonnell's reconsideration of the perceived history of visual music as an art form, and the broadening of the contextual considerations surrounding this, to more clearly flesh out the range of practices encapsulated by the term. McDonnell herself both draws from, and contributes to, the work of the Centre for visual music, much of the web presence of which provides a really detailed overview of theories and practices related to visual music (CVM, 2020).

Dealing also with visual music in a number of its chapters, and indeed featuring McDonnell herself, the recent collected edition 'Sound and Image: Aesthetics and Practices' (2020) edited by Andrew Knight-Hill offers a collection of individual perspectives on working with sound and image taken from academics and practitioners who have presented at the annual 'Sound/Image' conference in London, UK since 2015 (this author regularly included and, indeed, included in this volume). The book is a collection of chapters from artists, practitioners and academics the world over and is relatively successful in its attempts to integrate "practice with critical reflection, seeking to negotiate the construction of robust frameworks of understanding that are thoroughly rooted in both acting upon and thinking about the autistics and practices of sound and image works" (Knight-Hill, 2020, p. 5). It offers a series of chapters that are if not quite successful in providing 'robust frameworks of understanding' then at least offering insights into particular practices and ways of thinking about sound/image relationships from across a very broad spectrum. One of the stand-out chapters in the work is Knight-Hill's own *Audiovisual Spaces: Spatiality, Experience and Potentiality in Audiovisual Composition*, in which he advocates for the essential role of the spatial in understanding audiovisual works. Indeed, as he states in his conclusion:

We should not really be seeking individual moments – points in time – at which sound and image combine and sing. Rather, we need to recognise that it is within spatiality that we are able to fully dissolve the binarism between sound and image. It is through space that we can best begin to access the full potentiality of audiovisuality; and that imagining works as audiovisual spaces offers us rich potential to understand, explain and access this long-held desire for an audiovisual music.

(Knight-Hill, 2020, p. 62)

The Oxford Handbook of Sound and Image in Western Art begins some important conversations about relationships between sound, image and, crucially for Knight-Hill (above), space – perhaps most aptly summarised by Kaduri in the introductory chapter as an attempt to

map the modern and contemporary audiovisual cultural space by repeating on concepts such as the spatial, acoustic, and performative shifts, or musical, material, synthesizing, and vocal performativity, as well as by the repetition of important theoretical principles such as the creative dialectics between the abstract and ethereal, on the one hand, and the concrete and physical, on the other; the manipulations of matter, medium, time, and space as tools for theorizing within art; or sense perception in contrast to conceptual understanding. The present description thus emphasizes a central aspect of this audiovisual space to my view, which is the way it allows us to comprehend philosophical issues at the heart of modern and contemporary Western art with our senses.

(Kaduri, 2016, p. 6)

Certainly, the argument for developing an understanding of philosophical issues at the heart of Western art through the interplay of our senses is a powerful one, though I remain unconvinced that this is successfully achieved by many of the chapter contributors in the volume. There are, nonetheless, some important ideas and concepts around the nature of audiovisual experience explored in this work, including in Battey and Fischmann's chapter on visual music from an electroacoustic perspective, which will be revisited later in this section.

Similarly, *The Oxford Handbook of New Audiovisual Aesthetics* (Richardson et al., 2013) professes the lofty goal of calling for a "reassessment of both the centre and boundaries of the audiovisual" (Richardson and Gorbman, 2013, p. 3) and indeed there are some very interesting perspectives offered in the work; Holly Roger's assessment of spatial and temporal liminality in video art–music contains some fascinating insights, and Chion's extensions on his initial ideas of rendering in sensory aspects of contemporary cinema are a useful addition to his earlier thinking in this area. However, despite claims that the book offers a "definitive cross-section of current ways of thinking about sound and image" (ibid., p. 7) what the reader finds instead is a series of, in many cases, obtuse or difficult to decipher idiosyncratic chapters on

specific practices or thematic areas with limited coherence from one chapter, or indeed section, to the next. Again, what is missing here is any real form of conclusion or statement about audiovisual practices more broadly – the 15 thematic areas pointed to in the introduction and the editor's attempts to theorise across the various styles and approaches taken in the book offer a series of thoughts and provocations that, although hinted at in subsequent chapters, are never effectively reconciled. For those interested in audiovisual practices, broadly conceived, there are some worthwhile things here, but as Ben Winters puts it (in his excellent review of the book) "this is a volume to dip in and out of in the library, perhaps in conjunction with the other Oxford handbooks, rather than an introductory text with a strong sense of coherence" (Winters, 2014, p. 234).

The related publication, *The Oxford Handbook of Sound and Image in Digital Media* (related to the point of having been released in the same year and having two of the same editors, in fact) takes a slightly different approach. With its specific focus on digital media, the volume is positioned slightly more antagonistically to existing scholarship on sound/image relationships, with the introduction making statements such as: "Alongside harmonic convergences and ecstatic audiovisual mélanges, we find glitches, noise, rupture, and uncanny vestiges of outmoded practices. Our own mélange of scholarly approaches attempts to capture the texture and feel of this diverse media field" (Herzog and Vernalis, 2013, p. 3); yet within the chapters of this book its authors still attempt to accomplish this through the consideration of relatively narrow and idiosyncratic research projects, with few particular conclusions drawn by the editors at all. Whilst this is not necessarily a problem – indeed, a majority of edited collections of this type rarely draw specific conclusions, offering instead a general overview of a particular thematic area with more focused and specific examples – the positioning of these volumes as a 'handbook' suggests that they should perhaps be more than this. Axiomatically, we might suggest a handbook to be a volume providing guidance, an essential reference point – indeed, as *The Oxford Handbook of New Audiovisual Aesthetics* has it, the definitive cross-section of ways of thinking about sound and image. We might expect more, then, from these volumes – not only providing inroads into the topic, but an attempt at really codifying the boundaries and discourses of that topic as a whole.

One wonders if the apparent opposition the editors of the *Sound and Digital Media Handbook* outline above is the result not of a deliberate pushing against existing theoretical discourse, but of the lack of or void in effective discourse against which to push. Whilst terminologies such as 'audiovisual contract' and 'added value' are alluded to in both this and the previous handbook, there are few specific theoretical constructs against which to situate the broader discussion. Indeed, as the editors state "Most often sounds and images are configured by audiovisual scholars as comprising some sort of marriage, occasionally felicitous, but at least to some extent interpretable, with relations falling into recognizable categories, such as those of conformance, contrast, and contest" (Herzog and Vernallis, 2013, p. 7), with Nicholas

Cook's *Analysing Musical Multimedia* (Cook, 2000), offered as one of the seminal texts for these descriptors (a volume we will discuss shortly). However, whilst Cook is undoubtedly an example of clear thinking in the field, there is nonetheless a relative vacuum of texts, authors or practitioners who explicitly deal with the combination of sound and moving image outside of specific disciplinary or thematic areas – and therein lies the problem.

Indeed, Cook's text is an extraordinary one in attempting what it does, and is successful in a range of ways. In the preface, Cook points to the "absence of a generalised theoretical framework for the analysis of multimedia" (Cook, 2000, p. 5), an idea that will be alluded to many times in this volume, and Cook demonstrates an acute awareness of the difficulty of analysing what he describes as "instances of musical multimedia (IMM)" (ibid., p. 24), which Cook describes as being reflective of the lack of a central term applicable across different media in the same way 'piece' applies to music (another idea which will be revisited later in this volume).

Cook codifies IMM (and this is an oversimplification for the purposes of brevity) as falling into three basic models – conformance, complementation and contest. Here, the fundamental concern is the similarity or difference between media, and the nature of that relationship, with the ultimate designation arrived at through Cook's similarity and difference test. There is a clarity to the thinking here, and the way it is applied in the analytical chapters is convincing. However, one of the central problems is that this is a text that concerns analysis of *musical* multimedia (which should not be surprising, given the title), and it approaches that analysis through often complex means that in many cases require grounding in music theory; it would be difficult to decipher or fully understand a number of the examples if one couldn't read notation. This is not necessarily a failing – indeed, the text does exactly what the title suggests it will – it analyses musical multimedia in convincing ways. The difficulty here, though, is that while this is important it is still quite a narrow conception of the audiovisual (and, indeed, it doesn't use the term audiovisual, rather multimedia) which is only applicable or useful when encountering specific forms in combination with music – yet not everything that is sonic in multimedia is musical, as Cook himself points out. While the blurb for the book states that it is "the first study to put forward a general theory of how different media - music, words, moving pictures and dance - work together to create multimedia" this is not strictly true. The focus on music – as intended – roots the book firmly within its musicological silo, providing insights that are potentially applicable outside of its remit but not directly presented in such a way. Indeed, that the editors of the *Sound and Digital Media Handbook* continue to hold this up as an example speaks further to the lack of effective discourse against which to situate the discussion in that volume, and indeed the discussion in this one. That such heavily disciplinary discourse is still being cited as a key example in the field speaks to the lack of the maturing of that field, from an interdisciplinary conceptual and theoretical perspective.

This feels like an appropriate moment to move to Michel Chion's *Audio-Vision: Sound on Screen* (Chion, 2019), the book most often cited in examples of genuinely audiovisual discourse, and indeed most often referenced by participants in the questionnaire that forms a central part of Section 2 of this book. Chion's contribution is undoubtedly significant and the work, now over 25 years old, remains one of the central and essential texts for students embarking on a greater consideration of relationships between sound and image. Nonetheless, this is primarily a book about the relationship between sound/music and image in the context of narrative film, and one in which sound and image are dealt with as fundamentally different things, documenting the effect that one has on the other rather than the combined effect they have together. Some of Chion's concepts will be addressed later in this volume, and his ideas on audiovisual analysis brought to bear in Section 3 of this volume. His work is undoubtedly important, and the points it makes about sound/image relationships within narrative film resonant and easily applicable, but I would argue that its success and repute in the field of audiovisual studies more broadly are due, to some extent, to a lack of weighty counterparts.

Of perhaps more immediate use and resonance to this volume is Daniel's and Naumann's *See This Sound* project and its associated collected edition *Audiovisuology Compendium: An Interdisciplinary Survey of Audiovisual Culture* (2010). This compendium and the *See This Sound* companion website provide an extraordinarily detailed survey of histories, practices and conceptual directions in art involving sight and sound from both a historically and contemporary perspective, with a particular reference to the 20th century. Indeed, the introduction to the compendium of work outlines its extraordinary scope, stating

> The time span and thematic area covered by this compendium range respectively from antiquity to the present day and from philosophical models to existing apparatus and tools, for example from the Pythagorean theory of universal harmony to the audiovisual software of music visualization plug-ins for mp3 players.
>
> (Daniels and Naumann, 2010, p. 6)

Within this very broad remit, the topics covered within the compendium provide a really compelling snapshot of historical and contemporary audiovisual practices and, importantly, conceptual and theoretical ideas surrounding those practices. It is also worth noting that, across the board, this volume uses the term 'audiovisual' to describe and discuss the practices and histories it explores.

To sum up the contributions of this volume, it is once again useful to revisit the introduction, where the remit is explicitly stated:

> The guiding theme of the contributions in this volume is the relationship between the auditory and the visual in art, media technology, science,

and perception. The period covered spans from the eighteenth century to the present, with a particular focus on the twentieth century. This leitmotif is developed along four different thematic lines:

(a) the relationship between artistic genres and their respective aesthetic theories with reference to painting, sculpture, music, literature, and film;

(b) the coupling of images and sounds in the audiovisual media and artistic apparatus found in the realms of film, video, and immersive or interactive installations, as well as in their historical antecedents in the colour-light art of the nineteenth and early twentieth centuries;

(c) the interplay between these techniques and human perception to the point of potential boundary experiences of multimodal synthesis, such as those that occur in the phenomena of cross-modality, embodiment, immersion, and dissolution;

(d) the convergence and divergence of visual and auditory codes in various forms of cultural expression, which has been thematicised, for example, in the artistic avant-garde of the 1920s, in the intermedia art of the 1960s and digital media art since the 1980s, and in pop culture since the 1960s, as well as in the reflection of pop culture in contemporary art since the 1990s.

(Daniels and Naumann, 2010, p. 6)

Each of these topic areas is clearly explored through the chapters and, though perhaps not as directly as might be suggested in this preamble, there are some excellent attempts at broad, inclusive, interdisciplinary discussion here. However, much as with other collected editions discussed earlier in this section, a useful addition to this volume would be a section which reflects on and summarises the work presented; here, we are provided with an epilogue, but this is in the form of another essay on a specific audiovisual topic, this time from Michel Chion, as opposed to a consideration of the work of the volume as a whole.

Nonetheless, there are some highly resonant discussions manifest in this volume, with one of the most interesting being Chris Salter's exploration of *The Question of Thresholds: Immersion, Absorption, and Dissolution in the Environments of Audio-Vision* (Salter, 2010). Drawing extensively on cross-model synthesis, neuroscience, psychology and phenomenology, the chapter brings sensory, phenomenological and perceptual models in approaching audiovisual work to the foreground, many of which will be revisited later in this volume.

Another important thinker in the field is Holly Rogers, with *Sounding the Gallery* (2012) being a particular highlight in reconciling media with one another, historically, conceptually and aesthetically. Indeed, as she has in other articles (some of which will be considered later in this volume), Rogers points to the misapprehension that video art was a new art form, free from 'historical baggage', and suggests instead that the intermedial capabilities of video

allowed the combination and fusion of disciplines and their associated histo-
ries, suggesting an abundance of historical and conceptual context as opposed
to a lack of one. She argues that video technology, through permitting the cre-
ation of sound and image simultaneously and immediately, led to the 'birth of
the artist-composer' and 'process-driven, interactive intermediality'. Indeed:

> The beginning of the twenty-first century is the perfect time to attempt
> a historical recontextualisation of video art-music... As the digital age
> marks the demise of its usage, we are faced with an epoch that is almost
> already complete, a phenomenon rarely encountered before in the visual
> and sonic arts.
>
> In one sense, however, this closure is a false one. Artist-composers,
> such as Bill Viola, may have swapped their material preference from
> magnetic to digital formats, but the fundamental aesthetic aspects of
> video have been retained. In fact, the shift between formats has been so
> seamless that moving-image work continues to be collected under the
> term "video art," despite the obvious technological inaccuracy. While
> it is true, then, that analogue video technology is now redundant in
> terms of recording and playback, the implications of audiovisual fusion
> that it enabled are still thriving. Many contemporary video practitioners,
> for instance, continue to embrace the audiovisuality of the digital me-
> dium and take charge of both image and sound: Sabrina Pena identifies
> herself as both "avant-garde composer" and "video artist," while Kathy
> Hinde prefers the term "interdisciplinary artist" to describe her video
> work with music and image. The equipment may have evolved, then,
> but aspects of its technological basis and the opportunities for synthesis it
> affords continue to inform the new digital age.
>
> (Rogers, 2011, p. 401)

This is a compelling argument, and indeed as described and explored by
Rogers in this volume it is difficult to argue with the impact that video
technology had on the practice of artists working in the video epoch such as
Steina Vasulka and Nam June Paik. Indeed, much as Rogers argues for the
technological precedent to intermediality set out by artists such as Norman
McLaren, Oskar Fischinger, Mary-Ellen Bute, John Whitney and Jordan Bel-
son, it would be possible to consider the work of these and other earlier 20th
century artists/composers as not only technologically precedent but as an em-
bodiment of the ethos inherent in combining media to create an *other*. Much
as Rogers charts the subsequent lineage of video art-music through video
games, interactive installations and even fireworks, she also acknowledges the
technological, aesthetic and conceptual precedents to video art-music and, in
many ways, provides a useful historical and conceptual overview of works
relevant to this volume and others.

To return to Bret Battey, who we touched on earlier, it might be useful to
briefly explore his written work here. Battey explicitly describes himself as

an audiovisual creator and is a Professor of Audiovisual Composition at De Montfort University, Leicester, UK. That being said, much of his written work specifically interrogates or relates to the history of visual music, including his recent book chapter in the *Handbook of Sound and Image in Western Art*, on *Convergence of Time and Space: The Practice of Visual Music from an Electroacoustic Music Perspective*, co-authored with Rajmil Fischmann Steremberg (2016). The abstract states that the chapter:

> considers the historical lineage and conceptual origins of visual music, addressing the turn to abstraction and absolute film in visual arts, particularly in the first half of the twentieth century, and the turn to mimesis and spatialization in music, particularly through the acousmatic tradition after World War II.
>
> (Battey and Fischmann Steremberg, 2016, p. 1)

Here, and throughout the chapter, the terms 'audiovisual art' and 'visual music' are used relatively interchangeably in presenting and exploring the case studies offered, suggesting that there is an acceptance of the term visual music as being broadly applicable to a particular type of audiovisual composition – in this case "time-based audiovisual works in which visuals and sound are structured and integrated by means of musical processes" (ibid., p. 3). The arguments presented here, as related to the case studies developed, are compelling, but, perhaps, only really compelling as they relate to the individual case studies, the broader applicability, particularly with regard to perceived notions of value or references to the development of effective audiovisual relationships feel somewhat media- or context-specific.

Nonetheless, Battey's discussion of his own work historically offers significant insights and windows into the process of adopting or working with visual means as, initially, a composer grounded in primarily musical traditions and histories. His work on the development of a fluid audiovisual counterpoint (2015), for example, points towards the potential value of such a structuring mechanism in approaching both the composition and analysis of audiovisual work, but is also aware of its potential failings, suggesting that from a pedagogical perspective, audiovisual counterpoint should focus "less on highly quantifiable rules than does species counterpoint. Instead, it would be a 'phenomenological counterpoint', primarily developing a student's awareness of his or her own experience" (ibid., 2015, p. 2). Indeed, this is highly resonant with the analytical approach advocated later in this volume, though terms such as counterpoint in this context are specifically avoided because of their pre-existing connotations.

Battey extensively references the work of Diego Garro in the co-authored chapter cited above, specifically referring to Garro's conceptions of relationships between sound and image through their mappings and correspondences. In his 2005 paper, Garro suggests that "digital artists can explore the

relationships between the phenomenology of the objet sonore and that of the moving image, towards the definition of what we may call *objet audiovisuelle"* (Garro, 2005, p. 1) going on to present a series of examples and case studies for exploring particular audiovisual relationships, specifically those relating to how sound and image might be defined in relationship to one another along a continuum of audio versus visual gestural association strategies.

Garro's formulation, in this 2005 article at least, though having much to commend it is somewhat limited (at least for potentially applicability to and usefulness in this volume) by its lineage and perspective, as it positions the composition of sound and image, and the relationships formed between them as fundamentally distinct. Further, the discussion draws extensively from the electroacoustic tradition in suggesting that:

> Audio-visual art, in the form developed by many electroacoustic com-
> posers, can perhaps draw a number of viewers, students and film practi-
> tioners closer to the world of electroacoustic music, with which it shares
> the fundamental philosophy of approach to the time-varying materials
> and their articulation into artistic aggregates.
>
> (Garro, 2005, p. 16)

This research trajectory continues in his 2010 article, *From Sonic Art to Visual Music: Divergences, Convergences, Intersections,* in which he continues his discussion of the potential contribution of electroacoustic music and composers to the audiovisual field through a consideration of the parallels and relationships between sonic art and visual music. But this could be seen as an almost oppositional perspective; indeed, one section of the chapter is even titled 'Visual Music versus the Electroacoustic Arts', in which the two are presented as somewhat antithetical to one another with respect to particular aspects of their ethos. All this being said, Garro's work is clearly presented and potentially useful to composers approaching audiovisual composition from an electroacoustic musical tradition or background, and consequently has much to offer in that specific arena.

It feels apt here to address Jaroslaw Kapuscinski's work on intermedia relationships between sound and image, much of which is resonant with the ideas developed in this volume as a whole. Rather than conceiving the separate audio and visual media as constituent and related parts of an audiovisual work Kapuscinski states in his article *Basic Theory of Intermedia Composing with Sounds and Images* that his artistic premise is to

> compose structurally integrated intermedia works, in which sounds and
> images are given equal importance and are developed either simultane-
> ously or in constant awareness of each other. I am particularly interested in
> working with narratives that emerge BETWEEN aural and visual layers.
>
> (1997, p. 1)

Kapuscinski's work, and specifically the structural models he advocates for exploring audiovisual relationships, will be considered in more detail later in this volume in the formulation of elements of audiovisual composition, but it is nonetheless useful here to point towards his approach as potentially informative. Certainly, notions of composing in constant awareness of both sounds and images and exploring the spaces 'between' these layers resonate strongly with much of the discussion later in this section. Indeed, the notion of *between* is something that Kapuscinski also brings into his work on other composers, such as the following in writing about Norman McLaren as an audiovisual synergist:

> He deeply cared about what was BETWEEN elements and in result he often achieved more than their simple sum. He was fascinated by movement, which meant a preoccupation with what was happening BE-TWEEN images not what was on each of them. He was interested in presenting correspondences BETWEEN music and animation.
>
> (Kapuscinski, 1999, p. 5)

This conception of the between is shared by numerous others, including Zielinski, with the notion of relationships explored extensively in *Audiovisions*. Though in this case more concerned with media than material, he nonetheless calls for a

> media reality that is organised not vertically but horizontally, and characterised by a lively **alongside-of and in-one-another of distinctly different praxes**... My plea for the arts of pictures and sounds in the age of advanced audiovisions is emphatically to work on the strengths of diversity. Spectator, viewer, and participant/player are not positions or attitudes that are mutually exclusive. One can – according to situation and disposition – assume them in alternation.
>
> (Zielinski, 1999, p. 291, emphasis my own)

Having skirted around notions of counterpoint in this section, it would be remiss not to briefly touch on the work of Sergei Eisenstein, whose writing on film and montage has been so formative to contemporary filmmakers, including many of those cited in this volume. Eisenstein's extraordinarily prolific writings, in both quantity and quality, have been explored by a huge number of authors more qualified than I – and indeed have been the subject of numerous volumes of reflective writing, the vast majority of which is not practical to delve into here. Instead, I would point to the volume *Eisenstein on the Audiovisual*, by Robert Robertson (2011), an extraordinarily detailed and rigorous consideration of the director's approach to both working with and thinking about sound and image relationships in his films. The book as a whole is essential reading for those interested in how Eisenstein worked with, and conceived of, audiovisual relationships, but perhaps of particular interest

to this volume are Robertson's discussions of Eisenstein as an audiovisual composer and his use of audiovisual terminology. In analysing Eisenstein's writings, Robertson points to his likelihood to express himself in 'composerly terms' (ibid., p. 170) or to construct diagrammatic representations similar to graphic scores. He also points to his use of terminology which could be applied across both music and the visual arts – such as tonal or line – and his application of these terms differently according to context, pointing out that

> the resultant fluidity of meaning in Eisenstein's use of musical terms is due to the innovative nature of his subject: he is writing one of the first texts to explain in great detail how the audiovisual can work in cinema. He is dealing with a subject which is new and has not yet evolved a generally accepted terminology. The advantage of his plurality of meaning is a lack of encrusted taxonomies which can impede dynamic combinations of ideas.
>
> (Robertson, 2011, p. 184)

Certainly, the lack of encrusted taxonomies can afford these dynamic combinations of ideas, yet the absence of these taxonomies might be argued to create a discursive vacuum in which ideas that seem broadly applicable might be allowed to stand without significant opposition or detailed interrogation. This is not to imply this is the case with Eisenstein's work, but we might see this as being exemplary of interdisciplinary audiovisual discourse as a whole.

Eisenstein was referenced several times in the questionnaire responses (more on this in the next chapter) as were numerous of the other authors cited above. One we have yet to discuss, who was cited numerous times, is John Whitney – specifically his 1980 publication *Digital Harmony*. In it, Whitney is prescient in his predictions of the flowering of interest in, and greater availability of technology for, new audiovisual art forms. His ideas on the relationships between sound and image – many being routed in considerations of functional or Pythagorean harmony – also seem to be transformative for a number of questionnaire respondents in this study. In the chapter *From Music to Visual Art and Back*, he argues that

> Some day, the term digital harmony may be a commonplace expression associated with a major evolution of twentieth century technology. Because of digital harmony, music becomes visible. Performance escapes the bondage of time. Time achieves a totally new condition of substantiality... The fleeting insubstantiality of music is transformed. Composing becomes more like molding clay, because of the hands-on process of digital memory manipulations. The composer may mold this particular substance with his instant, interactive responses to the sensitivity of his own ear.
>
> Time is mastered and turned into substance... Add to this substantiated hands-on process of sound, the same hands-on process of the color image in motion. A revolution in intuitional intimacy with sound and

color is the result. The distances from music to visual art and back have been shortened by this newfound substantiality.

(Whitney, 1980, pp. 97–102)

In discussing this substantiality, what Whitney is alluding to is the affordances of technology to structure, and record, musical and visual materials in the moment and so mediate the complementarity between their interrelated musical and visual structures. Certainly, both the clarity of the audiovisual relationships inherent in Whitney's work and the way in which he describes and analyses his works and their ethos are hugely illuminating, as is the application of terminology from both music and visual art utilised in what is – in places – a cross-disciplinary discussion. Nonetheless, on the whole the emphasis here feels heavily musical, and Whitney's preoccupation with manifestations of harmony is clear throughout this and other of his writings, with little specific consideration of the spaces between music and visual materials or the audiovisual artefacts they mediate together.

Reading interpretations of Whitney's writing, and how his methods have been subsequently utilised and expanded, is in many ways as interesting as illuminating the original work itself. Composers such as Bill Alves have followed in almost a Whitney-school, extending ideas around sonic and visual harmony into new digital compositions (Alves, 2005). Yet in Cinesonica (2010), Andy Birtwistle positions Whitney's writings – specifically on the use of sound in Five Film Exercises – as being resolutely visual first, with sound a force to be contained and controlled. Interestingly, what initially attracted me to Whitney's writing, when completing my PhD in audiovisual composition, was what I perceived as his ability to effectively talk about and reconcile sonic and visual media as part of a single process. Revisited ten years later, Whitney's work seemingly offers the same thing but I interpret it differently – focusing instead on how he treats the separation of sound and image, even while attempting to consider them as part of a single process.

Expanding on notions of the *between* in combining media, it would be remiss not to include Dick Higgins's seminal *Intermedia*, which cannot help but intrude on the theoretical context for this work. As with many of the other texts referenced here, I have revisited Higgins's writings several years after first encountering it and find that it has become something other in my memory to what it, in fact, is. What I discovered, in rereading the work in full (and Higgins's 1985 response to it), was that I had conflated much later writing about Intermedia with Higgins's original text and had thought it to be an extended philosophical treatise on the nature of intermedia works. It is not – it is simply a statement about the existence of intermedia and ways to find 'ingress' into intermedia works. Indeed, as Higgins himself has it in the 1985 response:

I would leave the matter of intermedia. It is today, as it was in 1965, a useful way to approach some new work; one asks oneself, "what that I

know does this new work lie between?" But it is more useful at the outset of a critical process than at the later stages of it. Perhaps I did not see that at the time, but it is clear to me now. Perhaps, in all the excitement of what was, for me, a discovery, I overvalued it. I do not wish to compensate with a second error of judgment and to undervalue it now.

(Higgins, 2001 p. 53)

Yet, despite Higgins 'leaving the matter' of intermedia in 1985, the term itself does still have a certain amount of currency – a number of the questionnaire respondents for this study describe themselves as intermedia artists, or as making intermedia works, and it is a term that I hear used extensively in a range of contexts within the arts in higher education. Higgins sign-off here is significant to later chapters in this book, though, in stating the following

> it would seem that to proceed further in the understanding of any given work, one must look elsewhere—to all the aspects of a work and not just to its formal origins, and at the horizons which the work implies, to find an appropriate hermeneutic process for seeing the whole of the work in my own relation to it.

(Ibid., p. 53)

This 'looking elsewhere' is key to how the analytical section of this volume is approached and will be revisited in later chapters.

The term intermedia in some recent scholarship has been somewhat substituted by the term transmedia, and here it would be appropriate to consider *Transmedia Directors: Artistry, Industry and New Audiovisual Aesthetics* (2019), edited by Carol Vernallis, Holly Rogers and Lisa Perrott, who all contribute at least one chapter to the volume. This is a rich, detailed edited collection of articles addressing the work of directors who work across multiple media which, as Rogers puts it in her introductory text, "paves the way for refreshed and extended forms of audiovisuality" (Rogers, 2019, p. 8). Branching out from much existing scholarship on transmedia storytelling, most often concerned specifically with narrative, the collection nonetheless feels somewhat rooted in considerations of specifically audiovisual relationships in cinema and expansions thereon. There are some intriguing insights here, with Rogers's chapter on the Audiovisual eerie in the work of David Lynch a particular highlight for the purposes of this volume. Always keen to explore the potentiality of the audiovisual, Rogers cites Van Elferen's work on Lynch as trans-diegetic yet encourages us to push a step further, to think "beyond and between the boundaries of each cinematic representation to become trans medial" (ibid., p. 256). This emphasis on the 'beyond' and/or 'between' in transmedia scholarship is key to its relevance to this volume and to the audiovisual field as a whole and will be explored in more detail in Chapter 3.

Finally, much discourse on audiovisual practices is informed to some extent by neuroscience, perceptual theory or studies of consciousness. As an

example, Chris Salter's (2010) study on immersion in *See This Sound* talks extensively about the work of Shams and Shimojo on the effects of cross-modal sensory integration and modulation, whilst Grierson and Abbado both reference Sekular and Blake's (1994) work on the sensory colliculus in mediating multisensory experience. Indeed, much contemporary discourse on cross-modal perception indicates that specific physiological and neurological processes inflect on how we experience audiovisual pairings. Lewis (2010) argues that

> several parallel and hierarchical processing pathways for purposes of audio-visual perception of objects. This included dissociations of pathways and networks for the binding of audio-visual features based either on (1) intermodal invariant attributes of nonnatural, simple objects; (2) semantically congruent features of natural objects, especially life-long highly familiar human conspecific actions; and (3) semantically congruent features of nonnatural or artificial audiovisual pairings.
>
> (Lewis, 2010, p. 181)

suggesting that there is more than one way in which the brain interprets and processes audiovisual pairings. Petrini et al.'s (2009) study

> demonstrate(s) that acquiring specific expertise through practice enables precise timing judgements of sight and sound even when relevant visual information is missing or occluded. In other words, this ability to predict the effect of a certain action…might not be shared by trained and untrained listeners/observers.
>
> (Petrini et al., 2009, p. 438)

suggesting that audiovisual perception of specific events is training and experience dependent as opposed to solely a result of cognitive processes; indeed, the paper itself is titled *When knowing can replace seeing in audiovisual integration of actions*, further indicating the importance of knowledge and understanding in mediating audiovisual experience. Further, Shams and Beierholm (2010) state that "causal inference in multisensory perception can arise through reinforcement learning from interactions with the environment" (Shams and Beierholm, 2010, p. 431), while Mihalik and Noppeney's (2020) study on *Causal Inference in Audiovisual Perception* suggests

> that the lateral prefrontal cortex plays a key role in inferring and making explicit decisions about the causal structure that generates sensory signals in our environment. By contrast, informed by observers' inferred causal structure, the FEF–IPS circuitry integrates auditory and visual spatial signals into representations that guide motor responses.
>
> (Mihalik and Noppeney, 2020, p. 6600)

Certainly, much research in neuroscience, studies of consciousness and cognition and cross- or multi-modal perception suggests that there are many specific and cross-modal processes involved in how the brain processes audiovisual stimuli, and that these processes can be further inflected by context, knowledge and experience. Whilst the majority of these studies are specifically concerned with behaviour or motor function, this is nonetheless suggestive that much of the discussion that follows in this volume concerning the specific perceptual nature of audiovisual experience is underpinned by actual physiological processes in the brain.

There are, of course, multitudes of smaller texts and individual articles that deal with the nature of audiovisual experience in some form. There are also numerous artist-practitioners whose writing on their own work, and that of others, has gained particular currency within the audiovisual community – many of which were pointed to by the questionnaire participants for this study. This is, not an exhaustive list of texts and sources that are relevant to our enquiry – it barely scratches the surface, and I encourage you to explore the bibliography for this text for suggestions for further reading. Indeed Birtwistle's excellent Cinesonica, which I reference so briefly above, is littered with fascinating insights on the sounding of film and cinema and is an important contribution to audiovisual discourse in its own right. The above represents a tiny snapshot of potentially relevant fields of enquiry for this book – specifically, the ones that feel most resonant for the reasons I have outlined – but each in itself suggests numerous other avenues for exploration.

2 Analysis of questionnaire results

Methodology

The intention of the questionnaire, and subsequent interviews, was to gather a broad range of perspectives on contemporary audiovisual practices across a range of modes; consequently, participant research was deemed appropriate and necessary. There was an open call for participation, alongside the questionnaire being sent to a number of artists, researchers and theorists already known to the author; the final total of respondents was 79. The questionnaire contained a combination of multiple choice, Likert scale and open-ended questions, with participants being encouraged to be as detailed in their responses to the open-ended questions as they felt necessary. Once gathered, the data was analysis for themes, key concepts and patterns and each response was coded according to these criteria. Each type of question is analysed in turn, below, with the majority of the discussion here given to the themes that emerged through the open-ended questions.

Multiple choice questions

The first question was "Thinking about your relationship to audiovisual art, how would you describe yourself?" It was possible for participants to select more than one option here, as well as suggesting other terms in the 'other category', and the question elicited the following responses:

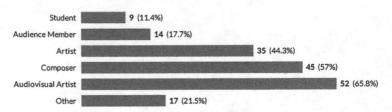

Multi answer: Percentage of respondents who selected each answer option (e.g. 100% would represent that all this question's respondents chose that option)

Figure 2.1 Responses to Q1

In the 'other' responses, the following additional designations were suggested:

- Academic leading and teaching audio production
- Composer/Performer/Media Artist
- I also teach some relevant areas within HE, currently to audio/music students, previously to fine art and video students
- Performance artist
- Sound artist/sculptor

This question indicates a strong preference in the direction of 'audiovisual artist' and 'composer' for those who completed the survey, with 45 of the 79 participants selecting either one or both of those options.

Cross-tabulated against other questions in the survey, we can note that responses to question 2 – How long have you been interested in audiovisual work? – grouped by level of experience, show that the majority of those selecting Composer and/or Audiovisual Artist had been interested in audio-visual work for over 15 years, whilst the majority of those selecting Student or Audience Member had been interested in audio-visual work for less than ten years. This is perhaps unsurprising, but bears further interrogation when considered against the answer to question 3.

It is interesting that such a high percentage of participants (84%) considered themselves to be both an audiovisual maker *and* thinker, but this is also perhaps a failing of the question. The categories here are somewhat reductive, but deliberately so; unlike the more open-ended responses encouraged later in the survey, this was intended as a more concrete question that encouraged participants to define their relationship with contemporary audiovisual modes in more specific terms. I had expected a split into roughly thirds between 'maker', 'thinker' and 'both', with a few participants selecting 'other' and not such a heavy skew towards 'both'. However, had I categorised these differently – using theorist instead of thinker, for example – I suspect the results would have been somewhat different. Nonetheless, this is still an illustrative response, suggesting that the vast majority of participants in the survey consider themselves as being involved in both the making of and

3 Would you describe yourself as a...

Maker · 11 (13.9%)
Thinker · 0
Both · 66 (83.5%)
Neither · 0
Other · 2 (2.5%)

Figure 2.2 Responses to Q3

thinking about audiovisual modes, and this is certainly represented in the detailed responses to the open-ended questions, which will be discussed later.

Likert scale questions

There were 12 questions posed in the form of a Likert scale, asking participants to consider to what extent they agreed with particular statements on the characteristics of effective audiovisual works. These questions were deliberately a little provocative in terms of how they were phrased, in order to both (a) reveal trends in what participants felt did and didn't constitute an effective audiovisual work and (b) encourage participants to interrogate and respond to the phrasing of the questions, specifically the use of the word 'should' (indeed, even the word 'effective' in this context might be considered somewhat contentious). Participants were also encouraged to reflect on their responses to the questions in a text box, with approximately half of the respondents choosing to do so – in many cases at considerable length. These responses will primarily be considered alongside the analysis of the open-ended questions, as there are many coded themes in common across all of these responses.

Despite the phrasing of the questions, clear trends in terms of agreement, disagreement or ambivalence to the question being posed emerged in each case, as follows:

This question received the highest percentage of responses on the 'agree' side of the scale and as is suggested by the coded responses from the open-ended questions seems to be one characteristic of an effective audiovisual work that the majority of respondents agreed with, with 60% of respondents agreeing with the statement and over 36% strongly agreeing.

This question also received high levels of agreement – over 50% agreed with the statement, but the response was more muted, with the highest

8.1 An effective audiovisual work should engage both auditory and visual perception equally

Rank value	Option	Count
1	strongly agree	29
2	mostly agree	20
3	somewhat agree	6
4	neither agree nor disagree	14
5	somewhat disagree	8
6	mostly disagree	1
7	strongly disagree	1

Mean rank	2.48
Variance	2.35
Standard Deviation	1.53
Lower Quartile	1.0
Upper Quartile	4.0

Figure 2.3 Responses to Q8.1

8.2 An effective audiovisual work should have an obvious relationship or correlation between sound and image

Rank value	Option	Count
1	strongly agree	17
2	mostly agree	24
3	somewhat agree	8
4	neither agree nor disagree	14
5	somewhat disagree	5
6	mostly disagree	6
7	strongly disagree	5

Mean rank	3.05
Variance	3.29
Standard Deviation	1.81
Lower Quartile	2.0
Upper Quartile	4.0

Figure 2.4 Responses to Q8.2

8.3 An effective audiovisual work should be immersive

Rank value	Option	Count
1	strongly agree	16
2	mostly agree	15
3	somewhat agree	17
4	neither agree nor disagree	24
5	somewhat disagree	3
6	mostly disagree	2
7	strongly disagree	2

Mean rank	2.99
Variance	2.06
Standard Deviation	1.44
Lower Quartile	2.0
Upper Quartile	4.0

Figure 2.5 Responses to Q8.3

percentage (30%) in the 'mostly agree' category. This indicates, as is further suggested by the coded responses, that an obvious relationship between sound and image was an important factor in effective audiovisual work for a large percentage of the respondents but was not universally agreed to be necessary.

I confess myself somewhat surprised by the response to this question, as I hadn't expected such a high percentage of agreement – higher, indeed, than question 8.2 at nearly 60% (though again, more muted, with a greater percentage of 'somewhat agree' responses). This is an interesting response, indicating that immersion is an important characteristic for a lot of respondents; however, the exact nature of what the term 'immersive' might mean in this context is opaque, and indeed this comes up in more detail in the coded responses. What we might take this to refer to is the immersive effect of combining sound and image to create a third experience beyond that of the

8.4 An effective audiovisual work should be innovative

Rank value	Option	Count
1	strongly agree	7
2	mostly agree	11
3	somewhat agree	25
4	neither agree nor disagree	19
5	somewhat disagree	7
6	mostly disagree	4
7	strongly disagree	6

Mean rank	3.56
Variance	2.45
Standard Deviation	1.57
Lower Quartile	3.0
Upper Quartile	4.0

Figure 2.6 Responses to Q8.4

two media in isolation; this is something that will be revisited later in this chapter. This could also be indicative of the nebulousness and lack of specificity engendered by the term 'immersive' in general (not just in this field), and reflective of respondents' intuitive response to immersion as part of affect as opposed to being one specific experiential 'thing'.

This question was responded to slightly less positively, but still suggests a preference towards agreement at 54%.

From this point, the majority of the questions showed quite high percentages of neutrality or disagreement, as follows:

8.5: An effective audiovisual work should contain narrative –
 55% disagree, 33% neutral, 12% agree
8.6: An effective audiovisual work should make a statement (social, political etc.) –
 65% disagree, 28% neutral, 7% agree
8.7: An effective audiovisual work should be time-limited –
 40% disagree, 40% neutral, 20% agree
8.8: An effective audiovisual work should be performative –
 32% disagree, 47% neutral, 21% agree
8.9: An effective audiovisual work should be fixed –
 49% disagree, 42% neutral, 9% agree
8.10: An effective audiovisual work should be different every time –
 55% disagree, 33% neutral, 12% agree
8.11: An effective audiovisual work should be easy to understand or decode –
 60% disagree, 24% neutral, 16% agree
8.12: An effective audiovisual work should be sculptural –
 46% disagree, 43% neutral, 11% agree

The patterns here are interesting and, to be honest, not entirely expected. For the majority of these questions – questions which were deliberately more

concrete and thematic than the more conceptual questions they followed – I expected higher levels of neutrality, indeed for the majority of them to rank highest in the 'neither agree nor disagree' category, with some weighting towards either agree or disagree in the remainder of the responses. I anticipated this as, from my own experience of audiovisual practices, I have encountered examples of each of these forms – works that are fixed, works that are time-limited, works that are sculptural, etc. – in both effective and less effective realisations. I therefore anticipated that the majority of respondents would feel similarly and respond neutrally.

In assessing these responses, further questions need to be asked – specifically about what these responses mean. Are they a response to the word 'should' in the question itself – a reaction to the idea that an effective audiovisual work 'should' exhibit any particular characteristic? If so, I would expect the results to be more consistent, as indeed I had anticipated, with less variance in agreement/disagreement from question to question. Further, do those mostly or strongly disagreeing that, for example, an effective audiovisual work should contain narrative (44%) or make a statement (51%) feel that an effective audiovisual work should actively NOT do these things? These ambiguities are one of the reasons why I elected to follow up the questionnaire with a series of more in-depth interviews with some participants – typically those who had reached out to me directly to find out more about the project having completed the initial questionnaire. These discussions will be dissected in depth in the next chapter.

Open-ended/text-based questions

The responses to these questions were a treasure trove of ideas and information, suggesting a huge variety of directions for this research – a great deal more than can be covered in one book! I have endeavoured to code the responses for the clearest and most apparent topics, and there are some quite obvious thematic areas that warrant further discussion. I will begin, though, with consideration of the responses to questions about (a) which artists participants felt made particularly effective audiovisual works and (b) which writers/theorists they felt effectively explained, discussed or documented audiovisual experience. These questions were asked to try to capture a snapshot of the current most prevalent artists and theorists associated with audiovisual modes.

With regard to the question about audiovisual artists, from 79 participants, 176 artist names were suggested, with some respondents giving very extensive and detailed lists of works they enjoyed and why. Several names appeared more than once, as follows:

Of these, the artists with five or more mentions were:

Ryoji Ikeda – 10 mentions
Ryoichi Kurokawa – 7 mention
Norman McLaren – 7 mentions
Myriam Boucher – 6 mentions

John Whitney – 5 mentions
Bret Battey – 5 mentions
Oskar Fischinger – 5 mentions

Table 2.1 Most frequently cited artist names

Alva Noto	3
Amon Tobin	2
Bret Battey	5
Dennis Miller	3
Francesc Marti	2
Herman Kolgan	2
Jaroslaw Kapuscinski	2
Jean Piche	4
João Pedro Oliveira	3
John Whitney	5
Jordan Belson	3
Kathy Hinde	4
Larry Cuba	2
Laurie Anderson	2
Len Lye	2
Louise Harris	2
Max Hattler	3
Maxime Corbeil-Perron	3
Myriam Boucher	6
Norman McLaren	7
Oskar Fischinger	5
Robert Henke	3
Robin Fox	3
Ryoichi Kurokawa	7
Ryoji Ikeda	10
Stan Brakhage	2
Steina Vasulka	4
Zimoun	2

Table 2.2 Most frequently cited writer/theorist names

Brett Battey	2
Michel Chion	15
Diego Garro	2
Dieter Daniels	2
Jaroslaw Kapuscinski	2
John Whitney	7
Joseph Hyde	2
Lev Manovich	2
Louise Harris	2
Maura McDonnell	3
Mick Grierson	2
Nicholas Cook	4
Sandra Naumann	2
Sergei Eisenstein	2
Wassily Kandinsky	2

With regard to writers/theorists, the list was shorter but still contained 66 names, several of which appeared more than once (and some of whom appeared most prominently, perhaps unsurprisingly).

Of these, only four writers were mentioned more than twice:

Michel Chion – 15 mentions (interestingly, most respondents just wrote 'Chion', foregoing the forename no doubt under the assumption it would be known who was meant).
John Whitney - 7 mentions
Nicholas Cook - 4 mentions
Maura McDonnell - 3 mentions

It is perhaps worth noting that only one name – John Whitney – appears on both lists within the highest ranking occurrences. There are, however, a number of other names with multiple mentions appearing on both lists:

Bret Battey - 5/2 mentions
Jaroslaw Kapuscinski - 2/2 mentions
Louise Harris - 2/2 mentions (though, as I am the author of this book and originator of the questionnaire this refers to, my inclusion should perhaps be taken with a decent sized pinch-of-salt!).

It is also perhaps worth noting that all of three of these names are currently academics and practice-based researchers working within Higher Education Institutions in the UK and USA. It is potentially unsurprising, then, particularly given the number of students who have completed the questionnaire, that names of this kind might appear on both lists.

More interesting, however, is the fact that while the lists of both artists and writers are long, there are relatively few names recurring multiple times – indeed, although Chion appears 15 times in the suggestions of theorists, this accounts for less than 20% of those surveyed. This could be indicative of a number of things. First, that the field of 'audiovisual composition', broadly conceived, remains in its relative infancy and has to date avoided developing a 'canon' of works and composers as such outside of specific, disciplinary areas; visual music, for example, has the beginnings of a canon including the works of Oskar Fischinger, Norman McLaren, John Whitney, Mary Ellen Bute and Jordan Belson. It could also be indicative of the fact that audiovisual composition, as positioned for this volume and as considered as a 'field' by those completing the questionnaire, draws from such a broad range of histories, lineages, technologies and practices, and the suggestions and responses are representative of this.

Perhaps, though, it is indicative of something else. Many of the questionnaire respondents – indeed, more than 25% of them (meaning this was the most common response) – suggested that they weren't able to identify effective theoretical work for exploring audiovisual experience, or that sound and

image were usually theorised separately but not together. Below are a small handful of these kinds of responses:

Q:7. Are there particular theorists, thinkers or writers who you feel successfully explain, discuss or document audiovisual works or experiences? Please give as much detail as you like.

> "not really - would like to find them…."
> "The different fields - audio and visuals -are mostly separated in documentation and experience."
> "The realm of the audiovisual is under-theorized."
> "I always struggle to find good theoretical approaches"
> "so far, no"
> "I think we are still in infancy here. There are fragments of perspectives, starting to form a foundation, but I don't think the audiovisual domain has an equivalent to, say, Denis Smalley's work on spectromorphology and its impact on the 'acousmatic' music tradition."
> "Good question. I would be interested to know this also. I know many sound/music theorists and many in the visual field, but not in particular both…"

Indeed, even those that cited particular writers did so with caveats – that too much discussion was focused on method and not experience, or focused only on particular styles, genres or definitions. There was certainly a lack of consensus over what constitutes a body of critical discourse engaged with audiovisual modes, which is resonant with my own experience.

However, related to this – from the perspective of the ethos of this volume – it is encouraging that, while a series of expected names appeared, the list also included musicians and music video makers, sculptors, directors and sound designers, suggesting that questionnaire recipients conceived of the term audiovisual composition as applying to art works beyond the experimental film, video art or visual music traditions most often associated with the term. Second, the intention was that the questionnaire be disseminated as widely as possible, and indeed participants were advised that

> We are hoping to get as diverse a response as possible and would encourage you to send this survey on to anyone else you think would have some interesting insights into how they either work with or understand audiovisual modes.

Consequently, while the names suggested do seem to have quite a Western focus, it is also possible that the broad reach of the questionnaire has allowed it to tap into a wide range of traditions in audiovisual practices as opposed to merely capturing one. This is purely speculative, as demographic information was deliberately not solicited as part of the survey, but some of the responses

(particularly those relating to language and residence, which will be discussed later) do seem to support it having a wider reach than its immediate European context.

Coded thematic areas

A range of thematic areas suggested themselves through the more open-ended questions in the survey, and the primary themes I have coded for are as follows (please note, themes are only discussed here if they were mentioned by more than 10% of participants in the survey – there were too many less commonly occurring themes to discuss in full):

- Functions of the term 'audiovisual', including:
 - Terminology, language and translation
 - Qualifiers
- Audience
- More than the sum of its parts
- Close relationship
- Balance, coherence, equity and equivalence

Within these thematic areas there is a certain amount of overlap, but they each warrant discussion in their own right.

Functions of the term 'audiovisual'

Participants were asked "What do you understand the term 'audiovisual' to mean?", and the responses demonstrated a majority who largely felt that 'audiovisual' meant involving both sound and image in a single work; this will be dissected in more detail later. The remainder responded in a variety of ways that I have coded into the sub-divisions of *Terminology, Language and Translation*, and *Qualifiers*. Each of these sub-divisions is related to the other, and indeed to the theme as a whole, but each warrant individual consideration.

Terminology, language and translation

First, several participants felt that the term audiovisual was 'dated', 'old', 'very 90s' or 'The term sounds a tiny bit 00-year-ish to me (like "multimedia")'. Other participants primarily associated the term with either the technical aspects of realising work involving both sound and image or the technology itself, indeed the "Technology associated with speakers, projectors, and monitors". I should point out that this was a minority of participants, but it is still worth considering as a potential failing of the term as utilised in the context of, for example, this volume. One participant even responded that "Audiovisual doesn't connote an artistic or experimental practice for me".

Other participants pointed to the associations of the term with techni-
cal departments, alongside the prevalence of other terms to describe works
involving sound and image simultaneously – including 'videomusique' and
'musique/visuelle'. Much of this was specifically related to connotations as-
sociated with particular countries, rather than being a universally applicable
objection to the term, for example "in my country, unfortunately, the tradi-
tion has established 'audiovisual' for documentaries. Because of this, I rather
use 'audio-visual' intended to encompass diverse genres such 'visual music'
and 'video art'".

Of those surveyed, roughly 10% raised points along the lines of those above
around the term audiovisual, which should give pause to those of us using
the term to consider its potential to be misunderstood, or misapprehended,
in international contexts.

Qualifiers

One theme that emerged quite clearly was that several participants felt the
term audiovisual was only meaningful if accompanied by a qualifying term
or designation – one participant suggested "The term audiovisual is vast and
general, like 'piano music'". The need to further qualify the term was ex-
pressed in a range of ways, such as "it would depend on what follows after
audiovisual. Art, Film, Performance, Installation, Technology…I can go on",
or "terms define the work as a miniature or mural in painting would", with a
range of subsequent designations offered in each case. The qualifiers offered
included the following (and many others – the below have only been included
as they appeared more than once):

Behaviour
Environment
Experience
Installation
Gig
Concert
Piece
Work

This feels resonant with my own experience with and understanding of the term
audiovisual as it applies to my own practice. Whilst I typically describe myself
primarily as an audiovisual composer, I refer to the threads of my practice-
research as audiovisual performance, audiovisual installation and fixed-media
audiovisual work, respectively. The designations here not only delineate these
aspects of my practice for my own sake, and the sake of the audience, but also
bring with them a set of expectations and, no doubt, preconceptions about what
the nature of the work will be. Indeed, as we have seen previously in Carvalho
and Lund's (2015) edited volume on audiovisual practices, these definitions are
nebulous but becoming increasingly concretised as the field matures.

Functions of the term 'audiovisual' – the predominant response

The vast majority of participants (80%) stated that 'audiovisual' was a term that they themselves used; of those, 75% used the term as a single word as opposed to *audio visual, audio-visual* or *audio/visual*. Of those respondents, the vast majority suggested that audiovisual meant to involve both hearing and seeing simultaneously in a single work or experience. There were a range of further suggestions and ideas evolving around what made an audiovisual work *effective*, and these will be discussed under some of the later themes. For now, however, the survey does seem to suggest that, for the majority of those either interested in or working with audiovisual modes, the term 'audiovisual' is well-understood and appropriate, and most commonly used in its single word form.

Audience

Many participants in the survey pointed to the importance of the audience in shaping audiovisual experience, indicating the extent to which respondents considered the role of the audience as central to both the development of their work and its subsequent reception. One participant remarked that "Everything changes when humans are present in work that extends beyond the traditional boundaries" with another suggesting that "An audiovisual system, especially one offering an immersive experience, should be molded by the unique contexts of individual user/users". Other participants went further, suggesting that the audience itself was central to a work being considered audiovisual, defining an effective audiovisual work as "A system that utilizes the modes of ocular and aural perception to *communicate with an audience*".

These comments were echoed throughout the survey responses, though not necessarily positioned in terms of audience – as an example, one participant remarked that "it depends on how the work is received" when addressing what makes an audiovisual work effective. Thematically, though, the importance of taking an audience into consideration when shaping the development of a work was clear to see in how participants responded to the survey. Indeed, this is also something that resonates with my own approach to developing work, specifically work for Expanded Audiovisual Format which I have discussed elsewhere (see Harris, 2020). In these works, the diverse environments in which the pieces are presented, alongside the various and idiosyncratic ways in which an audience will encounter them (and indeed the range of experiences they will bring to their engagement with the work), are central to how the work develops; acknowledging the role and agency of the audience is key.

'More than the sum of its parts'

The notion of audiovisual works containing multiple elements is, perhaps unsurprisingly, one that came up very regularly, with a majority of respondents

indicating that audiovisual works involve both sight and sound/seeing and hearing in a range of forms. However, as an addition to this, many respondents indicated that within audiovisual work the combination of sound with image creates something that is more than just the two in isolation – what Chion would refer to (as indeed was referenced several times in the responses) as *added value* (Chion, 2019).

We have already talked a little about Chion's work and acknowledged its importance; however it might be useful here to look specifically at the definition of added value as it first appears in *Audio-Vision*:

> By added value, I mean the expressive and informative value with which a sound enriches a given image so as to create the definite impression, in the immediate or remembered experience one has of it, that this information or expression 'naturally' comes from what is seen, and is already contained in the image itself. Added value is what gives the (eminently incorrect) impression that sound is unnecessary, that sound merely duplicates a meaning which in reality it brings about, either all on its own or by discrepancies between it and the image.
>
> (Ibid., p. 4)

Whilst this is a relatively easy statement to argue as it relates to narrative film – I think few of us would disagree that sound has the power to alter the effect of the image on screen – the way in which this is manifest in the responses given to this survey suggests that there might be more subtle, varied and nuanced relationships between sound and image afforded through their combination than that evident in narrative film and codified in books such as *Audio-vision*. Indeed, even the term 'added value' implies a separation between sound and image, through one thing adding value to the other, that does not resonate with my own understanding of audiovisual work or numerous opinions expressed through this survey. It could be that another term is necessary to explain how we encounter these more reciprocal relationships between sound and image in the context of audiovisual works, including narrative film.

To illustrate this, it would be useful to look at some of the examples of this phenomenon as expressed in the responses to the survey:

> "It feels it's not about audio and visual equally, but somehow creating a third space that is neither."
> "when the final result is 1+1=3"
> "The combination is more than the sum of its parts"
> "sounds and images… making a third, new, thing that you can't really take apart without it losing some part of its value"
> "Synergy between sound and visual rhythm, between concept and emotion, between movement and expression, between melody and color,

between words and semiotics, etc. The effectiveness lies within the "whole is greater than the sum of its parts" idea."

"A sense that the sound and the image work together to express something beyond either medium itself"

"Both media are linked to the extent that a combined word is more applicable than describing the work with preference given to one domain or the other"

"Incorporating elements of sound and moving image to heighten one another"

"That both the visual and the aural component are present, interlaced and both enriching the other"

These comments, though differently expressed, fundamentally suggest the same thing – that the combination of sound and image/seeing and hearing in an audiovisual work creates something that is more than just the two media or sensory experiences in isolation. The term 'added value' consequently doesn't seem to go far enough in explaining the nature of this heightened relationship, in which the audiovisual combination creates something 'other' rather than one media enhancing the next. Initially, I had wondered whether *symbiosis* might capture the mutually beneficially nature of the relationship between the two, but instead, as one of the participants has it, *synergy* would feel like the most appropriate term. That the combination of sound and image creates a synergic relationship in which the combination of the two media creates a third, audiovisual space, the combined effects of which is greater than the sum of its parts.

Close relationship

This seems an appropriate point at which to discuss the regularity with which the closeness of the audiovisual relationship was discussed in response to the survey; indeed, the word 'relationship' itself appears over 30 times in the course of the transcripts, and a couple of respondents even use the term 'marriage' to describe how the two media work together. Closeness of the integration between the two media, outside of the synergic relationships addressed above, was one of the most commonly described or identified aspects of effective audiovisual work; as with the theme above, the best way to illustrate this is to look at some examples from the questionnaire transcripts:

"both image and sound in a particularly close relationship, with strong emphasis placed on both components"

"integrated audio and video artwork, in which both are conceived and created together"

"The work stimulates both senses and produces cross-sensory pleasure, seeks sync points where cross-modal events occur simultaneously, and

develops a language of tonality, timbre, and intensity that is both visual and aural."

"I consider audiovisual work in terms of composition, where the contribution to the audience is equally of audio and visual nature, not one based on hierarchy"

"An audiovisual work should clearly show a concern for both modes of perception and reflect their relationship"

"artworks that require equal consideration of sound and visuals in relation to each other or working in tandem to create an experience for audiences"

"an interesting relationship between sound and image – there are many different effective models and it certainly doesn't need to be an 'obvious' relationship"

"Something where there is a discernible relationship between sound and image or where one complements or plays off the other"

"the relationship between the audio and visuals are like a good marriage. They work as a team"

Whilst many of these comments reflect similar concerns, it is worth picking up on and foregrounding a couple of these in more detail. Specifically, it is notable that the idea of the relationship between the two not needing to be an 'obvious' one is suggested above, and this appears in more than one other comment. This doesn't necessarily tally with the early Likert scale question of whether an effective audiovisual work should have an 'obvious relationship or correlation'. However, the frequency with which the relationship between audio and video are highlighted in the survey responses suggests the importance of this in developing audiovisual work; the specific nature of this relationship seems to be one that is more fluid and nuanced in terms of its importance.

One of the comments above that most strongly resonates with my own experiences of developing audiovisual work – as will be discussed in the next section – is that sound and image 'are conceived and created together', which is a theme that emerges regularly throughout the responses and speaks to the closeness of the relationship between sound and image. It is gratifying to see that some of the central concerns of my own work are reflected in how other artists and composers understand their own processes. However, as we will see in the analysis section of this book, this is not a concern that is shared by all artists who consider themselves to be working audiovisually, and is not necessarily an indicator of an effective audiovisual work.

Balance, coherence, equity and equivalence

Building on the idea of the relationship between sound and image being close, many participants further expanded on this closeness using terms such as 'balance', 'coherence', 'equity' or 'equivalence' between the two media.

This was the theme that emerged most consistently in the responses. Again, I will allow some of these comments to speak for themselves:

"equal interest in the two sensory operatives it describes"
"appear to belong together"
"audio and visual materials are treated as equally as possible. Neither audio nor visual entities become backdrops"
"really interact and play with or against each other"
"the interplay of the two senses"
"equal importance for the music and the visuals as a one artistic object"
"audio+video equally important"
"combined in an organic and coherent way"
"clear cohesion between the audio and the visual"
"Sound and picture relationship in which there is equivalence between the media"
"sound and image are equally balanced and equally considered"
"both audio and visual components are equally important, regardless of their contribution "percentage""

As with the comments on the closeness of the relationship, this is again something that resonates with my own experience of developing audiovisual work as I will explore later in this volume – a constant awareness and consideration of the balance and coherence of the relationship between the two media, and, wherever possible, actively seeking to compose the two media together. The prevalence with which comments of this type appear in the questionnaire suggests that my own perspective is shared by numerous other practitioners and writers working with or around audiovisual modes.

Summary and reflection on questionnaire responses

There were some very clear themes and preoccupations emerging from the questionnaire responses and, although some of the responses were unexpected, a vast majority of them resonated with my own experience of developing my audiovisual practice and exploring the practice of others. Further, the unexpected responses provided interesting food for thought in interrogating how we encounter audiovisual work.

In the next section of this book, I will address my compositional intention to create a sense of 'audiovisual cohesion' within my works – the sense that sound and image are completely interlinked, even if the nature of that link (perceptual, technological, aesthetic, functional, etc.) is not completely apparent to the audience. In analysing the questionnaire responses, the term 'audiovisual synergy' has also suggested itself, which, as posited above, has significant overlap with the notion of audiovisual cohesion, but there are important distinctions between the two.

The cohesive relationship is one in which sound and image are inextricably bound with one another, while the synergic relationship this facilitates is

concerned with the sense that combining sound and image in this cohesive form creates a third, audiovisual artefact, elevated above the sum of its medial parts to create an 'other'. Whilst difficult to quantify in positivistic terms, testimony from questionnaire respondents and interviewees (which will be discussed in the next chapter), alongside my own experience as a practitioner, reader, writer and audience member, suggests that these relationships and their experiential results are very apparent across a range of audiovisual modes.

This is significant specifically because it is reflective of the majority of responses to the questionnaire and should therefore have broad resonance with the wider community of practice engaged with audiovisual works. As we have discussed earlier in this volume, there is a relatively limited amount of discourse which deals with audiovisual work, outside of specific, disciplinary boundaries. Even those that do attempt a more holistic approach, such as Chion's *Audio-Vision* or Cook's 'Analysing Musical Multimedia', apply predominantly to narrative film or to other, more specific audiovisual modes and forms, and in the case of Cook's work from the perspective of music specifically in combination with other media as opposed to sound more broadly. Establishing key terms to codify our responses to audiovisual works, which are potentially applicable across all audiovisual modes, could form a foundational component of developing a discursive and analytical framework within which to situate our experience. As an example, as we have seen Chion's term 'added value' is used extensively by questionnaire respondents, but the term itself both suggests (though doesn't necessarily intend) medial detachment (one thing 'adding' to another) and is mostly readily and easily applicable, in the terms described in the book, to sound/image relationships within narrative film. Audiovisual cohesion allows us to describe the closeness, clarity, balance, tension, resolution, etc. of the relationship between sonic and visual media in a range of forms – narrative film, music video, non-narrative audiovisual composition, audiovisual installation, VJ performance – on an equal footing outside of specific disciplinary concerns. Similarly, audiovisual synergy allows us to recognise the impact of combining sound and image in ways that elevate the two media beyond what they would achieve on their own, again across all of the modes (and many more) listed previously, whilst also recognising human agency in this development of an audiovisual 'other'. Conceptualised like this it's apparent that considering audiovisual works and our responses to them in this way – cohesion describing the relationship(s) between the two, and synergy describing the perceptual outcome of those relationships – relates at a structural level to the process and product consideration of this book as a whole – thinking through both the act of composing sound and image together, and the result of that act, both in the works it develops and how an audience receives them and acts with them. These terms will therefore be utilised to lay the groundwork for the analytical framework developed in Section 3, through which a series of works will be accounted for and situated.

3 Defining transperceptual attention

This chapter is concerned with defining transperceptual attention – one of the key components of ongoing discussion in this volume. However, I will begin with a consideration of and reflection on the interview process for this volume, as this was key in developing the concept of transperceptual attention as applied to audiovisual experience.

The interview process was very illuminating, and it took place when both:

a the questionnaires had been completed and analysed, which allowed for reflection on individual and collective responses during the interviews themselves; and

b some of the analytical section of this volume had been attempted, at least in first draft format, which also allowed reflection on some aspects of this process through the interviews.

Indeed, the term 'interview' here is potentially too formal, as the discussions weren't really approached from the perspective of interviewer/interviewee – more as an unstructured and informal chat around some of the ideas presented by the participants in their questionnaire responses and subsequently. This allowed the conversation to flow in the most fruitful direction, as opposed to trying to directly answer specific questions or cover certain topics. The vast majority of those interviewed were themselves practitioners or audiovisual theorists and were drawn from both academic and non-academic contexts, with many working as freelance artists.

Much of the discourse with participants concerned the nature of audiovisual work more broadly, specifically how the participants viewed themselves or described themselves, and indeed how they described the work they did. Many talked about 'working with sound and image' or working in an 'interdisciplinary' context, and the vast majority, if specifically questioned, were happy to use the term 'audiovisual' to describe their work or offered the term as a description of the kind of work they did or were interested in doing. Most described themselves as 'composers' or 'artists' of some kind, usually qualified by terms such as 'audiovisual', 'interdisciplinary' or 'media'.

What the interviews revealed, above all else, is that practitioners know how to talk about their work and what their work does – what their aesthetic

concerns and considerations are. On the whole it was not through using terms familiar from the literature cited in the questionnaire responses, such as added value, audiovisual contract, synchresis, similarity and difference, or even consonance and dissonance. Instead, it was most often in terms such as shape, colour, time, form, line, structure, tension, resolution, relationship, balance, unity and coherence. And many participants also used terms of process such as listening, thinking, feeling, editing, composing, forming, shaping and developing. Terms such as visual music or music video came up readily but more often it was in the context of participants talking about their work as 'not quite' visual music or 'sort of' music video but not really fitting into any of the categories of audiovisual work that we are familiar with and often want to fit works into.

To hear artists in conversation is to know that these artists know their work and how to talk about it. What they may not know to so great an extent is how to define and compartmentalise their work; how to effectively situate their work within, for example, a historical trajectory or a current range of practices. Where this was less true was with practitioners who considered their work to be 'visual music' I suspect because, as we have already discussed in this volume, there is a relatively clear and well-documented historical tradition and current understanding of practices within this field. However, outside of these kinds of classification, there was a lot of uncertainly about how to talk about works – or more specifically how to label works as belonging to a particular 'type' of audiovisual work. Further, many participants talked about the various strands of their practice as being potentially diverse within these classifications, and of the struggle in attempting to codify and define these works within existing frameworks.

Indeed, this is nicely encapsulated through the testimony of one participant in particular:

> Any time you want to talk about a project – we write about our projects and in what would be the lit review you end up going through all the ground clearing moves (and I say this because I am starting to write a piece about a project) – in this case a multicam performance I've added imagery to the top of. It's 30 minutes long, and it's kind of music video, but it's long form so is it almost a rockumentary? It's not really a documentary because we produced it in order to be filmed, to film the performance, so that's not documentary. And there are these images of clouds – there's no reason for the clouds to be there but it works, the performance is cloudy. So, is it visual music at that point, but the rest of the time is it long form music video with documentary?
>
> So, I'm going to need to do all of these ground-clearing moves and make a far more succinct version of what I just said! And we walk through how you can and can't understand it, and how this works in this context and that, and it won't be until I've done all of that that I can really move on to talking about the project *as a project*. I think that every paper I've

ever written starts with those kind of ground-clearing moves and then
tries to dig into the core aesthetics above and beyond whether I consider
it to be expanded cinema or live cinema or live AV or something else.

This is certainly representative and speaks quite closely to a large amount
of discourse in the field of audiovisual practices more broadly; indeed, this
participant and I discussed some of the volumes dissected in Section 1 of
this book and reflected on this exact phenomenon; that, by and large, these
chapters and articles begin by setting out a theoretical context, usually based
on Chion or Coulter or Cook or Garro or Rogers or... and once these defi-
nitions have been made they move on to the discussion of the actual work
itself. Certainly, this is something I myself have been guilty of in the past; yet
this doesn't really resonate with how I *talk about* my work but feels necessary
when I *write about* it.

 One question we might ask is – would it not be easier to simply use the
term 'audiovisual' and allow this to stand for art forms that involve combina-
tions of auditory and visual stimuli within a single piece of work? Certainly,
more than one participant argued that in a lot of the discourse this initial
dissection of relevant theory and practices – almost in the form of a mini lit-
erature review – and subsequent attempts to categorise a work as one thing or
another feels more like box-ticking for the sake of demonstrating awareness
of context than it reveals anything about the work itself or the practices and
contexts it develops. However, were we to dispense with attempts to try to
fit our works into existing categories or theoretical frameworks they don't
quite fully work within – what then? Can we make space for a discourse that,
though aware of these historical precedents and contemporary situations, al-
lows works to speak to what they are in themselves as much as what they are
in relation to other ideas, practices, artists and concepts?

 The difficulty here potentially stems from the fact that audiovisual prac-
tices are fundamentally interdisciplinary, drawing usually from more than
one field in which critical discourse is extremely well established yet not
fitting fully into either one of them. Whilst discourse in other art forms has
advanced and developed over several hundreds of years, audiovisual practices
are still, at least in the forms in which they are considered in this volume, at
a stage of relative newness. Yet we have made few attempts to account for
their manifestations within a discourse that deals with their interdisciplinar-
ity on its own terms; rather, we have tried to find ways to account for it that
are closely aligned to discourses that we *do* understand and that are mature
enough to be easily applied. The suggestion made by a number of interview-
ees here is that this just isn't really fit for purpose, and that we need to find
new ways to have conversations about audiovisual practices outside of the ri-
gidity of particular disciplinary boundaries. Indeed, as one participant put it:

 Everyone's walking through this thing in different ways. Beyond Chion
 there's no singular thrust or body or work - it's always pulling it together,

which I guess is what you're always doing as an interdisciplinary scholar; you're always pulling together your literature and saying what's relevant.

If we consider ourselves as interdisciplinary scholars, then what does it mean to do interdisciplinary research in this context? Considering this question will suggest fruitful directions for furthering audiovisual practices as a field of practices and discourses in their own right.

Interdisciplinarity as a field of study and its codification into its current accepted form can be most usefully traced to around the middle part of the last century. In terms of a current definition of the term, Nissani offers the following:

> a discipline can be conveniently defined as any comparatively self-contained and isolated domain of human experience which possesses its own community of experts, interdisciplinarity is best seen as bringing together distinctive components of two or more disciplines. In academic discourse, interdisciplinarity typically applies to four realms: knowledge, research, education, and theory. Interdisciplinary knowledge involves familiarity with components of two or more disciplines. **Interdisciplinary research combines components of two or more disciplines in the search or creation of new knowledge, operations, or artistic expressions**. Interdisciplinary education merges components of two or more disciplines in a single program of instruction. Interdisciplinary theory takes interdisciplinary knowledge, research, or education as its main objects of study.
>
> (Nissani, 1995, p. 203, emphasis mine)

Yet, what is clear when exploring interdisciplinary studies in more detail is that the notion of interdisciplinarity is not a new one. Kitto describes the Ancient Greek openness to inclusivity in knowledge and pursuit as follows:

> The modern mind divides, specializes, thinks in categories: the Greek instinct was the opposite, to take the widest view, to see things as an organic whole [...]. The Olympic games were designed to test the arete of the whole man, not a merely specialized skill [...]. The great event was the pentathlon, if you won this, you were a man. Needless to say, the Marathon race was never heard of until modern times: the Greeks would have regarded it as a monstrosity.
>
> (Kitto, 2017, pp. 173–174)

That being said, Aristotelian thinking is often held up as a precursor to contemporary disciplinarity (Frodeman and Mitcham, 2007); yet his formulations of logic, physics and ethics never specifically precluded the sharing of knowledge between categories.

If we acknowledge, as many of the participants in this study seem to, audiovisual practices as potentially interdisciplinary – in the sense of, to return to Nissani "bringing together in some fashion distinctive components of two or more disciplines" (Nissani, 1995) – some further clarification might be necessary. A majority of literature on interdisciplinarity cites the relative interchangeability with which the terms interdisciplinary, multidisciplinary and transdisciplinary are used. However, Keestra and Menken's (2016) *An Introduction to Interdisciplinary Research* provides a useful delineation of these terms:

> The basic difference between these manifestations of research that spread beyond a discipline is the extent to which researchers aim for the integration or synthesis of (disciplinary) insights. Interdisciplinary research literally means research between disciplines, referring to the interaction of disciplines with each other... Such interaction may range from the mere communication and comparison of ideas, through the exchange of data, methods, and procedures, to the mutual integration of organizing concepts, theories, methodology, and epistemological principles. In multidisciplinary research, the subject under study is also approached from different angles, using different disciplinary perspectives. However, in that case neither the theoretical perspectives nor the findings of the various disciplines are integrated. Lastly, transdisciplinary research also involves actors from fields outside of the university, thereby allowing for the integration of academic and non-academic or experiential knowledge (Hirsch-Hadorn et al., 2008).
>
> (Keestra and Menken, 2016, p. 31)

If we broadly accept these definitions – and indeed, having explored contemporary thinking on inter-/multi-/transdisciplinary studies in some detail there seems little reason not to – we might consider audiovisual practices (broadly conceived) as being *transdisciplinary*, insofar as the development of both its practices and discourse involves participants and actors from across disciplines and also draws from non-academic and experiential knowledge. The key here is the fusion or merger of theories, positions and methods **between and beyond** disciplines. Indeed, many writers considering or discussing the nature of transdisciplinary art forms point to the 'trans' component of the word as key or significant – trans in this context referring to 'across' or 'beyond', as in to *transform* or *transcend* (Domingues and Reategui, 2005). This 'beyond' in particular seems to speak to the notion of audiovisual synergy discussed previously – the development of a thing that, through bringing together more than one discipline, becomes something other; by travelling across, it goes beyond.

The question here, then, becomes this: how might we develop an effective transdisciplinary discourse for audiovisual practices?

Before we dig into this in more detail, it is worth saying up front that the many definitions, designations and constructs that exist, and within which many of the artists and works in this book feel comfortably accommodated, are all valid and useful within their particular environment. The intention here is to attempt to build a foundational discourse against which these many frameworks, designations, genre boundaries and typologies might be broadly understood – to establish a groundwork of mutual understanding for audio-visual practices, within which we can begin to position some of our existing knowledge in a broader field.

Discussions on how to shape this discourse should proceed from the most basic considerations of the numerous, interrelated and transdisciplinary endeavours present and branch out from there. To this end, I will begin by designating a heading or description for the discourse – in this case the term 'audiovisual practices'. As we have already discussed, audiovisual implies only that both sound and visuals are involved, but not in what medium or material, form or format; consequently, this frees the discourse from specific disciplinary boundaries. From here, I will extend to a broad definition of the nature of practices that will sit under this discourse – those that involve working with auditory and visual materials.

There are no assumptions or designations made about the *nature* of these materials in the work – no qualification of any aspect of sound and image as such – simply that they both exist within the work. There are also no assumptions or designations made about the *type* of works this discourse will account for, beyond that they involve both sound and image. They may be performance, installation, fixed-media, sculptural, narrative, non-narrative, non-representational, abstract, concrete, improvisational, fleeting, temporal, static...the only qualifying criterion here is that they deliberately engage both our auditory and visual senses in some form.

How do we engage with the works? How do we talk about them? What are the terms/definitions/concepts/constructs we will use to describe our experience of either working with/developing/composing/creating audio-visual artefacts, or experiencing them as an audience member, participant or actor?

We will begin by considering how we engage with other art forms – how do we begin to understand a painting, a work of poetry, a piece of music?

Terry Smith advocates asking the following four questions of a work of art:

"What can I see just by looking at this art work?

How was this art work actually made?

When was it made, and what was happening in art and broader history at that time?

Why did the artist create this work and what is its meaning to them, and to us now?" (Smith, 2005, para. 2)

While Panofsky advocates identifying the following in interpreting a visual art work:

1. Primary or natural subject matter, subdivided into factual and expressional. It is apprehended by identifying pure forms, that is: certain configurations of line and color, or certain peculiarly shaped lumps of bronze or stone, as representations of natural objects such as human beings, animals, plants, houses, tools and so forth; by identifying their mutual relations as events; and by perceiving such expressional qualities as the mournful character of a pose or gesture, or the homelike and peaceful atmosphere of an interior...

2. Secondary or conventional subject matter. It is apprehended by realizing that a male figure with a knife represents St. Bartholomew, that a female figure with a peach in her hand is a personification of veracity... In doing this we connect artistic motifs and combinations of artistic motifs (compositions) with themes or concepts.

3. Intrinsic meaning or content. It is apprehended by ascertaining those underlying principles which reveal the basic attitude of a nation, a period, a class, a religious or philosophical persuasion-qualified by one personality and condensed into one work. Needless to say, these principles are manifested by, and therefore throw light on, both "compositional methods" and "iconographical significance."

(Panofsky et al., 1955, p. 2)

Similarly, and following on from Panofsky, Kit Messham–Muir suggests the following:

Here's a simple three-step method I use...:
1) Look
2) See
3) Think
The first two – look and see – are just about using your eyes, and observational skills. The third requires a bit of thought, drawing on what we already know and creatively interpreting what we've observed within an artwork's broader contexts.

(Messham–Muir, 2014, para. 4)

We might also draw on ideas on listening modes, or how we encounter sound materials and our auditory experience of the world. There are numerous of these, but perhaps the most often advocated are those developed by Pierre Schaeffer and, later, Michel Chion.

Schaeffer (1966) posited four modes of listening – ecouter, ouir, entendre and comprendre – which can be summarised as follows (this is, of course, something of an oversimplification for the sake of brevity):

Ecouter - listening for information gathering - for example, listening out for traffic before crossing the road.

Ouir - the most passive form of listening, or hearing, which goes on contin-
 uously and is largely unconsidered, consciously.
Entendre - perhaps most usefully described as selective listening, this is effec-
 tively choosing what we listen to from what we hear - perhaps attending
 to the music we are listening to, whilst simultaneously 'tuning out' noisy
 construction work.
Comprendre - listening to understand, to identify meaning or emotive con-
 tent in sound, as opposed to the information it contains about its source.

Chion (2012), by contrast, would point us towards three listening modes, as
follows:

Causal listening - listening for information gathering
Semantic listening - listening for the purposes of enhancing understanding
Reduced listening - listening for the musical or artistic qualities of the sound.

These structured, formal definitions of listening might provide useful start-
ing points, but other theorists would encourage us to consider the broader
contextual experiences and performance of listening. As an example, Pauline
Oliveros would encourage us to engage in deep listening, "a practice that is
intended to heighten and expand consciousness of sound in as many dimen-
sions of awareness and attentional dynamics as humanly possible" (Oliveros,
2005, p. 3).

 In 'On listening' Brandon LaBelle (2012) provides snapshots of treatises
and theories on listening from practitioners and writers as diverse as Pauline
Oliveros, Marshall McLuhan, Walter One and Didier Anzieu, placing lis-
tening in contexts such as 'self, environment', 'modalities of the ear', 'desire,
trauma', 'ethics, politics' and 'art'. Indeed, LaBelle summarises as follows:

> In moving in and out of focus, listening also moves in and out of dif-
> ferent relational meetings and territories: it readily supports the body as
> a figure in space, a subject touched and touching the world, affording
> sensual agency to being somewhere, at a certain time – a perceptual link
> actively tuning and detuning self and surrounding in a flux of inertia and
> momentum. Yet this impressionistic, sonic coordinate is also dynami-
> cally located within a duration always already shaped by social structures,
> apparatuses of control, the politics of identity, an economy of relating...
> As I've tried to map here, listening performs to create a dynamics of
> sharing that readily trespasses lines of representation, to haunt us with
> images of a common skin, or of ghostly bodies that seem to speak again:
> primary connections, of self and surrounding, and the intensities of a
> politics of what can be heard and when. Thus, an aesthetics of sound is
> never truly free from the pressures of the world.
> (LaBelle, 2012, para. 22)

This conceptualisation of listening as considered through an aesthetics of sound is an intriguing one, and we might ask whether audiovisual practices could potentially be apt to providing the same kinds of affordances through their transdisciplinary nature. If we accept the premise that sound arts pre-suppose strategies of participation and interaction precisely through the na-ture of sound as a medium – that it does not 'wait to be asked' – might we also infer this immediacy as a potential facet of audiovisual work through its necessarily involving sound? Certainly, there is much to be said for LaBelle's consideration of listening as a situated and participatory act, as opposed to an isolated or rigid collection of particular modes of engagement.

Similarly, in *Listening to Noise and Silence*, Salome Voegelin positions lis-tening as follows:

> Every sensory interaction relates back to us not the object/phenomenon perceived, but that object/ phenomenon filtered, shaped and produced by the sense employed in its perception. At the same time this sense outlines and fills the perceiving body, which in its perception shapes and produces his sensory self. Whereby the senses employed are always already ideologically and aesthetically determined, bringing their own influence to perception, the perceptual object and the perceptual sub-ject. It is a matter then of accepting the a priori influence while work-ing towards a listening in spite rather than because of it. The task is to suspend, as much as possible, ideas of genre, category, purpose and art historical context, to achieve a hearing that is the material heard, now, contingently and individually. This suspension does not mean a disregard for the artistic context or intention, nor is it frivolous and lazy. Rather it means appreciating the artistic context and intention through the prac-tice of listening rather than as a description and limitation of hearing.
>
> (Voegelin, 2010, p. 3)

The idea (and ideal) expressed here of suspending concerns with and consid-erations of genre, category, purpose and art-historical context in approaching material prefigures numerous of the arguments made in this volume regard-ing developing both an individual and situated approach to encountering audiovisual work. Indeed, Voegelins's later work, *Sonic Possible Worlds* (2014), takes this approach a step further, through applying possible worlds theory to the embodied act of listening. In it, Voegelin describes that

> The universe I want to draw on is not centered around and constructed from one world only, but is constituted of a plurality of actual, possi-ble, and impossible sonic worlds that we can all inhabit in listening and through whose plurality music loses its hegemony and discipline and the landscape gains its dimensions.
>
> (Voegelin, 2014, p. 18)

later stating that "In listening I inhabit the work, the confusion, the horror, and the fear, not from remembering its discipline or language but through being in its sounds and being through its sounds" (ibid., 2014, p. 21). This embodied, multifaceted and personal approach to listening, and indeed analysis, of works is resonant with my own experiences of engaging with audiovisual work, and the steps Voegelin takes to allow this approach to resonate across disciplinary boundaries are refreshing.

One of the potential problems to developing a similar approach to encountering audiovisual work might be, though, that while we have well-understood terms for listening/hearing and looking/seeing, there aren't terms readily available to describe the experience of both seeing and hearing simultaneously, as when engaging with audiovisual work. Chion suggests 'audio-vision' as defining the perceptual mode of reception in engaging with audiovisual work, describing audience members as 'audioviewers' (Chion, 1994). Yet there is still a passivity implicit here – the term 'reception' suggesting the audience member is receiving the work as opposed to acting with it. This, in fact, points to broader concerns regarding how the audio and visual components in the work relate to one another, and indeed how we relate to them – what we might commonly conceive of as an interactivity. Yet, it might be useful here to briefly visit Karan Barad's notion of intra-action, defined by Whitney Stark as follows:

> Intra-action is a Baradian term used to replace 'interaction,' which necessitates pre-established bodies that then participate in action with each other. Intra-action understands agency as not an inherent property of an individual or human to be exercised, but as a dynamism of forces (Barad, 2007, p. 141) in which all designated 'things' are constantly exchanging and diffracting, influencing and working inseparably. Intra-action also acknowledges the impossibility of an absolute separation or classically understood objectivity, in which an apparatus (a technology or medium used to measure a property) or a person using an apparatus are not considered to be part of the process that allows for specifically located 'outcomes' or measurement.
>
> (Stark, 2016, para. 1)

Considered through the lens of intra-action, the experience of an audiovisual work becomes not a linear action of engaging with a range of isolated sensory perceptual experiences, but a constantly shifting and fluid process of reciprocal interaction with the work. To consider audiovisual work in this way not only considers the work itself as fluid and dynamic, but the act of engagement with it as an exchange as opposed to a separating between subject and object, in which both are intra-acting. This is certainly resonant with the ways in which works have been encountered in Section 3 of this volume – Analysing Audiovisually – and will be revisited later.

It would be apposite at this point to consider the acts of listening and seeing, and the medium through which we experience these perceptual realms.

In particular, some of Tim Ingold's perspectives on seeing and hearing and, specifically, definitions of light and sound might be instructive here. These are topics he addresses in numerous of his writings, but perhaps most resonant to this current discussion is the below, taken from *Against Soundscape*:

> It is of course to light, and not to vision, that sound should be compared. The fact however that sound is so often and apparently unproblematically compared to sight rather than light reveals much about our implicit assumptions regarding vision and hearing, which rest on the curious idea that the eyes are screens which let no light through, leaving us to reconstruct the world inside our heads, whereas the ears are holes in the skull which let the sound right in so that it can mingle with the soul... Far better, by placing the phenomenon of sound at the heart of our inquiries, we might be able to point to parallel ways in which light could be restored to the central place it deserves in understanding visual perception...
>
> Sound, in my view. is neither mental nor material, but a phenomenon of experience – that is, of our immersion in, and commingling with, the world in which we find ourselves. Such immersion, as the philosopher Maurice Merleau-Ponty (1964) insisted, is an existential precondition for the isolation both of minds to perceive and of things in the world to be perceived... Sound is not what we hear, any more than light is what we see... sound, I would argue, is not the object but the medium of our perception. It is what we hear in. Similarly, we do not see light but see in it.
>
> Once light and sound are understood in these terms, it becomes immediately apparent that in our ordinary experience the two are **so closely involved with one another as to be virtually inseparable.**
>
> (Ingold, 2007a, pp. 10–13, emphasis my own)

Conceiving of sound and light in these terms, particularly the notion that they constitute the *medium* as opposed to the *object* of our perception, might provide a conduit to engaging with audiovisual work, or rather, interpreting and understanding our engagement with works simultaneously mediated through sound and light. If we accept the premise that sound and light are the medium and not the object of our perception, then we might need to rethink the way in which we conceptualise sound within the sound-image relationships underpinning audiovisual practices and, indeed, underpinning this volume as a whole.

If the word *sound* should refer not to what we hear but the medium through which we hear it, then continuing to refer to sound as the auditory component of an audiovisual work might prove less than useful. The terms we use to describe these things *matter*, and Ingold's point is certainly a compelling one – sound should describe universal medial experience, not sculpted or material sonic objects, and so referring to relationships between *sound* and image might be argued to be fundamentally unhelpful as there is a dissonance between the two terms. Do we therefore need to reconceptualise or redevelop our terminology to effectively encounter sound materials without

referring to them simply as *sound* to acknowledge the fundamental difference here between medium and material?

Perhaps the difficulty is not as problematic as it might appear, however – sound art, for example, is axiomatically understood as a form of art that engages with sound as both its medium *and* its material. And when I speak of *sound* in the context of this volume, it is very often in the constructs of addressing sound materials – materials formed through sound, to be heard – alongside visual materials – materials mediated by light, to be seen.

Salome Voegelin is instructive again here, in her response to Ingold's thoughts on soundscape. Whilst acknowledging his assertions that sound commingles and mediates an environment as opposed to providing a slice or scape, Voegelin sets herself up in opposition to Ingold as follows:

> Implicit, it seems, in his desire for a paradigm of sound as wind, moving all there is rather than being anything in itself, is a critique of art discourse that focuses on the object rather than on the process of perception. Ingold…ignores the agency of the material and of the subject, and pays no attention to the cultural prejudices and hierarchies with which we approach and interpret the world. Not all senses participate equally in the production of what the world is: how its pragmatic actuality, the notion of the real we live by, is constructed, sold, and bought. Thus, while of course the soundscape has a vista, a smell, and even a touch, if we approach it via a sonic sensibility, we come to another path and find another "centre of activity and awareness" that reflects back to us the world shaped and filtered through listening and, in this process, illuminates the cultural ideologies that limit this sense and favor others.
>
> (Voegelin, 2014, p. 11)

Voegelin's acknowledgement of the importance of cultural prejudices and hierarchies with which we approach and interpret the world is exemplary of the situated approach to audiovisual experience advocated later in this text, and is explored in more detail below.

We might argue that audiovisual works are the mechanisms through which the connected media of light and sound are sculpted and formed, surfaces are constructed and made material. Conceptualising light and sound in this way in relation to one another might provide a way of encountering audiovisual work which puts the perceptual experience onto a level footing; indeed, if we acknowledge that, viewed through this lens, our experience of light and sound as media becomes effectively inseparable, then we can begin to consider our auditory and visual experiences on an equal footing, comprehending their similarities as opposed to being discouraged by their differences. Indeed, as we have already seen, Merleau-Ponty would describe this as follows:

> The sight of sounds or the hearing of colours come about in the same way as the unity of the gaze through the two eyes: in so far as my

body is not a collection of adjacent organs, but a synergic system, all the functions of which are exercised and linked together in the general action of being in the world, in so far as it is the congealed face of existence.

(Merleau-Ponty, 1982, p. 64)

Consequently, a refocusing of our relationship to light and sound as both media and material, and a recognition of their inseparability, might allow a discussion of audiovisual work that is rooted not only in commonality of perceptual experience but also in a broad range of experiential and contextual dialogue.

The problem remains, however, of what we call this experiencing of audiovisual works, as this needs to be defined in order to effectively describe and situate the nature of audiovisual experience.

The difficulty with the necessarily linear nature of language and construction of terms is that it is very difficult to effectively suggest simultaneity. Even the term audiovisual advocated in this volume necessarily has a linear precedence – audio comes before visual as opposed to both occurring at the same time. I have looked at numerous potential pairings of words suggesting audio and visual, but still struggle with how to effectively suggest the concurrent nature of perceptual experience within these artistic modes. Perhaps audiovisual concurrence will suffice as a heading under which to describe our experience of audiovisual work. Or perhaps simply *audiovisual experience* will provide a wide enough conceptualisation of encountering pieces of artistic work that engage seeing and hearing simultaneously.

However, the responses to the questionnaire, subsequent discussion with interviewees and, indeed, my own intuitive understanding, suggest that there *is* something specific about encountering audiovisual artefacts which is different to encountering either a sound or visual work in isolation that is more than just a concurrence or a simultaneity. Clues to how this is enacted in the brain might be found in some of the models of perception described in Section 1, but this doesn't necessarily help us to codify the effect, and indeed affect, of that bodily experience.

Here I will draw on Ceraso's (2018) model of multimodal listening, the ethos of which resonates strongly with my understanding of not just listening but of audiovisual experience more broadly. Ceraso writes:

I define multimodal listening as the practice of attending to the sensory, contextual and material aspects of a sonic event. Multimodal listening moves away from ear-centric approaches to sonic engagement and, instead, treats sonic experience as holistic and immersive... multimodal listening accounts for the ecological relationship among sound, bodies, environments and materials...

(Ceraso, 2018, p. 10)

And later, she sets out the foundations of a multimodal listening pedagogy, as follows:

- Treating listening as a full-bodied act, as opposed to an ear-centric one
- Reflecting on one's own listening habits and embodied relationship to sonic experience
- Considering how a diverse range of bodies with various capacities and needs will experience sound in particular contexts
- Designing sonic work with which audiences can interact via multiple modes and pathways
- Exploring all of sound's available effects, affects and meaning in different settings via inquiry and experimentation
- Acknowledging listening as part of an ecological interaction between bodies, sounds and the physical environment
- Attending to how sound is connected to the aesthetic, material, technological and spatial features of listening situations
- Developing an awareness of how sound shapes interactions with objects
- Producing holistic sonic experience instead of or alongside sonic 'texts' (ibid., p. 25)

Ceraso acknowledges the pitfalls of using the term multimodal, principally through recognising that, although separating experience into separate modes might work at a conceptual level, it does not reflect actual bodily experience or interactions with the world. Indeed, "by isolating individual modes… multimodal approaches tend to ignore how sensory modes work together, ecologically" (ibid., p. 30). Nonetheless, Ceraso also acknowledges the strategic – as she has it 'tactical' – use of the term in attempting to tap into existing discourse and to 'get things done', and the rationale for this is made quite clear.

In this volume I have no wish to tap into or reflect specific, existing discourses and so will avoid the term multimodal precisely because of its historic tendency to look at sensory modes in isolation. Instead, to describe and define how we encounter or experience audiovisual work I offer the following term:

Transperceptual attention

'Trans' – as a prefix, meaning across, beyond or through

'Perceptual' – meaning the ability to perceive, become aware of or interpret through the senses

'Attention' – meaning the act or power of carefully thinking about, listening to or watching someone or something: notice, interest or awareness

Encountering audiovisual works is not the same perceptual experience as listening to a sound work, or viewing a visual work, but is instead a *transperceptual experience*, rooted in both of its individual sensory modes yet also moving across, beyond and/or through the spaces between those modes and the

effects those modes have on one another. By using the term attention to describe this form of engagement, I am deliberately trying to side-step terms such as 'watching' or 'listening', so loaded with preconceptions as sensory experiences, and trying to find a term that can speak to active engagement in more than one perceptual mode.

As discussed, unlike Ceraso's appropriation of the term multimodal, transperceptual is not used here strategically; indeed, I can find few references to the term in the context of either audiovisual experience or listening practices outside of Douglas Kahn's *Earth Sounds, Earth Signals* (2013), in which he dedicates a chapter to the concept (though intends it in a different way to how it is used here):

> A long sound is usually thought to be one that lasts a long time; yet there are sounds that are long in distance as well as duration. Moreover, some long sounds can be heard as having acquired their character through the course of their propagation, acoustically and electromagnetically. In this way, a sound is as much of the intervening space as it is from the source. **I use the term transperception to denote the perception of those characteristics—the influence of objects and artefacts, modulation and media (e.g., rock, air, Internet), and the time required by distance—along with the source. Very simply, transperception is an apperception, a consciousness or intrinsic awareness of an energy that includes what has been traversed.** In terms of the naturalization of telecommunications, it is also a perception of what has not been annihilated.
>
> (Kahn, 2013, p. 12)

In an interview on that volume, Kahn cites an example from the writing of Henry David Thoreau as an exemplar of transperception:

> Henry David Thoreau, on the other hand, described how the source of a distant sound lost its indexical character when one listened more intently to the space and elements in the intervening space as they modulated (his word) the sound in different ways, as one would see a distant mountain through an intervening mist. There is no ultimate reason, after all, to presume that the mountain should always have priority, since the roles could be reversed: one could look at the great expanse of mist, and a mountain intrudes into the background. Matters need not necessarily break down easily into source and channel. The same applies to the sound of a large bell through a fir forest. One may have been listening to the wind in the trees when a bell rushes through the branches. Transperception is this experience of a modulated hybridisation of seeing miles of mist/mountain or hearing the needles/bell. It does not always have to be in a linear imaginary through propagation, although that may be where it is most easily understood; when you listen to the wind in a tree you are

most likely listening to many winds in many trees from many directions. There may be phenomena and artefacts emulating or otherwise having little differentiation from one another that oscillate between source and influence that would best be heard in terms of transperception.

(Kahn and Macauley, 2015, para. 8)

What is interesting here is Kahn's suggestion that transperception is an apperception, and indeed it may be this consideration that brings his proposed usage of the term transperception closer to my own. If we consider apperception in the sense advocated by Lipps (1902), we can take it to mean the act of perceiving, but also the conscious attention to that perceiving and to the thing being perceived. This is exactly the kind of engagement I am advocating, both in this chapter and subsequent ones, in encountering audiovisual works. Attention is rooted in exploring not just the 'thing' itself, but our relationship to the thing and the thing in its broader physical, critical, mediated, modulated context – what Kahn refers to as a modulated hybridisation.

To return back to the threads of discussion that initiated this chapter, and indeed to those explored in the analysis of the questionnaire responses, the notion of audiovisual synergy and transperceptual attention can be seen as being inextricably bound to one another. Interestingly, almost regardless of disciplinary background, stage of career, level or type of interest in audiovisual practices or even geographical location, the vast majority of questionnaire (and interview) respondents talked about audiovisual work as being work in which sound and image combined together to constitute an audiovisual product greater than the sum of its parts; 1+1=3. Whilst this might be due to the way in which the two media, in whatever form, combine it is also suggestive of the ways in which those experiencing that audiovisual work position themselves in that act. Certainly, from my own perspective the way in which I encounter audiovisual work has altered significantly in the time since I began actively working in the field – and this applies to all forms of work that consciously engage both my auditory and visual senses. There is, undoubtedly, an effect that sound and image have upon one another in their own right, but audiovisual synergy is also a *product* of transperceptual attention as much as it requires it; by recognising that we approach attending to audiovisual work in a specific way that encourages us to explore and interrogate the relationships between sound and image, we, in turn, shape our perspective on that relationship and render ourselves open to heightening the effects of combining the two media. Much as practices of deep listening encourage a form of attention that heightens and expands our consciousness in the context of sound, transperceptual attention encourages a heightening and expansion of our consciousness across and between perceptual dimensions, necessarily affording the opportunity to be more open to experiencing the nature and qualia of relationships between sound and sight, and between ourselves and the work.

Before moving to consider how this transperception is enacted, it might be useful here to briefly draw on established models of perception, particularly

those advanced by Alva Noë (2004, 2008). Noë states that "perception depends, in this fundamental way, on understanding and knowledge. Perceptual consciousness requires understanding" (2008, p. 663). In *Action in Perception*, Noë argues that "Perception is not a process in the brain, but a kind of skilful activity of the body as a whole. We enact our perceptual experience" (2004, p. 15). This acknowledgement of the role of knowledge and experience, and the role the rest of our cognitive lives has to play on perception could be carried forward to transperceptual attention and, indeed, be seen as fundamental to its ethos when applied to the analytical approach taken in Section 3 of this volume. Noë draws extensively on Merleau-Ponty, who we have encountered in various forms already, but it is his advocacy of amodal perception that is important here:

> The object is only determined as an identifiable being through an open series of possible experiences, and exists only for a subject who produces this identification. Being only exists for someone who is capable of stepping back from it and is thus himself absolutely outside of being. This is how the mind becomes the subject of perception and the notion of "sense" becomes inconceivable. … Reflection must clarify the unreflected view that it replaces, and it must show the possibility of this succession in order to be able to understand itself as a beginning. To say that it is still me who conceives of myself as situated in a body and as furnished with five senses is clearly only a verbal solution; since I am reflecting, I cannot recognize myself in this embodied I...
>
> (Merleau-Ponty, 1982, p. 220)

Amodal perception, through fundamentally challenging the historically often-stratified senses of perception – particularly those that privilege sight – is a useful foundational approach for transperceptual attention. However, whilst we might argue that experiencing an audiovisual work – as experiencing the world in general – is an act of amodal attention, my contention here is that through specifically attending to sight and sound and their interaction, and through encountering other perceptual and contextual modes in light of that interaction, the act becomes transmodal/transperceptual – moving through and beyond perceptual modes through the apperceptive act of attending to the thing, attending to the attending to the thing, and attending to the things outside of the thing – including one's relationship to it and its relationship to oneself.

Transperceptual attention – an apperceptive act in which I specifically attend to sight and sound and their interaction, and encounter other perceptual and contextual modes in light of that interaction.

Coda – some terminology for transperceptual attention

Having established the understandings and presuppositions under which we approach audiovisual experience – that we do so through a form of intra-action, engaging and precipitating transperceptual attention, recognising that sound and light are so closely related as to be effectively inseparable, that they are the media in which we are situated and through which we move and that the audiovisual work entails a shaping and direction of audio and visual materials into a particular form – we can begin to explore *how* we encounter these works and what these encounters themselves entail.

Bearing in mind the different forms and formats of works we might encounter under the umbrella heading of audiovisual experience, we might advocate the following as a potential approach to encountering a new or unfamiliar piece of audiovisual work. However, this approach is presented with the recognition that the process of engaging with a piece of work is not, in actuality, compartmentalised in this way, and that the way in which we engage might not be as considered as this – this might simply provide a framework against which to consider initial analytical steps in encountering a piece of work:

1. Hear/look – **Sentire** (to sense)
 Begin by intuitively experiencing and sensing the work, on almost a passive level; without trying to think about the work, the media, what they are individually, what they are together, how they were made. Just experience, sense, hear and look.
2. Listen/see – **Audire** (to hear, to review)
 Begin to think more critically and in detail about what you are seeing/listening to and consider how to apply meaning. This might be specific/intrinsic meaning, or might be more intuitive – how does the combination of sound and image construct meaning *for you*? Are there specific things the work is trying to say or speak to, or things it is attempting to address?
3. Think/engage – **Cogitare** (to ponder, to think)
 Consider what you know about the work, the artist, the broader contexts, the way in which it might be described. What kind of work is this?

How can this or does this contextual awareness shape how you experience the work?

4. Understand/reflect – *Intelligere* (to understand)
 Combine these layers of perceptual experience with contextual ones; bring them together, ask how they relate to one another and how they shape one another. How does (or simply *does*) this help to codify your experience of and response to the work?

This should also be a recursive process, constantly open to reconsideration and reinterpretation, in light of new experiences, new ideas and changes in perspective. Much as with the listening modes described above, or the suggestions for ways to encounter visual work, this is in reality not necessarily a compartmentalised experience, but a fluid act of encountering which may be informed through some of these considerations.

Some notes on terminology

I am sceptical of providing another set of terms with which to explore or categorise audiovisual experience; as with the listening modes we discussed earlier in this chapter, we might question the value of codifying and defining particular aspects of experience in specific ways. What, after all, does this really reveal about the experience of the work itself?

However, it is important throughout this volume to remember the purpose for which it has been assembled. Whilst it is intended to explore a range of ideas, theories, concepts and aesthetics related to audiovisual practices, it is also intended to be used in educational contexts, and in that sense it is intended to address both subject specialists and those relatively new to the field. Consequently, the establishment of effective terminology and frameworks within which to situate experience and develop personal understanding is an important facet of this volume. It is also important to recognise that the readership for this volume might have a developed interest in the phenomenological aspects of encountering audiovisual work, or arguments relating to the materiality of sonic and visual materials, but equally they may have no experience or interest in either. Consequently, this book needs to try to provide starting points for both initial encounters and more detailed, complex and philosophical engagement with audiovisual artefacts.

Terminology, though, is difficult to develop – partly because we already have so many existing conceptions and preconceptions of the words we use and the things they refer to and imply more broadly, but also because in defining things as *being particular things* you are, by implication, suggesting that they are not something else. Further, in this specific case – and as I have alluded to above – the problem of defining and representing perceptual concurrence in terminology when dealing with multimodal art forms is difficult to deal with. You will note above that I have suggested both two-word pairings, separated by a '/', to indicate the different aspects or addresses of that particular action, alongside Latin verbs that I feel are most appropriate

or apt to the endeavour described and represented by that action. The Latin terms instinctively feel as though they have the potential to be pretentious or unnecessarily obfuscatory – why would I use Latin when I could use English or indeed any other modern language? My rationale in this case is because these terms are both specific and interpretive – we know what they mean, through the translations we are given of them and the way in which they have informed our own conceptions of these words in English, but the broader context around what they might be applied to and the contexts in which they may originally have been used are more opaque and not immediately apparent. To take each example in turn:

1. Hear/look – **Sentire** (to sense)
 I have chosen 'sentire' (to sense) here to reflect the intuitive aspect of this form of engagement, and also to indicate that this is multisensory – relating to both hearing and looking. To sense relates to both of these senses, and others, whilst also not specifically referring to either of them.
2. Listen/see – **Audire** (to hear, to review)
 Here, I have chosen 'audire' because of its meaning to hear but also to 'pay attention' or to 'attend'. There are also resonances with the contemporary term audit, and our understanding of this in terms of thorough review.
3. Think/engage – **Cogitare** (to ponder, to think)
 Cogitare was chosen here as although it refers specifically to thinking this is often specifically referred to in the context of intensively meditating on a particular subject as opposed to merely thinking about it at a surface level. Cogitare reflects the depth with which one is engaging or thinking about the work and our relationship with it.
4. Understand/reflect – **Intelligere** (to understand)
 Intelligere was chosen specifically because, although we now predominantly understand this term in the form of intelligence – our *ability* to understand – here it refers to the *act* of understanding. Consequently, in this context it has been chosen to specifically refer not to our ability to understand the work at hand, but to the act undertaken with which we attempt to enact that understanding.

The categories given above presented in this form – and indeed, numbered in this way – might feel linear and prescriptive; that this is how an audiovisual work *should* be approached in order to be understood. However, this is merely a starting point – a potential inroad into considering an audiovisual work and how we act, interact and intra-act with it. Necessarily, a theoretical and linguistic construct needs to be presented in some kind of linear form as above, and indeed presenting it diagrammatically would also present it in some form of relational or hierarchical structure, but it is not intended as such, rather a series of potential starting points through which to begin to encounter audiovisual work.

The processes outlined above lay a foundation, but they cannot build the walls.

Section 2
Composing audiovisually

This section presents my reflections on, and understandings of, my own audiovisual composition and how it has developed over the past decade. It also explores elements of audiovisual composition, presenting what I understand to be the building blocks of composing audiovisually with regard to sound and visual morphologies, relationships and terminologies, linked to examples from my own practice and ideas around transperceptual attention developed in Section 1.

Developing an audiovisual practice – my own experience as an audiovisual composer

As I have made clear earlier in this volume, I primarily describe myself as an audiovisual composer. In saying this, I consider that the strands of my practice research all involve a process of *composition*, as I have described it in Section 1 of this volume. This is perhaps indicative of my experience and background within music education, and it is very possible that I would describe myself differently if I came from a fine art, visual art or film studies background (though if that were the case, my creative work would also, no doubt, be vastly different). Nonetheless, despite the somewhat diverse strands of my practice research, audiovisual composition feels, to me, to be the most appropriate umbrella heading under which all of the creative artefacts that comprise my practice can stand.

I will begin by defining the three strands of my own practice research to date, all of which are discussed relatively extensively (mostly by me!) in other publications, so I will not go into unnecessary detail. I will then explore the themes central to the way in which I compose audiovisually, before considering how these themes resonate with the testimony of participants in the questionnaire and interviews completed for this volume.

The three strands of my research are as follows:

Fixed-media audiovisual work
Expanded Audiovisual Format (EAF) installation
Live audiovisual performance.

and what follows is a brief description of the fundamental components of each.

Fixed-media audiovisual work

I use this term to describe audiovisual pieces I have made, usually for single-channel video with stereo or multichannel audio, but in some cases audio-only works. This term best defines a series of pieces I made through my PhD and up until about 2014. These works were fundamentally concerned with exploring relationships between sound and moving image which I defined in my PhD portfolio as exhibiting the following relationships.

Direct: A direct relationship is one in which the sonic content of the piece is used to alter the content of the visual system in an obvious or easily perceptible way. In my doctoral portfolio the most common example of this was the use of amplitude to change the colour, shape, size or opacity of a single object, or number of objects, within the visual space.

Indirect/behavioural: An indirect or behavioural relationship is one in which the 'behaviour' of a visual system on a more structural level is controlled by aspects of the sound or the sonic form of an audio system. For example, a number of the pieces in my doctoral portfolio had visual systems that were governed by physics-based behaviours or algorithms. This type of relationship could involve using the amplitude of an audio signal to control aspects of the visual system such as gravity, friction, mass or forces of attraction and/or repulsion.

Inverse: An inverse relationship is one in which a visual system controls the behaviour of an audio system with the visual system not necessarily forming part of the presentational form of the work. So, the visual systems were used as a behavioural stimulus for an audio-only piece as opposed to being part of the audiovisual outcome of the work. An example of this would be the eight-channel spatialisation system I built for the audio-only work, *sys_m1*. In this, visual objects with a particular durational life cycle were triggered and interacted with one another, and the trajectory of their movements was used to define how sound objects moved within an eight-channel circular surround sound configuration.

These definitions, when revisited ten years after they were originally written, seem hopelessly naive and demonstrate (a) a preoccupation with sound above image, despite my defined intention in the portfolio to create balance and cohesion between audio and video, and (b) suggest heavily structural, process-based compositional concerns as opposed to a broader consideration of the nature of the audiovisual relationship as perceptual and experiential.

The last work of this kind was completed in 2014, before I began to move towards making Expanded Audiovisual Format (EAF) installation works. However, each of my EAF works can be presented as a fixed-media work, and indeed they regularly are in concerts and gallery settings, so I feel that this is a research strand I am still developing, albeit in a very different form.

EAF installations

As I've said, the first work of this kind – *pletten* – was developed in October 2014 and was initially screened as a fixed-media, dual-screen, 4.1 audio

composition. Indeed, the majority of the subsequent screenings/presentations of this work and several that followed it were in this format, but I consider them to be installation works as this is how they were conceived, if not always how they are able to be shown; this recognises the challenges of hosting work for expanded formats both sonically and visually, but speaks to the ethos of the work as it was composed. Indeed, it is perhaps best here to offer a definition of what I consider works for EAF to be – this definition taken from my recent book chapter as part of the Sound/Image collected edition:

> Works for Expanded Audiovisual Format (EAF) are those that seek to explore the possibilities of expanded exhibition formats from both a sonic and visual perspective simultaneously. These might include, but are not limited to, multiscreen, fulldome or projection mapping in combination with multichannel, multidirectional or ambisonic sound. Expanded Audiovisual Format works might also involve site-specific reconfiguration of both sonic and visual materials based on available exhibition spaces, or the design of an expanded audiovisual work for a specific architectural space.
>
> (Harris, 2020, p. 282)

As with my definitions of the types of audiovisual relationships in my doctoral portfolio, this definition might appear overly structural or process-driven, as opposed to considering the nature of the work and its materials. However, there are specific concerns in developing each of my works for EAF, many of which are related to site specificity or adaptability, or the cultural resonance of the materials used; all of this is dealt with in the book chapter cited above, so I will not go over this again here. Suffice it to say that, though the definition of a work for EAF may be concrete and structural, the range of materials and situations in which these are manifest resolutely are not, and indeed this is something that will be discussed later in this volume in the context of works other than my own.

Live audiovisual performance

This is a strand of my work that began to develop in 2011 whilst working at Kingston University, and is also something I have addressed in some detail in other publications (see Harris, 2016a).

Evolving from a single-screen, stereo-speaker format in my earliest work, *intervention:coaction* (2012), my most recent performance works involve either bespoke hardware and gameplay, in the case of *Noisymass* (2018), or attempts at working with expanded formats within a live context, in *Tiros* (2019).

I began to work with performance initially for pedagogic reasons; I wanted to encourage my students to think about working with audiovisual technologies in real time, responding live to unexpected events, and doing so myself felt like an appropriate way to encourage this kind of working in my students. At the time, I was also working with a number of colleagues to develop a

digital arts collective with our students, focused around working in real time with technologically mediated music making, so was necessarily developing this strand of my practice for this context. However, I also missed having a performance component to my work. As a classically trained flautist, pianist and singer, from the age of 11 I was heavily involved in performing in orchestras, wind bands, choirs and as a soloist, something which I had let fall by the wayside once I began studying within higher education, and even more so as I moved primarily towards technologically-mediated practices. Developing some of my early audiovisual performance works allowed me to move back into this more unpredictable space, and I have subsequently played with this unpredictability and ambiguity through incorporating elements of risk, game play and machine agency in the software and purpose-built hardware systems I perform with.

Central concerns when composing audiovisually

Whilst I reflect now on the way I positioned my research during my doctoral studies with some amount of discomfort, I do feel that, fundamentally, the central concerns underpinning the way I approach working with both sound and image have in many ways remained consistent. There are, however, some key changes in how I begin to develop work, much of which has come about through the development of my working practices facilitating a greater fluency with the technologies I use to mediate my process, but I will expand on this in more detail later in this section.

First the similarities, and we begin a consideration of the nature of the relationship between sound and image in my work. This will also be discussed later in this section, in the analysis of the questionnaire responses. Section 1 of this book deals with phenomenology to some extent, but there is a particular quote from Merleau-Ponty (which I have also cited earlier in this text) which quite strongly resonates with my own perspective on how sound and image work together in my audiovisual practice:

> The sight of sounds or the hearing of colours come about in the same way as the unity of the gaze through the two eyes: in so far as my body is not a collection of adjacent organs, but a synergic system, all the functions of which are exercised and linked together in the general action of being in the world, in so far as it is the congealed face of existence.
>
> (Merleau-Ponty, 1982, p. 64)

When first reading this paragraph, I was struck by how neatly it encapsulated my experience of existing in the world, and resonated with my approach to working with both sound and image. Fundamentally, what I have always sought to do in developing my work is create audiovisual spaces where the sound and image are completely interlinked – one could not function without the other – and indeed where the work itself would be

fundamentally altered by being either audio or video in isolation. In many cases, this has been through an attempt almost to create audiovisual objects, environments or behaviours on screen which are essentially part of the same process and same manifestation – so as my voice and the function of my organs are linked together within my physical being, the work I make is audiovisual in that the sound and image are completely intertwined within an audiovisual whole.

In attempting to explain this relationship, particularly in the context of teaching, I have often used the term 'media hierarchy' to explain both examples of modes in which either sound or image feel almost subservient in the audiovisual relationship, and the specific conditions I am attempting to avoid in my own work. In works in which there is a media hierarchy at play – some examples of narrative film I might consider to fall into this category (there is a reason Gorbman's book is called 'Unheard Melodies' (1987)) – the relationship between sound and image tends towards the prevalence or relative importance of one media over the other. Indeed, as Kassabian (2013) points out, there is a reason why the majority of studies of cinema contain some emphasis on the visual. In my own work, one of the keys to the audiovisual relationship is that, for myself as the composer, both sound and image stand on an equal footing.

Related to this is a qualification of the nature of this close relationship between sound and image – specifically that the two media feel balanced and coherent with one another. As we have seen earlier in this volume, Whitney would describe this as a 'complementarity' (1994), and Alves (following Whitney) as a 'digital harmony' (2005), but for my own purposes the term *audiovisual cohesion* feels most appropriate. Various definitions of the term cohesion can be found – Cambridge has it as '(of objects) the state of sticking together, or (of people) being in close agreement and working well together' (2020), while Merriam-Webster defines 'the act or state of sticking together tightly, especially: UNITY' (2020).

For my own purposes, audiovisual cohesion implies a balance and coherence to the relationship between the two, without necessarily implying a particularly obvious or direct relationship between sound and image – it might not always be apparent what an audiovisual work is doing, or how it is doing it, but there is nonetheless the sense that sound and image are completely interlinked and creating an audiovisual whole.

Now, the differences.

One thing that comes across quite clearly in my early discussions of my work is that, although I consider myself to be making audiovisual work, I typically talk about the sonic component of the work as the primary structuring element, with the visuals being combined with that sound through the manifestation of a particular audiovisual relationship. This is perhaps inevitable; at the time, I was completing a PhD within the music department of Sheffield University, so it is not surprising that I was seeking to position my work as being 'sound first'.

As I have discussed earlier in this volume, however, this is very much *not* how I conceive of my work now. Indeed, as I state in Section 1, the key component – for me, at least – of composing audiovisually is to consistently think about and account for both the sonic and visual components of the work, not as isolated elements but as part of a cohesive whole. This is where one of the principal differences between my working practices now versus a decade ago is to be found, as this is now manifest not only as a conceptual concern but also as a technical and technological one. To fully explain this, I will need to provide a little background to my development as an audiovisual composer.

When I began to work with audiovisual composition I was midway through my first year of doctoral study in composition – however, I was focused on composing acoustic, score-based music and, at the time, was working on large-scale vocal compositions. I had long been feeling very frustrated by acoustic composition, as I felt I couldn't really 'get at' the sounds I wanted – they always seemed to be somewhat out of reach, and my acoustic compositional practice felt lacking in direction. In truth, I had returned to doctoral study after a year away (following my master's degree) primarily because I missed learning, but with no real idea of what I would end up composing or clear sense of artistic trajectory.

My first audiovisual work occurred almost completely by chance, through a visit to the Site Gallery in Sheffield. I don't recall either the artist or the exhibition I went to see, but I was completely captivated by the sound of an ageing slide projector that was displaying some stills of the work in one of the side gallery spaces. Having never recorded anything before (which accounts for the background noise in the resultant work!) I returned with a field recorder to make a document of the sound on which to base my first studio composition. Taking this single source sound, I spent several feverish weeks in the studio editing, filtering and combining short snippets of material to create the sonic component of what would eventually become *Site* (2008), my first audiovisual work. This was my first experience of using a digital audio workstation – in this case Nuendo – and my first real experiments with editing or manipulating sound in any way (at the time, teaching classes in Max/MSP would have felt a long way off!).

Once the sound work was finished, I had a really strong sense of a visual realisation of the work I wanted to make, but absolutely no idea where to start; whilst I was rather inexperienced in working with music technology I had no clue whatsoever where to begin with generative visuals. Fortunately, at the time the University of Sheffield had the most extraordinary technician – Dr Dave Moore, to whom I feel I owe an extraordinary amount of my current career (and indeed, he later introduced me to my husband) – and he introduced me to the basics of coding visuals in processing. The relatively simple black-to-white grid pattern for the work still seemed far out of my reach, but with some practice I was able to develop something that approximated what I wanted and, having rendered out all 70 individual tracks of the

sound work I was able to run these into processing and have them control the opacity of 70 squares within a 7 × 10 grid.

This was the first of a portfolio of works that would eventually form my doctoral submission, but at this stage my understanding of what I was doing, from a technological perspective, was relatively limited – I had some difficulty 'getting at' the audiovisual materials I wanted to generate because I just didn't really know how to go about making them. Unsurprisingly, in the intervening ten years my technical and technological capabilities have extended significantly, partly through my research but also through necessity in my teaching practice; indeed, the interesting thing about working with technology is that students are always introducing me to new software and hardware that facilitates creativity in intriguing ways.

When I approach the composition of an audiovisual work now, it is with a significantly greater degree of freedom. Ten years ago, I may have felt restricted by what I felt I was able to realise – both sonically and visually – with what I perceived as my relatively limited skill set. This is not to say that, particularly where coding is concerned, I am an expert – I can use processing, Max, pd, Arduino, etc. well enough to both serve my own purposes and effectively (I hope!) teach my students, but I am not a computer scientist and never will be. I know enough to facilitate my own creativity without restrictions and, importantly, know how to find answers to questions I might have (and, crucially, how to ask those questions) in order to realise a specific creative output.

This level of technical and technological fluency and autonomy means that I am able to think through *how* I want to realise my work in more detail now, as an integral aspect of the composition itself. In *ether* (2020), for example, I developed and expanded on a process I describe as algorithmic aleatoricism, originally developed through the composition of *alocas* (2017), through incorporating both chance- and rules-based procedures into the audiovisual realisation of the work. I am also able to use single data sets or other structuring mechanisms to facilitate processes of simultaneous audiovisualisation – an example of this would be in my recent performance work *Tiros* (2019), in which I temporally audiovisualise a number of differently configured snowflake fractals.

Interestingly, though, whilst my technical and technological capabilities have expanded I don't feel that my preoccupations and interests in developing audiovisual work have altered hugely in the past decade; I remain interested in developing cohesive and perceptually-balanced audiovisual relationships through works in which both sound and image are completely interwoven into an audiovisual whole. The methods and means by which these works are manifest have shifted, as has my ability to effectively describe and contextualise the work I am doing within the broader field of audiovisual practice, but the central compositional concerns driving my approach to composing audiovisually have remained largely consistent. That is not to say that they will not alter as my career progresses – this is perfectly possible and perhaps

even inevitable – but there is a clarity and consistency to how I compose and conceive of my audiovisual work, even within diverse strands of practice, which seems to be relatively consistent. Indeed, the fundamental ethos underpinning the works I make seems to resonate with and be shared by other contemporary artists and audiovisual composers, and this will be the focus of the next chapter.

4 The elements of audiovisual composition

This chapter will lay the groundwork for Section 3, Analysing Audiovisually, through exploring what I consider the building blocks of audiovisual composition to be. Initially, this chapter will begin with a consideration of the elements of the composition process as it exists within music, visual art, film, photography and dance. It will then look to find ways to reconcile these elements into a single set of characteristics for consideration in audiovisual composition. In so doing it will also offer a tentative linguistic framework for dealing with audiovisual composition on its own terms, rather than through discourse associated with other, specific art forms.

Music composition

Purely for the sake of ease, I will begin with music composition, broadly conceived, as this is the area historically most familiar to me. Within this, I will try to consider music composition as an extended endeavour, related not only to traditional notated music but also to electronic, electroacoustic, acousmatic and other related forms of composition for which strands of specialism have developed over recent centuries.

Some (by no means all) of the key components of music composition might be considered as follows:

- **Pitch**
 Though perhaps more directly relevant to notated music, all forms of musical composition typically involve pitch in some form and relationships between those pitches. In my own work, I often use synthesised or recorded pitched material, often outside of equal temperament, and relationships between pitch and pitch character can quite clearly shape the aesthetic trajectory of a work.
- **Rhythm**
 Not necessarily to do with motif or repetition, the rhythm of a work can also connote its sense of momentum or direction, or merely the relative time durations of sound events within the montage.

- **Tonality**
 Again, most directly relevant to notated music, tonality could be argued to relate to any structural hierarchical relationship with a central tonic; whilst typically this is manifest within functional harmony, a soundmark, for example, might function as a tonic in a soundscape composition.
- **Harmony**
 Usually closely related to tonality in a musical context, harmony here could also mean the balance and relationship between sonic elements in the work.
- **Shape**
 This might be the smaller shapes of an individual motif or sound object, or the larger shape of a phrase or section.
- **Form**
 Potentially relating to classical forms, such as sonata form, but could also describe the formal components of a work as it unfolds over time. In that sense, quite closely related to…
- **Structure**
 How a work is structured and develops over its temporal duration, or within sections or moments in time.
- **Timbre**
 Which we could perhaps also describe as colour; the quality that a particular sound has because of its acoustic make-up.
- **Texture**
 Again, equally applicable to earlier notated music, e.g. polyphony, monophony, homophony, this might also describe more intuitive engagement with the quality of a sound – granular, smooth, dense.
- **Process**
 I have included process as, particularly within the last century or so, an integral component of composers' practice. As an example, within my own work, the conceptual and compositional process are often directly related to a particular structural or technological one.

From here on, I am exploring outside of my specific disciplinary silo, so will rely on definitions provided by wider reading to explore the elements of composition in different art forms.

Visual composition

The defined elements of art and principles of design that might comprise a visual composition seem to vary slightly according to source; however there is a general agreement on the fundamentals. This very succinct separation into elements and principles, and their individual component definitions, is provided by the Massachusetts College of Art and Design.

Elements of art

The visual components of **colour, form, line, shape, space, texture** and **value.**

- **Line**
 An element of art defined by a point moving in space. Line may be two- or three-dimensional, descriptive, implied or abstract.
- **Shape**
 An element of art that is two-dimensional, flat or limited to height and width.
- **Form**
 An element of art that is three-dimensional and encloses volume, includes height, width AND depth (as in a cube, a sphere, a pyramid or a cylinder). Form may also be free flowing.
- **Value**
 The lightness or darkness of tones or colours. White is the lightest value; black is the darkest. The value halfway between these extremes is called middle grey.
- **Space**
 An element of art by which positive and negative areas are defined or a sense of depth achieved in a work of art.
- **Colour**
 An element of art made up of three properties: hue, value and intensity.
 Hue: name of colour
 Value: hue's lightness and darkness (a colour's value changes when white or black is added)
 Intensity: quality of brightness and purity
- **Texture**
 An element of art that refers to the way things feel, or look as if they might feel if touched.

Principles of design

Balance, emphasis, movement, proportion, rhythm, unity and **variety** are the means an artist uses to organize elements within a work of art.

- **Rhythm**
 A principle of design that indicates movement, created by the careful placement of repeated elements in a work of art to cause a visual tempo or beat.
- **Balance**
 A way of combining elements to add a feeling of equilibrium or stability to a work of art. Major types are symmetrical and asymmetrical.

- **Emphasis** (contrast)
 A way of combining elements to stress the differences between those elements.
- **Proportion**
 A principle of design that refers to the relationship of certain elements to the whole and to each other.
- **Gradation**
 A way of combining elements by using a series of gradual changes in those elements (large shapes to small shapes, dark hue to light hue, etc.).
- **Harmony**
 A way of combining similar elements in an artwork to accent their similarities (achieved through the use of repetitions and subtle gradual changes).
- **Variety**
 A principle of design concerned with diversity or contrast. Variety is achieved by using different shapes, sizes, and/or colours in a work of art.
- **Movement**
 A principle of design used to create the look and feeling of action and to guide the viewer's eye throughout the work of art (MCAD, 2020, paras. 1–5).

Film composition

The majority of glossaries of film composition are concerned primarily with how elements are arranged on screen, with the terms scale, angle, space, background and colour featuring most prevalently. This also extends into photography, where additional elements of design feature pattern, symmetry, texture, line and depth of field (Mayo, 2019).

Dance composition

Dance composition, more frequently described as elements of choreography, seems to most frequently be grouped into shape, space, timing and dynamics, within which specific consideration is given to balance, symmetry, tempo, rhythm and scale (Smith-Autard, 2000).

Mapping between sound and images

Drawing extensively from Smalley's spectromorphological approach to analysing electroacoustic music, Diego Garro suggests the following phenomenological parameters of moving image and sound in isolation, without considering their combination.

Phenomenological parameters of the moving image

Colour – hue, saturation, value (brightness).
 Shapes – geometry, size.
 Surface texture.

Granularity – single objects, groups/aggregates, clusters, clouds.

Position/movement – trajectory, speed, acceleration in the (virtual) 2-D or 3-D space recreated on the projection screen.

Surrogacy – links to reality, how 'recognisable' and how representational visual objects are.

Phenomenological parameters of sound

Spectrum – pitch, frequencies, harmonics, spectral focus.

Amplitude envelope – energy profile.

Granularity – individually discernible sound grains, sequences, aggregates, streams, granular synthesis/reconstruction.

Spatial behaviour – position, trajectory, speed, acceleration in the 2-D or 3-D virtual acoustic space recreated in a stereo or surround sound field.

Surrogacy – links to reality, how 'recognisable' and how representational our sound objects are (Garro, 2020, pp. 6–7).

Elements of audiovisual composition

Looking again at the elements of composition defined in each of the art forms above, there are some very clear parallels and crossovers between disciplines and evident commonality in terminology, even if they are applied somewhat differently in each case. The terms that appear in almost every discipline include shape, colour, texture and form, and while their application is slightly different in each case, the fundamental aspect of the composition each refers to remains relatively consistent.

I find it particularly interesting that terminology within visual art breaks down composition into the individual elements composing the work – line, shape, form, etc.: the elements of arts – and the way in which those elements interact and the effect that creates – movement, variety, proportion, etc. – the principles of design. This feels particularly appropriate for audiovisual composition; as we have already discussed, the term composition is being utilised here both to refer to the process of composing the work and the outcome of that work itself – I am a composer, I make compositions. Similarly here, we can consider the elements of audiovisual composition as the individual components of the work, and the combination and effect of those elements in realising the larger composition. To reflect this, I propose the following elements of audiovisual composition, grouped under broader categories – *Shape, Colour, Time* and *Space* –within which there are both individual compositional elements and the result of combining those elements within the temporal realisation of the work.

Whilst this is, of course, somewhat reductive – as all these glossaries of terms and defining of elements of a work of art are – it might still provide some useful ways of exploring how we encounter audiovisual works and how we understand elements of that work combining to create a particular effect. These are starting points – ways of exploring how particular elements are manifest in a given work. They do not attempt to deal with the 'type' of the

Table 4.1 Elements of audiovisual composition

Category	Individual elements	Compositional result
Shape	Shapes/gesture/motif/dynamics	Structure/form
Colour	Pitch/tone	Timbre/texture
Time	Rhythm/movement	Momentum/direction
Space	Location/place	Spaces/site

work, or its broader contextual concerns, nor indeed how we encounter the works and change the works through these encounters – this will be dealt with in Section 3. Rather, they deal with some of the things we can observe and understand in our encounter with an audiovisual work as both maker and audience, to inform our broader contextual considerations.

Indeed, though there is a certain reductive nature to the terms advocated above, and the ways in which they are enacted, the potentially variable ways in which they can be applied and variability of that application are both useful for our purposes and reflective of the nature of the perceptual act utilised in exploring audiovisual work. In his reflections on the modalities of perception advocated by McLuhan and Merleau-Ponty, Leon-Carlyle points out that

> A musical note can be described as 'high' or 'low.' Similarly, 'soft' can describe both surfaces and sounds, 'loud' can describe both sounds and colours, and 'warm' or 'cool' can describe both colours and surfaces. Such attributions are as figurative as they are literal, and yet they are almost universally understood. Adjectives used to describe experience travel freely between sensory modalities, applying to vision just as well as they apply to audition. The crossmodality of sensory description is indicative of a common body to which the stratified senses belong – after all, if the five human senses were truly distinct from each other, would they not require five incommensurable forms of discourse to describe them?
>
> (Leon-Carlyle, 2014, p. 27)

This fluidity of meaning across perceptual modes, alongside our almost universal understanding of the terms advocated, should render discussion of the elements of audiovisual composition in this context both crossmodal and fruitful.

To better illustrate these elements, these terms will be used extensively in the close analytical readings of individual works in Section 3 of this book, within the broader situational framework proposed for encountering audiovisual works across a range of modes. For now, a more detailed fleshing out of each, alongside some specific examples from my own practice, might help to better situate the terms in context. I am utilising examples from my own practice because, as I am dealing with particular facets of audiovisual composition in isolation, my assertions about each work will be necessarily reductive, and also because they are the only works in this volume that I can speak about with absolute authority from a compositional perspective.

Shape – utilising examples from *fuzee* (2010)

Individual elements: shapes/gesture/motif/dynamics

The individual visual shapes used in this work are simple, geometric and two-dimensional – a series of lines made up of hundreds of incrementally overlapping rectangles which, when provided with enough amplitude from the audio components of the work, curl up into tight circles, eventually creating cog-like structures as the corners of the rectangles fan out around the edges of the circles. Complementing this, the basic sound materials are taken from clocks ticking and chiming, with relatively minimal additional sound processing, providing a combination of more isolated, angular sonic forms – reflected through the twitching movements of individual lines, and smoother, more elongated forms – reflected in the increasingly tightening circles and cogs.

One of the central motifs of the work is the ticking/twitching motion, serving initially as an interlude between sections before becoming the repeated grounding of the work as a whole. Beginning with a single tick in isolation, more are added incrementally until the motif becomes a repeated, five-tick phrase that persists, though increasingly less apparently, as the work progresses.

The central, extended material section of the work features a series of audiovisual gestures, often chimes or ticks in isolation or larger audiovisual objects comprised of a combination of sounds and movements.

Compositional result: structure/form

The actual structure of the work involves increasingly lengthy sections in which the system is excited and allowed to come to rest. The materials in each section remain relatively similar, restated and expanded on audiovisually each time, with a larger, more exploratory section in the middle in which the audiovisual gestures highlighted above are proposed and expanded on, increasingly suggesting a build towards a final, climactic moment – which eventually occurs at 06:58 of a 07:42 piece – before the work is allowed to very slowly come to rest with the gradual fade of reverb tails and the return of circular forms to their original linear shape. If one were to assign a formal structure, as such, it might be as follows:

Section	A	Interlude	A1	Interlude	B	Coda
Duration	25 sec.	27 sec.	33 sec.	7 sec.	5 min. 26 sec.	44 sec.
	00:00–00:25	00:25–00:52	00:52–01:25	01:25–01:32	01:32–06:58	06:58–07:42

The overall form of the work is one in which simple, geometric shapes in combination with simple sound materials are combined and layered to create the sense of a larger, audiovisual whole – indeed, key to this is that a great many of the lines originate from or terminate outside of the visual frame. The extremely close correlation between sonic and visual materials creates the impression of a single audiovisual system, as opposed to exhibiting isolated sonic and visual events.

Colour – utilising examples from *pletten* (2014)

Individual elements: pitch/tone

The colour palette used in the work is a combination of predominantly muted blues and greys, with some more apparent pinks and yellows in particular shapes on both the first and second video channel becoming more apparent at certain points in the work. Correspondingly, the sonic materials are derived from one single source recording of cornflour being compressed in a rubber membrane, and develop both non-pitched and more specifically pitched versions of this sound, through the use of a comb filter and pitched granulation.

Compositional result: timbre/texture

As this is a dual-screen work, the two video channels function slightly differently with respect to timbre and texture, though they are built from the same software patch and the audiovisual response is similar (but differently manifest). The more diffuse second channel, formed through the overlapping of numerous coloured layers, effectively presents a very close-up manifestation of the relationship between the differently sized, overlapping rings in the first channel. Within these two versions of the visual system, certain motives or sound relationships are foregrounded through the evolving combination of colours as they overlap and intersect with one another, manifest differently in each video channel of the work.

Time – utilising examples from *alocas* (2017)

Individual elements: rhythm/movement

Another dual-screen work, *alocas*, like *pletten*, uses a single visual system – in this case built around magnetism and particle systems – in two distinct ways. Unlike *pletten*, this world is largely generated simultaneously, sonically and visually, as opposed to sound controlling the behaviour of the visual system. Key to the sonic material of the work is an evolving series of binaural beats and other forms of rhythmic beating, layered to create clusters of tones that correspond to the levels of magnetism and number of particles in the particle

system in the first video channel, and the movement of the particle chains in the second video channel. The movement of the two audiovisual systems is manifest differently in each case, with the increasingly large numbers of particles and fluctuating magnetic field in the first channel creating patterns reminiscent of Chladni plates in correspondence with the elongated tones of the auditory material, and the movement of the particle chains in the second channel corresponding to the more gestural fluctuations in the sonic materials in the second channel.

Compositional result: momentum/direction

Alocas is the result of a compositional process I describe as algorithmic aleatoricism (Harris, 2020), and a great deal of its forward momentum and sense of compositional direction is dictated by how this process creates audiovisual outcomes. The work is palindromic, with the central audiovisual materials running in forward direction until the mid-point of the work, c.5 min., then in reverse (in terms of how the materials happen over time, not literally running in reverse) from that point to the conclusion of the work. Against this, the position of unexpected visual behaviours in the initial render of the visual system without corresponding audio material dictates at which point in the piece interventions were made in the audiovisual materials, rendering elements of the momentum and direction of the work open to both algorithmic and change-based procedures.

Space – utilising examples from *Visaurihelix* (2018)

Individual elements: location/place

Visaurihelix is a site-specific installation commissioned by Cryptic and The Lighthouse, Glasgow's Design and Architecture Museum, as part of the Mackintosh 150 celebrations. The work utilises materials recorded in a number of Charles Rennie Mackintosh buildings in and around Glasgow, and utilises shape, forms and colour palettes taken from those buildings or artefacts therein in the design of the visual system. Consisting of six movements, audiovisual motif and gesture in the work are an exploration of the combination of recordings from Mackintosh buildings with pitched synthesised materials (the relationship between pitched materials being mapped to specific Mackintosh designs), with visual systems inspired by Mackintosh artefacts and coloured according to Mackintosh stained glass colour palettes. The work is for 6.1 linear spatial audio, reflecting the six Mackintosh buildings and positioned through the length of the water tower at the former Herald Building (now the Lighthouse) in Glasgow, with visual projection in 1:1 aspect ratio in an octagonal plinth built at the base of the tower. Each of the individual audiovisual objects and gestures in the work addresses

this site-specific context in a different way, through the combination of Mackintosh-specific sonic and visual materials, and how they are manifest on screen and through speakers.

Compositional result: space/site

I have discussed the site specificity of *Visaurihelix* extensively elsewhere (Harris, 2020), so will provide only a brief summary here. In terms of the space occupied by the work, this is multifaceted. A slender, octagonal, 50 m tall architectural space with a helical staircase is the primary setting for the work, and the fixed-media components of the work were assembled with this idiosyncratic physical space in mind. Similarly, while the site specificity of the work refers to this space, it also refers to the cultural locations and resonances of the Mackintosh buildings and artefacts used as the basis for the work. Consequently, the relationship between location/place and space/site in this work is particularly fluid, because of its ties to a range of diverse cultural and spatial contexts.

What is it to compose audiovisually?

The terminology suggested above might be helpful both to those looking to create audiovisual work and to those who seek to analyse and better understand their experiences of audiovisual work. However, the key component – for me, at least – of composing audiovisually is to consistently think about and account for both the sonic and visual components of the work, not as isolated elements but as part of a cohesive whole. To compose audiovisually is to compose with audiovisual elements simultaneously – not necessarily from a temporal perspective, as it may be that one media must necessarily follow the other in terms of how the work is constructed – but considering both elements to be of equal weight and importance in the integrated outcome of the work. This is a difficult concept to concretise, describing primarily a feeling or an intuition about a process as opposed to a specific process itself; yet as we have seen in the responses to the questionnaire for this volume this is a perspective shared by a large percentage of those interested in or working with audiovisual modes today. Composing audiovisually is a transperceptual act, one in which sound, image and their relationship to one another are constantly attended to.

I do not feel, however, that audiovisual composition is a term that should only apply to the kind of non-narrative, experimental audiovisual works I, or others, make and in which this kind of audiovisual integration might be both easier to manage and more readily discernible. An example from narrative film I have often used in my teaching, when exemplifying the process of 'thinking audiovisually' about how sound and image work together, is the Coen Brothers and their long-standing collaboration with Skip Lievsay and Carter Burwell. In his article on the film *Barton Fink*, Barnes (2007) talks with Lievsay and Burwell about how they approach the audiovisual composition of

the music and sound design to the images on screen, from thinking through the emotional resonance of a scene and its broader context within the film, through to more concrete, technical concerns such as the splitting up of the frequency spectrum between sound and music to allow greater foregrounding of one or the other. The way in which sound and image integrate in the Coen Brothers collaborations with Lievsay and Burwell has, for me, always felt highly effective and a product of careful audiovisual thinking concerning the relationship between sound and image, as opposed to one media supporting the other; indeed, this is something I had remarked on personally before reading any of the collaborator's testimonies concerning their working processes.

There are also countless examples of thinking audiovisually within the realm of music video, enough to fill another full volume, in fact. The example I will use here is the collaboration between Bjork and Michel Gondry on the video for *Human Behaviour* (1993). Numerous other authors have talked extensively about Bjork's music videos, with All is Full of Love and Crystalline featuring extensively in a number of works (Dibben, 2006, 2009; Beisenbach et al., 2015), but *Human Behaviour* is not only one of the first of Bjork's videos I became aware of but feels like a really good example of collaborators thinking audiovisually about the manifestation of a work. Bjork and Michel Gondry have collaborated on numerous occasions subsequently, but this initial venture into music video is particularly convincing for its effective interplay both between the sonic and visual materials and themes, alongside both of the collaborators' individual preoccupations, and begins the (audiovisual, at least) story of Isobel, which is subsequently explored in the videos for *Isobel* (1995) and *Bachelorette* (1997). Both Bjork and Gondry have spoken individually, and collectively, about their fascination with nature, the human condition and mythology, and this music video appears to be a perfect encapsulation of their individual and collaborative spirits alongside a really effective audiovisualisation of Bjork's song.

The lyrics of the song begin as follows:

> If you ever get close to a human
> And human behavior
> Be ready, be ready to get confused
> There's definitely, definitely, definitely no logic
> To human behavior
> But yet so, yet so irresistible
> And there's no map
> They're terribly moody
> And human behavior
> Then all of a sudden turn happy
> But, oh, to get involved in the exchange
> Of human emotions
> Is ever so, ever so satisfying

with the musical material featuring a modal synth timpani-and-bass motif against Bjork's often disjointed central melody line and a persistent snare quaver pattern. The musical effect is familiar but disquieting; appearing almost bimodal, there is the sense of a central 'tonic' to both the melody and accompaniment, but it's never quite clear if they're the same thing, particularly when set against the relentless momentum of the persistent percussive line. Similarly, the visual material is familiar but disquieting; Bjork herself, in a cabin in the woods, a stop-motion bear, headlights – there are echoes of *Goldilocks and the Three Bears* juxtaposed against familiar horror movie tropes.

The visual work feels, to me, like an ideal manifestation of the musical material, perfectly capturing the playful-yet-sinister lyrical and sonic content in a visual environment which feels both mythical and material. The nature of this collaboration seems to suggest that, not only does Gondry sensitively interpret the musical materials he is tasked with working with, but that a genuinely collaboration has developed in which the relationship between sound and image is completely integral in the outcome of the work. Reading more about Bjork's central interests in approaching and thinking about her work, in a conversation with Timothy Morton discussing Object Oriented Ontology (OOO) she states "my favourite favourite favourite thing is how it connects to animism, that in each object there is soul. And therefore asks for difference reaction to ecology? Each laptop, each bird, each building" (Bjork cited in Beisenbach et al., 2015, p. 4). The continuing resonance of Isobel as a character is clear to see in this conversation too:

> my Isobel was perhaps partly overcoming the ridicule of the singer/ songwriter mission, why this possessed need to tell your tale? So most of my lyrics I have written myself, but roughly one lyric per album I've sat down with my oldest mate and author Sjon and we're documented together this separate mythological character, Isobel... but I'm not sure how much it travels to the listeners that it is sort of taking the piss a little, I find it hilarious!!! Her name is a little magic realist drama, kinda sensationalism, over-romantic, haha. And she had an urban/rural dilemma she is constantly trying to solve.
>
> (Ibid., p. 10)

The character of Isobel is variously explored in Bjork's work, and in the videos to the songs she features in, but it is in *Human Behaviour* that this character and her associated thematic constructs are initially exposed in carefully constructed, audiovisual form.

To return to my own works, as I have described above I consider my process – when composing audiovisually – as another manifestation of transperceptual attention, here enacted in the creation as opposed to the perception or experience of a work. Thinking through some of the works discussed above, although the individual features and compositional results I have pointed out are manifest as I describe, what is perhaps most interesting

is what happens in between each of these elements of the audiovisual work – and indeed in between the sonic and visual layers of composition.

As an example, within *pletten* the shapes and forms of the audiovisual outcome of the work are completely informed by a single act of play – the squashing and compressing of a rubber stress ball filled with cornstarch. This is the primary audiovisual material explored in the work – the recording of the sound of this squashing, and how this is represented as a visual outcome in rings and layers of simple geometric forms that appear to expand and contract. Although the domains are composed separately in this case, the central ethos of an exploration of this act of compression is the central audiovisual underpinning of the work – the transperceptual, embodied act of play described above. Indeed, when I discuss the work or even think about the work, I find myself repeating the physical action with my hand that was the impetus for its composition.

That being said, when I play the work to students and ask for their responses, they are very rarely able to pinpoint what the initial source material for the work actually is, yet always respond positively to the audiovisual outcome and typically suggest that both sound and image must have been composed as part of a single process. Perhaps there is something about the timbre and form of the sound material in combination with this visual realisation that renders the piece familiar and recognisable, if not fully legible. Equally, perhaps the transperceptual compositional act precipitates a sense of audiovisual cohesion in the work that is difficult to quantify. To return to an example discussed above, whilst the Coen brothers are undoubtedly talented film makers, and Burwell and Lievsay masters of their craft in both music and sound design, it is through their thinking audiovisually – transperceptually – about the complete audiovisual outcome of the work that affords what Barnes describes as "their ability to generate an atmosphere that reflects Barton's internal and external worlds" and indeed to providing sound and image with an "integrated structure" (Barnes, 2007, p. 12).

5 Teaching audiovisually

How to teach audiovisual composition. This is a big question.

To answer it begins with the recognition that the term audiovisual composition, within the pedagogic context in which I specifically deliver it, refers to a specific thing – that within this context I am expecting it to be a particular thing. Yet, I have often found that what I am expecting it to be is not necessarily what students are expecting it to be. This is one of the problems with the nebulousness of the term 'audiovisual', and its application – whilst many students undertaking a course in audiovisual composition seem to understand what I might expect the term to mean within this specific context, many do not. Variously students imagine it might involve working specifically with narrative film, or music video, developing post-production audio, working on theatre projects and so on. And indeed, it might! But audiovisual composition, for me at least, is about an *ethos* of working with sound and image explored in the previous chapter – it is about process and intention, and how these things shape the audiovisual outcome.

In the earliest stages of teaching audiovisual composition we establish what it means to compose audiovisually – and indeed, working through some of these ideas for this book has been enormously helpful in this regard. If we return to the title and subtitle suggested in the introduction to this volume:

Composing audiovisually: an exploration of the processes, products and experiences of arranging, combining and putting together sounds and images.

To compose audiovisually is to arrange, combine and put together sound and image. But beyond that, in teaching students to compose audiovisually what I am fundamentally seeking to do is to have students think in detail about how sound and image relate to one another, and to consider the importance of each media in developing their creative work. I am asking students to embrace the idea that neither sound nor image should be subservient or should be an afterthought in developing the work – that both are of equal importance. That does not mean that, in the outcome of the work, both will have equal prominence – but rather that in how the work is conceived and conceptualised, the role of both sonic and visual elements and their relationship with one another are considered in depth and detail and as an integral part of the compositional product and outcome. Further, this does

not mean that they should be created simultaneously, or even by the same person; audiovisual composition can be a collaborative process. The ethos of composing audiovisually should always be that sound and image are equal actors in the creative process.

Audiovisual composition is one of the primary components of my current postgraduate teaching, and a key early aspect of this teaching is that students are encouraged to begin by exploring existing work and interrogating their responses to it. In many ways, though not in the terms in which it will be discussed in this book (yet), they are encouraged to undertake in-depth personal interpretive analyses of examples of audiovisual work, to try to understand and account for their personal responses to individual pieces of work, drawing from their own educational and experiential backgrounds. From here, they are encouraged to explore further, to be able to situate the work they encountered within the broader context. How might we define this work? What kind of audiovisual work are we dealing with? How might we interpret this work? What critical or discursive frameworks might help to situate our responses to it?

In an earlier chapter in *Creative Teaching for Creative Learning in Higher Music Education* (Harris, 2016b), I present some of my perspectives on practice-based, research-led teaching, much of which are particularly relevant to this discussion and which will provide the groundwork on which the rest of the chapter will be built. Consequently it is useful here to begin by describing some of these perspectives before discussing how these inform my approach to teaching audiovisual composition.

The chapter in question – entitled *Thinking, making, doing: Perspectives on practice-based, research-led teaching in higher music education* – drew on interviews with current and former colleagues at the institutions at which I work and have worked, alongside numerous of my (at the time) current and former students to attempt to codify some of the more and less successful aspects of (my) research-led teaching practice. This is important here, as my teaching within the field of audiovisual composition is directly research-led, from a practice-based perspective, and as a consequence this is the most solid foundation on which to base this discussion.

This discussions also proceeds from the recognition that, for me at least, one of the most effective ways to develop a student's individual creative practice, and their understanding of that creative practice within the broader context, is to foster the creation of a co-research relationship within the context of "effectively scaffolding an individual learner's creative identity within a community of practice" (Harris, 2016, p. 76).

The phrase to 'scaffold a creative identity' is one that I use to outline a framework for effective practice-based, research-led teaching within the creative arts which is particularly appropriate to both the subject matter I am discussing here and the level at which I currently deliver this teaching. The framework has a number of distinct yet interrelated areas, and although it can be represented diagrammatically (and indeed this can be seen below) it is one which should be seen as non-linear, and more as a meshwork of

interconnected areas. The framework is heavily informed by Wenger's (2009) three characteristics of communities of practice, as follows:

1. The domain – A community of practice has a domain, an art of knowledge, experience or practice that renders the members of the community distinct from those outside it. Within the specific context here, the domain refers to audiovisual composition, particularly as it is taught in a particular institution and in a particular context, and might 'to some extent be established before the learning activity takes place, while also being informed by the nature and the context of the learning environment'.
2. The community –

 > within the community, members build strong relationships based on discussion, on sharing and on developing mutually beneficial learning environment. Essential to this is the sharing of perspective and practice, of collaborative learning and of continuing dialogue and interaction, both within and outside the formal learning environment.
 >
 > (Harris, 2016)

3. The practice – 'Members of a community of practice are practitioners. They develop a shared repertoire of resources: experiences, stories, tools, ways of addressing recurring problems – in short a shared practice. This takes time and sustained interaction' (Wenger, 2006, p. 13). For our purposes, this might be the development of skills and shared knowledge to facilitate creativity, or might be the eventual outcome in the form of creative practice.

 > It is the combination of these three elements that constitutes a community of practice. And it is by developing these three elements in parallel that one cultivates such a community.
 >
 > (Ibid., p. 13)

The components of the framework are shown below, alongside how they correspond with the three characteristics of communities of practice.

Domain	Community	Practice
Laying the Groundwork		
	Internal and External Reflection	
	Collaborative Learning and the Construction of Communities of Practice	
Planning Time and Teaching Methods		
	Forming Professional and Individual Creative Identity	

Figure 5.1 A framework for effective practice-based, research-led teaching

Laying the groundwork is particularly important in teaching audiovisual composition, as often students are coming to the field with little or no experience or understanding of existing audiovisual practice outside of narrative film, TV or music video. However, as I have argued previously, this is not just about laying the contextual, conceptual, theoretical or historical groundwork of the domain, but also the personal, practical and experiential in engaging with the works themselves and not just what has been written about them. A thorough picture of these components of the field is important – but as we have seen and will see in this volume, also potentially tricky. Whilst certain areas such as visual music have been subject to extensive historical and critical study, other forms of audiovisual practice are less well documented and less extensively discussed. Part of this component of the scaffolding process in teaching audiovisual composition, then, is identifying the specific domain the student is interested in exploring and tailoring reading and watching and listening suggestions to their particular needs. This is time consuming and recursive, subject to change throughout the process, and I often find myself suggesting individual reading and watching/listening lists for each student in my class (not a huge problem in a class of c. 12 students, but for any more this could become unmanageable). This is one of the reasons why asking students to think through their likely creative output – and provide an indicative project proposal at an early stage – is so important, as it allows me to point them in the most fruitful directions in terms of laying appropriate groundwork.

Internal and external reflection is a huge part of all of my teaching, but is important here from day one (as I have already touched on) as it is an essential aspect of developing the co-researcher relationship with the student cohort. This begins in week one, with the acknowledgement that I have not seen every example of audiovisual work (as is always made clear in the early classes for this course, as I'm constantly discovering new things) and that exploring new works is a process of research and discovery both for the student cohort and myself – consequently, the co-researcher relationship begins here. This co-researcher dynamic exists and is firmly rooted in the development of the community of practice, initiated in the degree programme as a whole but persisting in this course through the constant discussion and sharing of work and ideas, both inside and outside of the classroom environment, and the internal and external reflection this engenders. Part of this is through activities not directly related to the course itself – as an example, weekly discussion groups, in which students select readings/creative artefacts to engage with and discuss, provide them with agency over that aspect of their studies and help to develop their critical and creative identities from the earliest stages of their degree programmes. The development of a learning community grounded in sharing practice, both their own and that with which they have engaged, is key to developing a really dynamic and rich exchange of ideas. Indeed, as was discussed in the chapter cited above, former students describe this aspect of their learning experience to be one of the most beneficial, not only in developing their own work but also in expanding their

confidence to express opinions and enhancing their communication skills in general.

Specific strategies for developing internal and external reflection include:

- Asking students to bring in examples of works they have responded to strongly, either positively or negatively, and inviting them to spend some time articulating their responses to the work to the rest of the group. This can be a very informative process, helping students to interrogate and situate their own responses to a piece of work but also allowing discussions and interactions with peers to inform their initial, intuitive response.
- Asking students to act as though they were a conference or festival steering group or curatorial committee, and give them a series of works to review, for inclusion under a particular brief or thematic heading. In years where this has coincided with an actual festival during the teaching year, they have been able to participate in this process in a real-world context.
- Assessment is, obviously, part of the course and having students fully understand how their work is assessed is an important aspect of internal and external reflection. To do this, students are asked to look at a range of audiovisual compositions – often examples of previous submissions for this course (with the required permissions, of course!) – and assess them as though they were marking the work according to our marking criteria. This allows students to develop a more detailed understanding of how their work is assessed, and also allows them to better interpret the feedback given on their work, both formatively and summatively.

Collaborative learning and the construction of communities of practice are enacted in a range of ways, and can initially be through the lecturer/ tutor sharing and inviting critical engagement with their own work – this is something that I find incredibly uncomfortable, no matter how much I do it, but I think is really important in encouraging students to think about the professional context of my work and in developing their understanding of the relationships between research and teaching in a higher education context, something which (from personal experience) can feel quite opaque.

Regular sharing of work in progress through show-and-tell sessions is also very important in developing the community – this provides targets, milestones or pivot points around which a student can begin to develop their work, which many students respond well to. However, this isn't an ideal motivator for all types of learners, so it is also made very clear to them that they don't have to have anything 'finished' to show, or even anything substantial, but that it is more about sharing ideas with one another. Many of them find that articulating those ideas and answering questions or getting feedback on them can help them to develop more fruitfully.

Planning time and teaching methods are also important, and this will be addressed in more detail later in this chapter in some of the suggestions

for developing curricula and lesson plans. However, one of the key aspects of this is recognising the limitations of time, and indeed of 'traditional' teaching methods in exploring the field of audiovisual composition and being able to step outside of both of these constraints. First to use what scheduled time you have as best you can, but to be open to rethinking session plans on the spot if this is necessary. As an example, whilst I might try to devote the first hour of a two-hour session to the sharing and discussion of examples of audiovisual work, if this is proving particularly fruitful then this should be allowed to continue. Similarly, if a cohort of students doesn't feel hugely engaged in what is happening in a particular class, having the confidence to completely step away from this in the moment and do something else is important; indeed, some of the audiovisual exercises suggested below, particularly those that are collaborative, can be a useful way of 'shaking up' a session if it feels like it has become flat or that students are unresponsive.

Using time effectively outside of that which is officially 'scheduled' is also important, as is recognising that not all students learn in the same way; whilst some will be keen to do all the required and recommended reading, others may find this problematic for a host of reasons. Find ways to get round this by providing inroads to thinkers and ideas, or practices, that don't involve immediately, and in isolation, encountering the 'key' pieces of work – for example, if you wanted to introduce Donna Harraway's *A Cyborg Manifesto*, begin perhaps with a YouTube video of her speaking or one of the many, slightly more accessible, interviews she's done rather than launching straight into a weighty piece of reading. If you want to introduce the work of Norman McLaren, perhaps begin by showing 'pen point percussion' as an introduction to some of his processes, before showing full-length examples of his work. Inroads are important, particularly when presenting a range of interconnected fields of work, much of which may not be familiar to your student cohort.

Thinking about and presenting audiovisual experience as a transperceptual, physical, bodily and experiential act is also important, and can help to encourage students to explore their environment and the artistic contexts they are surrounded by in more detail and with a more critical perspective. If you are fortunate enough, as I am, to teach in a city in which there is a really vibrant artistic community then there might be regular events, exhibitions and festivals, such as Cryptic's Sonica (https://sonic-a.co.uk), to take students to. Experiencing work with them in a real-world context, and having them reflect on it in real time, can strengthen the co-researcher relationship and the community of practice and be just as valuable in developing their critical and creative thinking as an hour of lecture content. If not, finding ways to alter or subvert the format in which you usually present or discuss work can also prove fruitful.

Part of this awareness of the broader context and the arts community outside of their educational context can also help students to **form a professional and individual creative identity.** One of the things that I find

somewhat frustrating about teaching creative practice within a higher education context is that only myself and usually a handful of others get to experience the often extraordinary work my students create. Through encouraging them to think about and address the external audience for their work – through submitting it for festivals or open calls for work, or even targeting specific events or residencies they'd like to develop work for – I hope to encourage students to consider their professional and creative identity outside of its educational context and view their work as outward-facing and part of their professional portfolio as opposed to merely something that is assembled for the purposes of assessment. One aspect of this is my ongoing attempts to develop outward-facing mechanisms, such as concerts or festivals, at which students can present work, in order to encourage them to confront the professional context for their creative work.

Summary of principles for effective practice-based, research-led teaching of audiovisual composition

In another chapter, this time an edited conversation between myself and my colleague, David McGuinness (Harris and McGuinness, 2017), I draw on the framework described above to summarise six key principles for fostering effective practice-based, research-led teaching. In the list below, I have restated these principles, specifically tailored towards the teaching of audiovisual composition:

1. Students should feel actively involved in their learning and feel part of a collaborative learning community.
2. Students should have frequent opportunities to receive feedback on their work and provide feedback to others.
3. The community of practice should spend time reviewing and critiquing existing work and articulating and reflecting upon their responses to it.
4. Students should feel that their individual perspective is valuable.
5. Students should feel that their individual creative work is valuable, is contributing to an ongoing professional portfolio and has longevity outside of assessment within the university context.
6. Students should ideally develop a co-researcher relationship with their tutor/lecturer to explore their specific field of interest within audiovisual composition.

Suggested lesson plans, or possible ways to proceed

Below is a suggestion of five-week and ten-week approaches to developing courses or modules in audiovisual composition. These are just suggestions, drawn largely from what has worked in my own teaching and, indeed, what

hasn't, and provide only a suggested framework, foundation or starting point as opposed to specific curricula or content.

There are two different types of plan developed below – ones that are practice-based and practice-led. For the purposes of this discussion, I will be using Linda Candy's (2006) formulation of the difference between practice-based and practice-led research as follows:

> There are two types of **practice related** research: practice-**based** and practice-**led**:
> 1. If a creative artefact is the *basis* of the contribution to knowledge, the research is practice-**based**.
> 2. If the research leads primarily to new understandings about practice, it is practice-**led**.
>
> (Candy, 2006, p. 1, emphasis my own)

In this context, a practice-*based* course on audiovisual composition will be concerned primarily with the development of individual or collaborative audiovisual compositions or creative artefacts through the study of the field of audiovisual composition more broadly. A practice-*led* course, by contrast, will primarily involve a critical, conceptual and theoretical engagement with audiovisual composition in one specific area, and a rigorous and detailed reflection on that engagement through non-creative practice-based means, which may or may not be an extended piece of critical writing (this might be, for example, through audiovisual essay, podcast or presentation).

In my own teaching, I always insist on any assessment that is primarily through creative artefact being accompanied by a detailed, rigorous and re-flective critical commentary that documents and discusses the process the student has gone through in developing their work and considers the context in which they are working. This is a personal preference, but one that I feel is a key component of the development of a co-researcher relationship. This commentary is usually in the form of a piece of critical writing, but could also be presented in some of the formats advocated above, where appropriate.

Within practice-based courses there is usually an amount of skills devel-opment to be done, and this will be contingent on the nature of the student cohort and the focus of the course or the kinds of work they are likely to want to undertake. Consequently, skills development in my own case is usually presented through initial snapshots and introductions to particular materi-als or options, followed by more detailed sessions on specific techniques or technologies.

As with all courses within higher education, these should be underpinned by aims and Intended Learning Outcomes (ILOs) against which a student can better understand what the course will entail and how they will be assessed.

The ones below are adapted from my own course on audiovisual composition, currently being taught at the University of Glasgow, and may provide a reasonable starting point for the formulation of course-specific aims and ILOs.

Course aims

The overall aim of this course is to develop students' understanding and practical skills in audiovisual composition. In particular the course aims to:

- Examine, interrogate and conceptualise relationships between sound and image
- Explore the creative potential of audiovisual materials
- Consider audiovisual composition as an experimental and transperceptual practice
- Develop students' technical skills and critical perspectives in composing and experiencing audiovisual works

Intended learning outcomes of course

By the end of this course students will be able to:

- Realise an audiovisual composition, performance or installation through a process of design and experimentation
- Deploy appropriate technical means to capture or generate sound and visual materials
- Deploy appropriate means to integrate sound and visual materials
- Apply critical evaluation and aesthetic judgement across both the audio and visual domains
- Identify and relate key features in their work to relevant concepts, theories or other practice in the field

Where possible, the courses below should take place alongside an ongoing weekly or bi-weekly student-led discussion or practical group at which issues relating to the subject matter are addressed or where they are able to discuss the course as it progresses. Students can suggest particular readings to do or creative works to explore, and can decide whether or not they want to invite the tutor along, on a week-by-week basis if appropriate.

Tutors may also want to consider the use of minute-paper feedback on a weekly basis, both to check learning and to take advantage of real-time feedback on the course to make small adjustments, week-to-week.

Audiovisual composition – a practice-based five-week plan

Mode of assessment: audiovisual work of a length/duration/type decided by the tutor, accompanied by a piece of critical writing.

Week	In class	Outside of class
1	Initial presentation and discussions of what the term audiovisual composition *means* and what it might refer to. Overview and discussion of different forms of audiovisual composition and some introduction to relevant histories and aesthetics	Exploring audiovisual work and identifying an example to bring in for next week. Some preliminary reading and exploring/analysing video documentation examples. First audiovisual walk – individual
2	Sharing of student examples and interrogating responses. Beginning to work on project proposals, individually and collectively	Beginning to construct critical and practical contexts surrounding project work – indicative reading and watching/listening, informed through discussions with tutor. Preparing ideas for initial show-and-tell. Individual audiovisual exercises as appropriate
3	Skills development 1 – snapshots and introduction to possible tools. Initial show-and-tell session	Further aspects of skills development – focused on project specifics. Further strengthening of contextual research. Second audiovisual walk – small group
4	Skills development 2 – more in-depth exploration of one or two specific tools	Preparing for second show-and-tell, both key discussion points and questions to be answered. Individual audiovisual exercises as appropriate
5	Show-and-tell 2 – preparing for assignment submission.	Finalising project work in preparation for submission. Third audiovisual walk – larger group.

Audiovisual composition – a practice-based ten-week plan

Modes of assessment:

Summative assessment – audiovisual work of a length/duration/type decided by the tutor, accompanied by a piece of critical writing.

Formative assessment through research project presentation in week 8

Week	In class	Outside of class
1	Initial presentation and discussions of what the term audiovisual composition *means* and what it might refer to. Overview and discussion of different forms of audiovisual composition and some introduction to relevant histories and aesthetics	Exploring audiovisual work and identifying an example to bring in for next week. Some preliminary reading and exploring/analysing video documentation examples. First audiovisual walk – individual

(Continued)

Week	In class	Outside of class
2	Sharing of student examples and interrogating responses. Beginning to work on project proposals, individually and collectively – discussing proposals in pairs and trios and discussing initial ideas.	Beginning to construct critical and practical contexts surrounding project work – indicative reading and watching/listening, informed through discussions with tutor. Preparing ideas for initial show-and-tell. Individual audiovisual exercises as appropriate
3	Beginning to develop individual audiovisual compositional languages – small group, short exercises in combining sound and image.	Initial planning for research project – decided on topic and area of focus and assembling/interrogating list of sources. Individual audiovisual exercises as appropriate
4	Skills development 1 – snapshots and introduction to possible tools for developing work. Initial show-and-tell session	Further aspects of skills development – focused on project specifics. Further strengthening of contextual research. Second audiovisual walk – small group
5	In-class, collaborative detailed interpretive and interrogative analysis of two contrasting works, in the form advocated in this book.	Reflective write-up of in-class audiovisual analysis and subsequent responses to the works encountered. Individual audiovisual exercises as appropriate
6	Skills development 2 – more in-depth exploration of one or two specific tools.	Preparing for second show-and-tell, both key discussion points and questions to be answered. Individual audiovisual exercises as appropriate
7	Skills development 3 – additional in-depth exploration of one or two specific tools through small group working. Third show-and-tell session	Reflection on show-and-tell and planning next steps. Completing work on research presentation. Third audiovisual walk – larger group
8	Research project presentations – these can be assembled in advance, in the form of an audiovisual essay or podcast, if students are uncomfortable in presenting live, but should be played back and fed-back on in a full-group setting.	Reflection on research presentation and on how other presentations might impact creative process. Some more detailed interrogation of areas of interest highlighted through presentation. Individual audiovisual exercises as appropriate
9	Individual and small group tutorials on project work	Preparing for final show-and-tell – considering where feedback is most needed and areas to be addressed. Individual audiovisual exercises as appropriate
10	Final, in-depth show-and-tell – preparing for assignment submission.	Finalising project work in preparation for submission. Final audiovisual walk – whole group.

Audiovisual composition – a practice-led five-week plan

Mode of assessment: research project engaging with a particular aspect of audiovisual composition, presented through extended writing or other means (audiovisual essay, podcast, presentation, series of interviews and discussions, etc.).

Week	In class	Outside of class
1	Initial presentation and discussions of what the term audiovisual composition *means* and what it might refer to. Overview and discussion of different forms of audiovisual composition and some introduction to relevant histories and aesthetics	Exploring audiovisual work and identifying an example to bring in for next week. Some preliminary reading and exploring/analysing video documentation examples – short piece of critical writing in preparation for next week. First audiovisual walk – individual
2	Sharing of student work examples and interrogating responses. Beginning to work on research project proposals, individually and collectively. Show-and-tell 1 – first sharing of critical writing	Beginning to construct critical and practical contexts surrounding research project work – indicative reading and watching/listening, informed through discussions with tutor. Individual audiovisual exercises as appropriate
3	Analytical development 1 – in-class, full-group critical interpretive analysis of existing audiovisual works, using method developed in this book (see Section 3)	Further aspects of analytical development – focused on examples specific to research focus. Further strengthening of contextual research. Second audiovisual walk – small group
4	Analytical development 2 – small group analytical exercises, similar to week 3	Preparing for second show-and-tell, both key discussion points and questions to be answered. Individual audiovisual exercises as appropriate
5	Show-and-tell 2 – sharing of longer form critical writing. Preparing for assignment submission.	Finalising research project work in preparation for submission. Third audiovisual walk – larger group.

Audiovisual composition – a practice-led ten-week plan

Mode of assessment: research project engaging with a particular aspect of audiovisual composition, presented through extended writing or other means (audiovisual essay, podcast, presentation, series of interviews and discussions, etc.).

Formative assessment through research project presentation in week 8

Week	In class	Outside of class
1	Initial presentation and discussions of what the term audiovisual composition *means* and what it might refer to. Overview and discussion of different forms of audiovisual composition and some introduction to relevant histories and aesthetics	Exploring audiovisual work and identifying an example to bring in for next week. Some preliminary reading and exploring/analysing video documentation examples – short piece of critical writing in preparation for next week. First audiovisual walk – individual
2	Sharing of student work examples and interrogating responses. Beginning to work on research project proposals, individually and collectively. Assigning topics for shared short critical writings	Beginning to construct critical and practical contexts surrounding research project work – indicative reading and watching/listening, informed through discussions with tutor. Individual audiovisual exercises as appropriate
3	Planning research presentations in small groups – deciding on theme and focus. Show–and–tell 1 – first sharing of critical writing	Beginning work on research presentations, digging into critical and contextual groundwork in specific area. Individual audiovisual exercises as appropriate
4	Analytical development 1 – in-class, full-group critical interpretive analysis of existing audiovisual works, using method developed in this book (see Section 3)	Further aspects of analytical development – focused on examples specific to research focus. Further strengthening of contextual research in preparation for second show-and-tell. Second audiovisual walk – small group
5	Show-and-tell 2 - sharing of slightly longer form critical writing based on analytical exercises	Further development of research presentation – shaping materials following feedback in show-and-tell. Individual audiovisual exercises as appropriate
6	Analytical development 2 – small group analytical exercises, similar to week 3	Preparing for third show-and-tell, both key discussion points and questions to be answered. Individual audiovisual exercises as appropriate
7	Show-and-tell 3 – sharing of collective writings based on given examples	Further aspects of analytical development – focused on examples specific to research focus. Further strengthening of contextual research. Third audiovisual walk – larger group
8	Research presentation	Reflection on research presentation and how to utilise feedback in preparing final research project. Individual audiovisual exercises as appropriate
9	Individual and small group tutorials on final research project	Preparing project for final show-and-tell. Individual audiovisual exercises as appropriate

10	Final show-and-tell session for nearly finalised research projects. Preparing for assignment submission.	Finalising research project work in preparation for submission. Final audiovisual walk – full group.

These plans are indicative only, and will of course need to be tailored to the context of the teaching, the available technology and resources, the nature and interests of the student cohort, and the broader context of both the education institution and the surrounding community. They are intended to provide potential starting points for assembling courses of this kind and of this sort of duration within a higher education context.

Some practice: ten audiovisual exercises

In my teaching, I have long been an advocate of short, succinct exercises that help to situate a student relatively quickly within the context of the field in which they are learning but also help to stimulate and challenge them to think about how they experience the world and how they experience the creative works they encounter. To this end, many of Pauline Oliveros's *Sonic Meditations* (1974) have proved fruitful in my undergraduate teaching, as have (some of!) R Murray Schaffer's 100 exercises in *A Sound Education* (1992) and many of the exercises recommended in Andrew Hughill's *The Digital Musician* (2012). To that end, I have tried here to provide a series of (not always very short) exercises for students to undertake, individually and collectively, to help them explore their responses to their audiovisual experience of the world and how they experience creative work from an audiovisual perspective. The plans above advocate doing some of these particular exercises at particular points in each course, but they can be utilised at any point as a means to challenge and strengthen a student or cohort's audiovisual thinking.

1. Sensory deprivation

Begin by sitting quietly in a space you know well, ideally with your eyes closed. Think about the space – visualise it, consider its shape, form, size, colour, lightness, darkness, texture, timbre. What is in the room? What do you know or think you know about it? Try to note its predominant features in your mind. Then open your eyes – how does the room change from what you remembered in your mind? Do you hear the space differently than you did before?

Next go for a walk whilst wearing earplugs. Try to walk through a place you're familiar with, that is usually quite full of sound, for at least three to four minutes. Then repeat this process without your earplugs in. What do

you notice? How does how you feel in the space alter? What do you notice about how you hear the space, and how you listen to it, once your earplugs have been removed?

2. Sounding shapes, patterns, colours

If you are at all self-conscious, feel free to attempt this exercise on your own.

Find a picture book, a visual art reference book or do a quick Google image search for 'coloured shapes', then select one of the images that comes up – this might be very simple coloured form or something more complex. Take one image or component of an image and – quickly – make a sound with your mouth/voice/body that you feel describes that image. Don't think too much about this as a process – just make sound. Then reflect on the sound you made – what aspect of the image were you responding to? The colour, shape, texture, form? Or the whole thing? If it was one aspect of the image, try to respond to another – if you initially thought about shape, try to sound the colour.

Repeat this process for a more complicated visual image – perhaps a pattern or a more complex two dimensional shape, or an object. Think initially about responding to it vocally, then perhaps using an instrument or some other means of making sound you have access to.

Extend further – find an image, piece of film or other visual 'thing' you respond to, either positively or negatively, then try to go out into your environment and find a sound that describes it. If possible, record the sound, and play it back with the thing. Do you notice anything about the way you perceive the visual thing when it is accompanied by that sound?

3. Seeing sounds, gestures, motifs

As with the process above, find some unfamiliar sounds – initially isolated, individual sound materials before moving on to longer, more complex forms. You might use a website such as freesound or the BBC sound archive initially, then something like Soundcloud or another repository for sound and music works such as Monoskop or ubuweb. The choice is entirely yours – don't feel restricted to choosing a particular type of sound or music.

Select an isolated or individual sound to start with. Listen to it, and intuitively draw an image that you feel describes that sound. Try not to think too much about this – just draw (and don't worry if you don't feel like you're good at drawing – this isn't about your drawing skills).

Consider the image you've drawn – why did you draw this? What aspect of the sound were you responding to? Listen again – can you respond to a different aspect of the sound? Do you draw a new image or extend or add to the existing one?

Repeat this process for a longer sound or a piece of music, or simply sit outside and listen for a certain duration and draw the sounds you hear. Then reflect on why you have drawn what you have.

4. Audiovisualising

This exercise requires some basic skills in editing and combining moving image and sound materials. If you're at all unsure how to do this, and you're not in formal education or are working with a tutor, friend or colleague you can speak to about this, then the internet can help through forums, YouTube tutorials and other open access resources. There are also a host of open source options for working with these materials if you don't have access to expensive, proprietary software. Indeed, this is also an exercise that can be done on paper/without technology if necessary (more instructions on this process will follow).

Choose some unfamiliar sonic and visual materials of around two to three minutes in length – you can use something like the Prelinger archives (https://archive.org/details/prelinger), for example, alongside materials from other online sound archives or repositories. Try to experience as little as possible of the materials before you make your choice – almost choose at random if possible.

Spend some time with both of your materials. Note the shapes, forms, colours, rhythm, timbre, gesture, motifs, rhythms, movement... within both the sonic and visual components (it may be that the visual materials you've downloaded will have their own soundtrack, and that's ok – you can work with that as another aspect of the audiovisual montage).

NB: before you begin, make sure you save original versions of each of the materials you are working with – this exercise proposes working with each in its original format three times, so you always need an original version to go back to.

Begin by working with either your sound or visual materials – construct a c. one-minute 'composition' from these materials. You might focus on a particular shape or gesture in the original materials and find ways to explore and foreground that, or you might intuitively combine certain things, and remove certain other things, to create your composition. Whatever the word 'composition' means to you – do that! There is no right or wrong way to go about this task.

Once you have this one-minute composition in place, add either sounds or moving image to it (depending on what you started with) through editing that material so that it 'fits' with what you've already composed. Again, this can be done through consciously exploring a particular aspect of the materials, in a similar way to how you composed the initial one-minute work, or can be through specifically editing the materials alongside what you already have assembled. Once again, there is no correct way to do this.

Repeat the process, beginning with the other media than that with which you began the first time – so if you began with sound initially, begin with visuals this time. Compose in one media first, then compose the second to go with what you have made.

Reflect on these two works and note similarities and differences. What were you hoping to achieve in each case, if anything? Do the works 'work'?

What might you do differently were you to attempt the process again? Are there particular sections, moments or just short ideas or gestures in the works that you feel work particularly well, or indeed, don't?

Finally try to compose with both the sound and visual images simultaneously. To do this, try to think of them not as separate media, but as layers of material that can be combined together. Try also to take a different approach to those you have taken in the first two exercises, if possible.

Reflect on all three of your pieces, individually and collectively. If you are working in a community of practice in which you feel comfortable sharing your work, then do so.

If you don't have access to the kind of technology necessary to do this exercise as advocated above, this can be done through using images or objects to develop a visual montage and then finding ways to sound that montage, then repeating the process by beginning with making sound and assembling visual materials. This will not be quite the same as the above, but should precipitate a similar kind of audiovisual thinking.

5. Audiovisual 'walking'

This is similar in process to a soundwalk, and indeed won't on the surface appear to be drastically different to your usual mode of walking or being in an environment, but an audiovisual 'walk' is about thinking about how you are moving through sound and light and how the substances and surfaces of that sound and light are being shaped and formed around you and by your being in that space.

Many of the principles of audiovisual walking are inspired by the soundwalking advocated by, amongst others, Hildegard Westerkamp, and the suggestions below draw heavily from her work in the field. However, I use the term 'walking' in inverted commas here, with the recognition that not everyone is capable of walking, and indeed for example under global circumstances in 2020 not everyone is necessarily able to leave their home due to COVID-19 restrictions or concerns for health and well-being. Consequently the term 'walking' here should be understood to mean experiencing through bodily presence, and doesn't necessarily require movement through an environment other than that which you usually inhabit.

Some ideas for audiovisual walking are discussed below:

- A slow to moderate pace will help you to focus on experiencing the audiovisual affordances of your environment in more detail and more expansively. Stop regularly, and try to retain a relaxed frame of mind. Don't think too much about the direction in which you are travelling; meander freely.
- Spend some time listening with your eyes closed, and seeing with your ears closed (as far as possible) either through using earplugs or simply covering your ears with your hands. How does this alter what you're seeing and hearing? What happens when all aspects of your sensory perception

are restored? How do you feel when your eyes or ears are closed, and how do you feel when they reopen? Spend some time in the environment with both your eyes and ears closed – how does this make you feel? What do you notice about the space you are in? What do you notice about how your other senses function? Do you feel cold/warm? What can you touch from where you are? How does it feel?

- What is the loudest sound you can hear, in the short-, medium- and long-term? What is the most striking visual shape, form, gesture or colour – close to you, in the middle distance, far away? Can you try to combine two of these things into an audiovisual whole, even if they're spatially dislocated?

- What is the quietest sound you can hear, in the short-, medium- and long-term? What are you ignoring, visually? What is taking your attention?

- Are there audiovisual shapes, forms, gestures, rhythms that seem to be-long together – either because they are coming from the same thing/object/person or because they seem to relate in some way – rhythmically, through colour, shape, form, gesture, motif, direction, space, texture?

- Make note of the audiovisual composition of the space – where are the areas of activity or of stasis? Is there an overall shape, form or structure to where you are? What are the boundaries of it?

- How might you categorise the materials you can hear and see? Are they natural, organic, urban, human? Are they polished, shiny, rough, smooth? Granular, isolated, dense, chewy?

- How do you exist as an audiovisual object within this space? How do others experience you? Are there things around you that alter how you look/sound to others and how they look/sound to you – light, shadow, colours, surfaces, lenses, enclosed spaces…?

- How are you moving? And how does your movement alter your experi-ence? Can you run? Can you get on a bike? Can you sit on a bench? Can you lie on the ground? How does each of these acts affect your sensory experience?

- How are other things moving in your environment? What's the audio-visual effect of this?

- Change your perspective on your environment – our head is usually at one particular level, so what happens when we stop, crouch, crawl, lie down. How is your audiovisual experience of one location altered through these changes in perspective? Can you move through these changes in perspective to make them more fluid?

6. Collective audiovisual walking

Repeat the process above, in a pair or small group. Walk together for a certain duration, then make a note of your experiences – come together and share and discuss these experiences. Then walk in different directions for a similar duration and repeat the discussion.

7. Shared experience

As a small group, select an audiovisual work (ideally something less than five minutes in length) and watch it together. There is no particular restriction on the 'type' of work you choose, other than that it engages both sight and sound. Whilst doing this, individually write down three words – one word that you feel describes the sound materials, another that describes the visual materials and a third that describes how the two relate to one another.

Put these words together in three locations – one for sounds, one for visuals and one for the relationships. Note the similarities and differences between the words you've used. Discuss this as a group – why did you choose these words? What do they mean to you in this context? Was there a particular aspect of each of these three things that you focused on in deciding on your word?

Watch the work again, and this time repeat the exercise but choosing from the collective set of words the one you find most appropriate for each of the categories. If you choose a different one, be prepared to discuss with the group, after the second showing, why you changed your word.

8. Shared experience II

Repeat the exercise above, this time for an experiential audiovisual work – an installation or sculptural audiovisual work. This time add two more words – one to describe the space in which the work is situated, and another to describe how your body feels in that space.

9. Shared experience III

Go to the cinema together and repeat the exercises above. This time add a final word, to describe how you experienced time during the work.

Having attempted these exercises, spend some time together reflecting on how the language you used – the terminology with which you described certain things – impacted on your experience of it.

10. Lived experience

For two weeks, keep a journal of audiovisual experience and try to make a note of every time you find an interesting/unusual/engaging combination of sound and images or audiovisual experience – either in creative artefacts or just in your experience of the world. At the end of the two weeks, reflect on the journal – are there particular things you were more apt to notice? Did how you described or documented your experience change over the course of the two-week period? Did how you attended to audiovisual experience change over the course of the two weeks?

———

Summary – teaching audiovisually

Much like the ethos of this book as a whole, this chapter has attempted to provide starting points against which to begin to develop teaching in audiovisual composition. Many of the ideas presented here are drawn from other authors' writings, and other practitioners' thinking on creative teaching for creative learning and I would heartily recommend you to explore some of these texts in more detail (the book I cite earlier, *Creative Teaching for Creative Learning in Higher Music Education* is a really rich resource in presenting effective strategies for practice-based and practice-led teaching in a higher education context, as are the wider works of both Haddon and Burnard).

There is something specific about teaching audiovisual composition that I feel is very different to much of the rest of the teaching I do, the specifics of which I find quite difficult to articulate; nonetheless, I will try to do so here. I think it stems from the fact that, throughout, I am trying to encourage students to think about two things at once – a kind of ongoing pedagogic multitasking. When I teach my undergraduate courses on sonic arts, I am clear on the context, background, history, modes, mechanisms and means with which I can present material and concepts; it feels like a very established area within which, although I can teach in interesting and innovative directions, much of the trajectory is already set. When teaching audiovisual composition there are almost limitless directions that teaching could take as the course is not about one specific disciplinary 'thing' but the practice of working with both sonic and visual media and thus could consequently apply to a hugely broad range of practices, traditions and 'things'. Whilst this is enormously freeing in many ways, and allows me to do some of my most student-centred work, there is nonetheless a sense that the field as a whole lacks a formal structure within which I can situate my pedagogical practice. As we have touched on elsewhere in this volume, this is perhaps the nature of interdisciplinary scholarship, and interdisciplinary pedagogy in general, and needs to be approached as an opportunity as opposed to a difficulty. By being open to a huge range of practices and perspectives (please forgive the slightly tortured metaphor that follows) we open up a sea of possibilities, but we are equally and necessarily set somewhat adrift on that sea so that it can be difficult to find an anchor point. By firmly rooting our own practice at the centre of our research-led teaching, and through encouraging the development of a co-researcher relationship with our students, we can find not one but numerous anchor points within the wider field of audiovisual practices, allowing the development of a pedagogy that is truly responsive, flexible and adaptable and that can exist somewhat outside of the long-standing disciplinary rigidities that might exist elsewhere.

Section 3

Analysing audiovisually

As I hope has been made abundantly clear up to this point, this text is not intended to offer universal truths – I do not believe it is possible to do so within a field of such diverse modes and meanings. The following chapters are intended, instead, to be as intersectional as possible, and to develop methods and mechanisms to account for our experience of audiovisual work that is both personal (individual) and situated (contextual). It attempts to account for the individuality of audiovisual experience, whilst developing a framework that will allow the reader to both interrogate and situate their own engagement with an audiovisual work from a range of perspectives.

We begin with a recognition – that none of us sees/hears/experiences audiovisual work in the same way. Just as we don't universally understand what the flavour of a cheeseburger is, or how we perceive the colour of the sky at midday on the summer solstice. Everything we experience through our senses is perceived, and that perception is subjective, interpretive and open to our specific, personal inflection.

This isn't as simple as acknowledging the axiom that 'we all see things differently' – we know that, and I won't sport with your intelligence by waxing overly poetic on the importance of understanding individual experience. However, recognition and understanding of the layers of prior knowledge, experience and context we each bring to encountering a work should enable us to better understand our individual responses to it, and indeed provide us with some ways to account for how we respond, and potentially how others respond, to a given stimulus.

This has always been my understanding of how I experience the world, but has come into sharp relief in the context of teaching within a higher education context. To illustrate this, I will use an example from my postgraduate course on Audiovisual Composition, which I have discussed in some detail in the previous section. One of the early sessions of the course always entails students bringing in an example of an audiovisual work they responded to strongly in some way. Students are encouraged to show the work in question and then present their responses to it – this sharing of response is done *after* showing the work, in order to avoid other members of the group developing preconceptions of the piece. Students are also encouraged to find ways to articulate their response ahead of the session, and really spend some considerable time digging in to *why* they responded as they did, rather than just

identifying their response. This is key to the following section, as much as it is to this aspect of my teaching.

It is perhaps worth pointing here to the somewhat unique nature of the student cohort for the MSc in sound design and audiovisual practice at the University of Glasgow – something which I have alluded to previously. Admittance to the programme is primarily through portfolio of work, rather than strict reliance on academic qualifications – not to say that these aren't important, but what we are mostly interested in is our students' openness to working with and exploring sound and image in experimental forms, and as a consequence we take students from diverse educational traditions, including (unsurprisingly) music and music technology, but also fine art, literature, sociology, philosophy, engineering, etc. Identification with the ethos of the programme and the willingness to push disciplinary boundaries are a really key aspect of our student body. I mention this here as it is important in understanding some of what follows.

In October 2019, a student brought in the work *Pearl Vision* by Mark Leckey. The student had responded positively to the work, and afterwards I asked him to summarise his thinking on the piece:

> It is in Leckey's words an attempt to show the qualities that he likes about himself; mainly rhythm and sensuality. The drum performs as a mirror (gaze, the self, the unobtainable image), symbol of transformation - as it turns from object to image through other dimensions. Even the materiality of the drum appears to me to be very modernist, makes me think of Ballard's book crash with the eroto-tech of chromium 'the cheek of handsome youths torn on the chromium latches of quarter lights'. All of the materials, pop references, image making is a product of someone who has been polluted by pop culture, an era of tech and gender education; which he himself says is the case.
>
> I felt our class was very much based on functionality and had missed the kind of talk that I engage in with friends who come from a fine art background. I wanted to show a video that I thought best represented its own internal world, the audiovisual relationship to me felt a lot more symbolic and not so much functional, and its exploration of perceptual aesthetics being something I've tried to reconcile with for some time (like 4k TVs that are more detailed than my own vision, which freaks me out). I wanted to show something that pushed people and prodded them a bit.

I, however, had an entirely different response, one which I can perhaps trace to a couple of particular factors – first, my gender, and second, some uncomfortable past experiences which I won't go into here. I found the portrayal of the drum problematic – the close-ups of the stick and the hole, the apparent fetishism with which the skin and sculptural form of the drum were presented, and what I perceived as the position of the female voice within the broader context of the work – appearing subservient and objectified – all left me feeling quite disconcerted and uncomfortable. I found it difficult to fully engage

with the sonic and visual materials presented in relationship to one another as materials in their own right because of the way in which they were presented and the very specific and visceral emotive response this triggered in me.

Describing Leckey's work, Alex Kitnick states the following:

> Pearl Vision focuses on a faceless performer sitting with a snare drum fit snugly between his alternately red-panted and naked legs. The drummer is no master of the instrument – he lazily taps along to the song purring through his Sony headphones – and yet the drum produces a variety of effects in addition to sound. It gives off beautiful chrome reflections; its mechanical parts open and close; at one point it becomes its own animated avatar. Indeed the brand of the drum, Pearl Vision, points to a synesthetic confusion of the senses; it is a musical instrument, but it promotes vision and a pearlescent one at that. The warped crotch shots that form the video's leitmotif, however, suggest that this object and its attendant effects, as with so many of the objects that surround us today, ultimately speak to us libidinally, in a language of sensation that over-whelms any one particular sense. The drum's myriad effects are meant to turn us on. Such stimulation, however, often takes place in a solitary space – the drummer sits alone, slowly keeping the beat.
>
> (Kitnick, 2013, para. 3)

While Francesca Gavin describes the work as follows:

> Leckey's is all about rhythm. Originally made for Channel 4, he has described it as "a kind of self-portrait in a Chrome Snare". The piece focused on a snare drum, or the digital replication of one, being hit by a faceless drummer. First in tight red pants, then naked. There is a visceral fetishistic pleasure in the reflection of the drum's metal surface, the beat of the soundtrack, the repetition of the words "Off on off on" at each time the stick hits the drum. Here the body, the machine, the medium, the action are all fused into one thing.
>
> (Gavin, 2013, para. 2)

Viewed subsequently, in light of both the student's response to the work and, later, having reviewed the artist's testimony and that of other writers and critics, my perspective altered; having, to some extent, reconciled my initial response to the work with that of others, and having a greater un-derstanding about how the work was conceived, I was able to concentrate more on the shape, colour, time and space in the work and the nature of the audiovisual relationship – noticing interesting points of correspondence and departure that had not been immediately apparent on first viewing as I struggled with my personal response. And, whilst I no longer found the work as problematic as on first viewing, I still found elements of it uncom-fortable, yet now this was in quite a different way – more detached, critical perhaps, less visceral.

This kind of transition through, or alteration of, our experience of audiovisual work – indeed, of creative artefacts more broadly – I notice happening increasingly as I spend more time working in education. As an example, all of the creative work my students submit for assignments must be accompanied by a reflective, critical commentary not only detailing their process but also the aesthetic and conceptual underpinnings of the work – the broader context and situation surrounding what they are doing. Often a work which might, on first experience, seem slightly less than convincing can take on new meaning when the broader context is understood – adding layers to my understanding of or engagement with the work and reframing the work in light of its context.

I have grappled with how to describe this altering of understanding, or altering of engagement, which can evolve gradually or can equally be quite fixed and rigid. I had initially wanted to describe these layers as *domains*, but domain feels somewhat territorial, as though there were some sense of ownership or power structure. Instead, I will refer to these various and often shifting ways of experiencing a work as 'layers of engagement' – *layers* to define the various strands, though not hierarchical, of contextual experience we bring to a work and *engagement* to describe our specific experience, without qualification or value judgement.

In this section of the book, I will explore these 'Layers of Engagement' as they relate to a number of specific examples, taken from across a broad range of modes, and in light of a close analytical reading of each of the works in question, utilising the elements of audiovisual composition and steps for engaging with audiovisual work described earlier in this volume. Throughout, this will be done with the recognition and understanding that these Layers of Engagement are (a) entirely person- and context-dependent, (b) they are by no means exhaustive and (c) in actuality they don't function as layers, as such, but as part of the nebulous meshwork of contexts and experiences that shape how we engage with audiovisual artefacts, and indeed with the world in general. These close readings are personal – they reflect my own knowledge, understanding and experience of the works presented – but they aim to offer inroads for readers of this volume to attempt their own close readings of works engaging sound and image.

The Layers of Engagement discussed here will be broadly conceived as follows, with recognition that there will be considerable intersection between them:

Experiential – concerned with how one experiences the work, including spatial factors, physical location, situation and technological mediation.

Personal contextual – may be autoethnographic; concerned with any personal, perceptual, physiological or psychological contexts that have a bearing on the interpretation or reading of a work

Critical contextual – concerned with the aesthetic, conceptual, theoretical, philosophical, phenomenological contexts surrounding the work

Intentional – concerned with the compositional, aesthetic, conceptual, po-
litical, social, narrative or other specific intentions the artist had in de-
veloping the piece discussed.

These layers of engagement will be woven into a broader analytical consid-
eration of the works in this chapter, making use of both the terminology
and steps for encountering audiovisual works suggested in Section 1 and the
elements of audiovisual composition suggested in Section 2. The process for
interrogating and analysing the works in this section will be as follows:

1: Hear/look – **Sentire** (to sense)
 Begin by intuitively experiencing and sensing the work, on almost a
 passive level, without trying to think about the work, the media, what
 they are individually, what they are together, how they were made. Just
 experience, sense, hear and look.
 This will facilitate the **Initial, intuitive response** section of each of
 the analyses below.
2: Listen/see – **Audire** (to hear, to review)
 Begin to think more critically and in detail about what you are seeing/lis-
 tening to and consider how to apply meaning. This might be specific/in-
 trinsic meaning, or might be more intuitive – how does the combination
 of sound and image construct meaning *for you*? Are there specific things
 the work is trying to say or speak to, or things it is attempting to address?
 Within this particular component of engaging with the work, we
 might begin to consider some of the **elements of audiovisual compo-
 sition** suggested in Section 2 of this volume:

Category	Individual elements	Compositional result
Shape	Shapes/gesture/motif/dynamics	Structure/form
Colour	Pitch/tone	Timbre/texture
Time	Rhythm/movement	Momentum/direction
Space	Location/place	Spaces/site

3: Think/engage – **Cogitare** (to ponder, to think)
 Consider what you know about the work, the artist, the broader con-
 texts, the way in which it might be described. What kind of work is this?
 How can this or does this contextual awareness shape how you experi-
 ence the work?
4: Understand/reflect – **Intelligere** (to understand)
 Combine these layers of perceptual experience with contextual ones;
 bring them together, ask how they relate to one another and how they
 shape one another. How does (or simply *does*) this help to codify your
 experience of and response to the work?
 Steps three and four of this process will inform the **Layers of En-
 gagement** with which each of the examples in this section is considered.

The works

Before providing the list of works that have been chosen for these analyses, it is important to define what I understand each of these forms to be. These definitions are informed by the conceptual and theoretical discussions in Section 1 of this book.

As we have seen previously, many of the forms described below might also be referred to as visual music; indeed, Maura McDonnell has described the nebulousness of the term, and the variety of ways in which it is employed, suggesting that its variable applicability can be shaped by:

- the technology employed to create the work;
- the background the artists/composers/practitioners come from, and whether it is (primarily) a music composition, filmmaking, vj-ing, visual art, computer engineering, computer programming background;
- the method(s) used for its presentation to audiences (e.g., fixed-media video and sound screening, performance of musicians and video, installation, live improvisation of visuals and music, real-time interactive rendering of images and sound...).

(McDonnell, 2010, p. 6)

It is, of course, apparent that an artist's background, the traditions they come out of or draw from, the methods, techniques and technologies utilised to create their work, and a huge range of other factors will have a bearing on how they conceive of that work. This is specifically why the term 'visual music' is avoided here, as it can refer not only to the work itself, but the ethos and conceptual/theoretical underpinnings of the work – something which will be considered specifically with regard to each individual creative artefact encounter. As has been previously stated, this volume specifically considers audiovisual composition as the act of arranging, combining and putting together sound and visual materials, and as a consequence the definitions of the forms this takes below have largely to do with concrete, observable, definable elements of their specific make-up, or definitions offered by the artist(s) that created them, as opposed to any aesthetic, conceptual or theoretical responses to the works themselves.

The six forms that will be analysed are as follows:

Fixed-media audiovisual composition:
A (usually) screen-based composition consisting of a fixed, temporal, audiovisual work, (usually) with single-channel video and stereo or multichannel audio.
Audiovisual performance:
A live performance work involving both sonic and visual components in combination.
Audiovisual installation:
An installation work, which may or may not be interactive, specifically assembled to address both sonic and visual sensory experience.

Audiovisual sculpture:
A three-dimensional audiovisual work in which the sonic and/or visual components are generated through the existence, enaction or interaction of/with sculptural forms.
Music video:
A short film combining music with filmic imagery, often (but not always) produced for promotional or commercial purposes.
Narrative form:
Any form of screen-based narrative form such as narrative film, short film, television.

Six examples have been chosen from these broad categories. On the whole, I have tried to choose works I have not previously encountered from a range of artists, both established and lesser known, and in many cases suggested by participants in the questionnaire.

The examples chosen are as follows:

Fixed-media audiovisual composition: Rebecca Ruige Xu and Cecilia Wu – *For Tashi* (2019)
Audiovisual performance: Nicole Lizee – *Hitchcock Etudes* (2010)
Audiovisual installation: Mariska de Groot – *Cinechine* (2012)
Audiovisual sculpture: Michele Spanghero – *Pebbles* (2016)
Music video: Echo Ladies – *Close to Be Close to Me* (2016)
Narrative form: Anusha Naanayakkara – *A Love Story* (2019)

I have also chosen to analyse a longer form work that straddles more than one of these forms – the rationale for this will be discussed later in this section.

Of particular difficulty in this aspect of the research is attention to the Experiential Layer of Engagement. Due to the ongoing lockdown in the UK as a response to the COVID-19 pandemic, it has not been possible to physically attend installations or performances of these works. However, this in itself engenders a different Layer of Engagement which warrants further discussion, and which will be teased out as it applies to each case study.

I would also state here that I have been attempting to make no, or very few, statements in the ensuing analysis about what I consider to be the quality or value of the works discussed here; I don't consider them to be particularly convincing or representative examples of each type of work, and all the examples were chosen ahead of my actually viewing any of them. That is not to say that I think any of them *aren't* convincing or representative examples of each type of work – only that the analysis below attempts to make no value judgements at all, and part of doing this was to choose entirely unfamiliar works ahead of engaging with them.

However, before we begin the analysis in earnest, I think it's important to address the nature of this analysis and the rationale I have for undertaking a close reading of these works in these ways.

Why analysis?

When I initially began to conceive of this book, I was quite adamant that there would be no reductive analyses of pieces of work. Perhaps because of my own (rather negative) experiences of attempting analysis of musical works during my undergraduate degree and earlier, I had always somewhat reacted against analysis as a mechanism of revealing anything meaningful about a piece of work. However, in further considering the ways in which I would like to confront audiovisual artefacts in this text, I began to realise that (a) not only do I consistently engage in, and learn a lot from, analysis or close reading of existing pieces of work in my research and teaching practice but also that (b) analysing my own works was actually a very fruitful and revealing exercise. In the application of some of the elements of audiovisual composition to my own work in Section 1, I learned a great deal about the works themselves, much of which had been intuitive during the compositional process but, on reflection, revealed some very specific, concrete things about how I approach developing audiovisual materials, specifically with regard to colour, shape and proportion.

The central questions in approaching the works above are: What is this analysis for? What does it serve? Why is it useful – fundamentally, what do we want to achieve? And I feel this can be summed up in a single word: understanding.

In using the term understanding here, I mean it with respect to uncovering our knowledge or developing a sympathetic awareness of the object being addressed. This does not mean to attempt to fully 'understand' a piece of work, but rather to attempt to come to an understanding of our own responses to it. So:

What is this analysis for? To better understand how we individually encounter audiovisual work and interrogate our responses to it.

What does it serve? Our own ends, in the development of our own practice, and potentially that of our shared community, through more detailed interrogation of our responses to audiovisual artefacts.

Why is it useful? It may not always be so, but where it is it might reveal things about works, and our responses to them, that were previously unknown. It might also encourage us to reflect on our encounters with works of art more broadly, and the contexts surrounding them.

Why do we want to do this? To extend our understanding, of the thing being analysed and of ourselves in response to it.

Consequently, this analysis is a personal pursuit. In the main, it won't refer to external analytical models at all, except in exploring the critical context surrounding the works encountered here – indeed, it may be as a consequence that analysis is not necessarily the correct term here, but it will serve to illustrate the detailed investigative and interpretive work that will be done. It will be guided by an interrogative approach to my intuitive responses to the work, further informed through the Layers of Engagement suggested above and in light of an analytical consideration of the works through the lens of the elements of audiovisual composition I propose in Section 2 of this book. I hope that the resultant analytical discussions will provide something useful – starting points for considering the practice of attempting this kind of close reading of audiovisual artefacts.

Case Study 1 – Fixed-media audiovisual work: *For Tashi* (2019), 00:07:30, Rebecca Ruige Xu and Jiayue Cecilia Wu

Composer, Recording Engineer, Voice, Music Production: Jiayue Cecilia Wu

Computer Graphics: Rebecca Ruige Xu, Sean Hongsheng Zhai

Konghou Performance: Lucina Yue

For Tashi is a 7.5 minute collaborative audiovisual work, composed in 2019 principally by Rebecca Ruige Xu and Jiayue Cecilia Wu. The work was chosen as Rebecca Ruige Xu's work was suggested by one of the questionnaire participants and I was not familiar with her output at that point. What follows is a summary of my initial and subsequent responses to the work, my understandings of its central components with respect to shape, colour, time and space and my reflections on my own Layers of Engagement with the work.

Initial, intuitive response

The work begins with cluttered, almost-cacophonous field recordings in which snippets of material became specifically identifiable or foregrounded before fading into the auditory background. The constantly shifting visual environment, which is maintained to some extent throughout (though in different forms, much like the field recordings), reflects this foregrounding and backgrounding, through shapes and forms that bubble to the surface before being folded back into the broader audiovisual texture. The result is a subtle and shifting audiovisual environment which continually draws attention in different directions through, for example, a repeated rhythmic phrase, shift in colour/hue or a recognisable snippet of material.

The pace begins to quicken a little at c. 30 seconds through an excitement of audiovisual motion, an ongoing and insistent rhythmic motif. There is the overall feeling of a gradually increasing pace and intensity through the next minute before the most significant audiovisual fracture at 01:24, suggested through a deeply visceral, scream-like sonic gesture in combination with the fragmenting of the visual environment into more granular, almost brush-stroke-like segments that retain their fluctuating underlying motion alongside more surface-level, granular disruption. This fracture leads to an elongated B section, in which both sonic and visual materials feel more heavily processed and detached from their original form in an increasingly distorted and uncomfortable way until c. 3:40, followed by a long and gradual fade in audiovisual materials.

From c. four minutes, the work moves to its second main section, marked initially through the return to the original clarity of field recordings, this time with a baby's cry and heartbeat as central sonic motifs against a more rapidly shifting, blurrier visual environment and a real departure in colour palette – from the muted greens, browns and reds of the first half to very clear, vibrant, almost arctic blues with hints of white and yellow. There is a reminiscence here of the opening of the work, but with a sense of instability and change.

From c. 05:00 there are some clear audiovisual sync points, particularly with the more painterly visual motion in combination with the Konghou, and this section proceeds through the audiovisual foregrounding of the musical material, occasionally threatened by darker gestures attempting to emerge into the palette, both sonically and visually.

The programme notes for *For Tashi* suggest the following:

> "For Tashi" attempts to depict the physical and emotional journey that a woman goes through when losing her baby prematurely, aims to share this deeply personal, largely unspoken and often overlooked experience with the public, in the hope to transfer the previously private excursion to a communal experience.
>
> (Xu and Wu, 2019, para. 1)

This will be considered in more detail later in this discussion, but this initial context is important to my first response to the work, in that I viewed the work as being in two sections – the first exploring the extraordinary pain of the initial loss (exemplified through the initial audiovisual fracture at 01:24) and the second attempting to find ways to reconcile that loss and return to some semblance of, if not normality, then at least acceptance.

Shape

Individual elements	Compositional result
Shapes/gesture/motif/dynamics	Structure/form

The work is heavily dynamic and gestural; avoiding relying extensively on direct or obvious correspondence between sonic and visual materials, there is nonetheless a very cohesive relationship between sound and image throughout the work which develops a real sense of audiovisual synergy; this is particularly apparent at the climactic moment of the first section, at 01:24, during which the swirling yet fragmentary and granular audiovisual gestures create an extremely emotive and visceral effect. Where there are clear moments of direct audiovisual correspondence, these are noticeable as individual gestures and usually provide momentum towards points of structural or formal change or departure in the work. From a structural and formal perspective, we might consider the work as follows:

	Section 1		Section 2
	A	B	C (some ref. to A)
Duration	00:00–01:24	01:24–03:59	03:59–07:30
Overall duration	4 minutes		3 minutes 30 seconds

Proportionally it is split almost directly down the centre, comprising two halves; within Section 1, however, there is a clearer sense of two distinct sections, differentiated by the fracture point at 01:24, but Section 2 is a longer meditation and exploration of the shapes and gestures comprising that section.

Colour

Individual elements	Compositional result
Pitch/tone	Timbre/texture

The audiovisual components of pitch and tone are heavily foregrounded through, though in quite diverse ways. The Konghou glissandi and tremolos towards the end of Section 2 for example, in combination with the more painterly motion in the shifting visual materials, create specific and direct/synchronous reflections between pitch and tone, while the shifting colour palette in Section 1 against the more cacophonous field recordings creates more intuitive pitch/tone relationships.

The texture and timbre of the work are similarly shifting, with audiovisual undulation something of a recurring theme. The clarity of the visual environment and the layers and forms therein are often directly correlated to the clarity/legibility of the auditory material, as for example in the opening section where snippets of sound material emerge from the background noise; yet this is not always the case; Section 2 begins with a very legible baby's cry and heartbeat with what might be vinyl static or rain drops on a percussive surface against the emerging Konghou melody; yet here the visual environment is initially more diffuse, feeling more like a series of shifting points of light through a hazy or opaque surface than the more concrete (if not necessarily representational) visual forms from both earlier and later in the work. Whilst one might expect this to correspond with more heavily processed or filtered sound materials, their relative clarity against this less discernible visual environment poses questions for the audience about the nature of the audiovisual relationship at this point. One might best describe the textural and timbral audiovisual materials as in a state of dense clarity, spatial without being excessively spacious, in which certain components are discernible, legible or recognisable; yet the persisting audiovisual ambiguity allows for personal interpretation.

Time

Individual elements	Compositional result
Rhythm/movement	Momentum/direction

Once again, the audiovisual relationships involving rhythm and movement are cohesive without continuously being directly corollary or synchronous, though there are moments where this is particularly apparent, many of which have already been touched upon. Both the sonic and visual materials have a continuous sense of movement through space; as I described the texture as having dense clarity here, I might describe the temporal aspects of the work as being in a continual state of static fluctuation, as many of the focal points are both relatively fixed and central – such as the continually shifting yet visually coherent visual environment or the Konghou melody in Section 2 – whilst also maintaining their own sense of rhythm and direction within that of the overall work.

The formal and structural basis of the work, described above, speaks also to how momentum is maintained, and direction is shaped in the work. Section 1 builds towards the fracture at 01:24, with onward direction maintained from this point until the close of this section, but momentum is slightly forestalled as the audiovisual materials have a feeling of folding in upon themselves as the section progresses. Section 2, by contrast, has more of a feeling on an on-going exploration or meditation, in which forward momentum is providing primarily by the subtly shifting visual environment in combination with the melodic material provided by the Konghou. Other rhythmic and percussive gestures are briefly foregrounded, before folding back into the audiovisual environment.

Space

Individual elements	Compositional result
Location/place	Spaces/site

Though not necessarily recognisable as specific locations to the audience, the field recordings utilised suggest a range of specific places and the spatial nature of those locations within those recordings is evoked. Visually, the work feels as though it explores a range of visual places, though it is perhaps a single place viewed from a range of perspectives; certainly, the visual environment as presented at both the beginning and end of the work feels fundamentally the same, though our perspective on them and the ways things operate within them seem to have shifted slightly. During Section 1B, the audiovisual fracture disrupts and breaks down the audiovisual space as we have been presented it to this point, creating a chaotic and confrontational audiovisual space that persists, though gradually reducing in intensity, until the beginning of Section 2.

The audiovisual spaces presented in the work through the combination of materials feel both deeply personal and intimate, yet also draw from a range of (if not specifically) recognisable sources and evoke a range of cultural contexts through the use of specific recordings, vocal fragments and instruments.

The resonance of the spaces and sites evoked through the work are likely to be experienced differently by each audience member; yet the clarity of the central, extremely painful, site of experience at the heart of the work is likely to be widely legible, if not specifically recognisable.

Layers of engagement

Experiential layer

As highlighted above, due to COVID-19 restrictions I have had to experience this work at home, rather than in a concert, gallery, festival or other public arts setting as one might usually encounter this kind of work. Consequently, one of the experiential layers of the work is fundamentally different to how it might typically be – viewing these works at home is simply not the same, in a range of ways, to seeing them in the context of an art event or in an unfamiliar physical location. However, within these constraints, I have tried to experience the work in a range of ways, to see how each might shape the experience of the work and whether this informs my response to the piece.

Specifically, I have experienced the work in my home studio on a 21" screen with 2.1 audio, on the same screen with monitoring headphones, on a 65" television screen with monitors and matched sub and on a mobile phone with wireless earbuds.

There is enormous complexity within the audiovisual materials in the work that are only fully discernible when played back in the highest fidelity possible. The work was visually most effective on the 65" 4K television screen, therefore, though also effective on the 21" HD screen in my studio as I was positioned significantly more closely to the screen than when viewing on television so was more able to discern specific visual detail. Although the sound materials worked well on the monitor speakers in both my studio and in combination with the television, I felt that the work itself was best listened to on headphones; there is an intimacy to the sound materials – which is perhaps indicative of the nature of the subject matter – that I feel is best experienced through headphone listening. The audiovisual fracture at 01:24, though always emotive and somewhat visceral, is deeply affecting when experienced through high quality headphones and when one is able to really dig into the visual detail of that moment. Indeed, I would say that even through wireless earbuds, the intimacy this affords rendered it very effective; the effect the earbuds I used had was to somewhat amplify the upper frequency content of the sound materials, which was particularly noticeable during the audiovisual fracture, and when viewed on a phone screen the colours were strangely altered, with the greens in this section rendered particularly vibrant and almost lurid. Each of the technological/experiential renderings of the work afforded a different perspective on its audiovisual materials and relationships, and it was interesting to see how this was manifest.

Personal contextual layer

Having worked within audiovisual practices for over a decade, the network of experiences, expectations and preconceptions I have when approaching an initial viewing of a work of this kind is significant; it is difficult, therefore, to know in any real detail how I would have experienced this work for the first time without any of this background in place. Indeed, much as I try to remain detached and objective when experiencing a new work, this becomes increasingly difficult through the familiarity afforded by subsequent viewings, and I inevitably find myself thinking more directly about the specific details of what I am hearing/seeing, as opposed to their effects within the work, and, very often, about the technical and technological processes inherent in realising the work. This is difficult to get around – which is why I have attempted an initial, intuitive reading of the work ahead of the more interrogative, detailed close reading of individual components above.

There are a lot of cultural references and resonances in the work, specifically within the sound materials, that I am unable to fully appreciate, more specifically, that I can in many ways only really experience from the perspective of an outsider. I am familiar with the Konghou through my formal musical education, but it is not part of the musical traditions I was surrounded by during my formative years or subsequently so holds no great cultural or emotive resonance for me. There are snippets of speech and language in the work, but to my shame – my language skills being somewhat dismal (thank you English schooling in the 1980s and 1990s) – I am unable to translate them. There are sounds that are familiar but not necessarily legible – I hear what I think might be a busy outdoor space such as a market, but the specifics of that space are unknown. The percussive chiming sounds that appear throughout, almost as a sound mark, are familiar, but I wouldn't want to definitively pin them down to belonging to a specific 'thing'. For me, this sonic familiarity without, necessarily, legibility works extremely well with the visual materials in the work; the undulating, fluctuating visual environments suggest shapes and forms that are familiar if not completely specific, and there is an audiovisual resonance afforded by this which may be specific to my own experience of the work.

As already stated, *For Tashi* is about the physical and emotional journey a woman goes through during the premature loss of a baby. Having experienced a very early miscarriage myself, there are layers of emotive resonance here that are specific to myself and, likely, a small cross section of the work's audience. The pain of this experience is one that is very difficult to express through language; yet I found that *For Tashi*, though not necessarily fully representative of my own experience, was nonetheless highly evocative and, particularly during my first viewing of the work, I was very deeply affected by it emotionally. Had I not known about this particular facet of the work before I may have responded differently; however, I will say that my response

felt entirely visceral and natural, and I believe that the work would have pro-
voked an emotive response even had I not known its specific subtext.

Critical contextual layer

There are a range of potential critical, contextual considerations that might
be relevant to this work – indeed, almost infinite if one was minded to inter-
pret both the work and the theoretical constructs in a specific way. For the
sake of brevity, we will concentrate here on those most directly relevant to
fixed-media audiovisual composition or visual music, as defined in Section
1 of this volume.

It is interesting to note that Rebecca Xu specifically mentions visual music
in the artist statement on her website, so it might be fruitful here to refer back
to Ox and Keefer's definitions and designations of types of visual music as a
starting point. Within their definitions, perhaps the most apparently closely
related to this work would be "A visualization of music which is the transla-
tion of a specific musical composition (or sound) into a visual language, with
the original syntax being emulated in the new visual rendition" (Ox and
Keefer, 2006, para. 4); without further investigation it is not entirely clear
whether this is the case yet intuitively, this would seem to be the most closely
related definition to the processes and methods of *For Tashi*.

To explore visual music further, we might also revisit McDonnell's exten-
sive doctoral thesis to consider how the term might best apply in this context
and, indeed, how this collaboration might be situated within the broader
context of collaborative work designated as visual music within the current
practice. Interestingly, much of the discussion I had with the artists about this
work was concerned with ideas around visual music, and as such this will be
explored in more detail in the intentional layer below.

There are also broad contextual concerns related to the genesis of the
sonic and visual components, as these have been contributed by collaborating
artists in this case. On the visual side, this might be particularly related to
human-computer interaction, algorithmic processes and the structuring of
the visual environment. Xu, in her artist's statement, describes exploring "the
impact of artistic intention and influence on the final outcome, while trying
to find the balance between artistic intervention and the computer program's
autonomy as well as the randomness and predictability contributing to each
particular project" (Xu, 2020, para. 4). She goes on to describe her artistic
influences as follows: "Visually, my creative practice is influenced by min-
imalism and traditional oriental artwork. To both, balance and contrast of
color, space, texture, as well as light are essential means to improve visual
aesthetics" (Xu, 2020, para. 6). Certainly, the visual palette is very suggestive
of an interest in minimalism and correspondences between sonic and visual
colour, as outlined above, are both convincing and intriguing throughout
the work. Similarly, Wu cites an interest in contemplative culture through

her research and a developing project in Embodied Sonic Mediation, both of which seem to speak to the communicative elements of this work and its ability to communicate a specific message to its audience. The sonic palette assembled in the work has resonances in electronic and electroacoustic composition and sound design, as well as the composer's cultural heritage and use of traditional instruments, all embodying a slightly different critical, contextual component to the work which might warrant further exploration.

This is to barely scratch the surface of the possible contextual considerations of a work of this type, and these will also be inextricably linked to the Personal Contextual Layer; my existing knowledge of the contexts described here is, for example, entirely different to that of my immediate family, so the ways in which I bring them to bear – or the fact that I do at all – are likely to have an impact on my engagement with the work.

Intentional layer

The programme notes for the work provide us with some insight into the intention behind this work; however I was also fortunate enough to be able to have a lengthy discussion with both Rebecca Ruige Xu and Cecilia Wu to explore some of the processes and means of collaboration involved in realising the piece.

I was gratified that both of the artists felt that my analysis represented quite an accurate reflection of their intentions in putting the piece together and that a lot of the textural, temporal and structural features I had teased out in my analysis reflected aspects of their approach and some of the central concerns underpinning the work. There were some points of departure – for example, whereas I had described the work structurally as being in two main sections (with the first subdivided into two), the artists had conceived of the work as being in three distinct sections, though our ideas about the main structural points of departure were very closely related.

I was particularly interested in how the two described their process of collaboration, and that the work had undergone several different revised forms before the finished version I had seen – particularly the ending, which Xu had conceived quite differently to Wu before ultimately conceding that this final version ended in the best way. It was interesting to note that the piece went through numerous iterations before coming to this finished form, and it was also interesting to note that this is the first collaborative work between these two artists, who obviously work well together but are at the early stages of this collaborative relationship. Indeed, the way Xu and Wu describe their initial ideas to work together – through shared interest developed as a result of seeing each other at various conferences – suggests quite an intuitive and organic beginning to their process, and this is reflected in how Xu talks about Wu's vision in developing the work and how natural it was for her to adapt to this vision.

Wu herself describes her compositional process as being heavily intuitive and improvisational as opposed to tightly controlled or structured, which I think is apparent in the work as it evolves in a fluid and organic way that is reflected very directly in the visual material. This may well be because, as she herself describes, Xu sees colours and forms when listening to music (though describes herself as not having full synaesthesia) and so had a relatively clear idea of the visual representation of this work with each subsequent iteration she received. As alluded to above, we also discussed ideas relating to visual music when exploring the work, and Xu was keen to point to her own understanding of the term and why she used it – that within visual music, music and visual material play together, without needing to respond to each other directly, but that they can fill each other's space. Crucially, Xu discusses the notion that music and visuals combined create something that is 'bigger than each individual component', reflecting the notion of audiovisual synergy and the perceptual experience of sound and image combined as being greater than the sum of its parts. Certainly, the idea of composing audiovisually as being as transperceptual act advocated earlier in the volume finds resonance in this collaboration, as both artists seem to be very closely attuned to the component of the audiovisual work for which they don't have direct responsibility, and their own approach to developing material for the piece seems to take this into account.

We also spent some time talking about my responses to the work, and whether the features I had identified and explored are universally recognisable or are more likely to be identified because of the background I bring to the work, much of which I described above. Related to this, we discussed the 'ideal' viewing context for the work, and the notion of it being potentially more powerful as a shared experience than an isolated, individual one. Certainly, my own emotive connection to the work, alongside the knowledge of what the work is about, will have significantly informed my response to it, but having also played the work to a number of my students it is clear that the central, visceral crisis point of the work is experienced very emotively by a large percentage of viewers yet often interpreted in different ways (many students discussed its being representative of either the death of a loved or another form of deep emotional trauma, before they were made aware of the thematic context of the work).

The additional context the discussion with these two artists added to my understanding of the work certainly enhanced my experience of it as an artefact and my relationship to and engagement with it – particularly the more detailed knowledge of the processes involved in developing the work and the way in which the two artists worked together. As an audiovisual composer, whose work – of all those engaged with in this book – is perhaps most closely related to this piece, it was interesting to see the points of both coherence and departure between my own working method and those developed between these two artists.

Case Study 2 – Audiovisual installation: *Cinechine*
(2012–ongoing), Mariska de Groot

Cinechine is a site-specific audiovisual installation by Mariska de Groot, which began in 2012 and has been rendered in a range of diverse spaces between then and now. On her website, de Groot describes *Cinechine* as follows:

> Objects that remind of a disassembled movie machine are positioned in the room.
>
> Beams of light shoot through rotating disks, projecting a composition of dynamic black and white, hard edged forms that find a direct antecedent in the experiments with sound on film carried out by the Russian avant-garde in the late 1920s.
>
> The changing light frequencies are picked up by light sensitive speakers and transformed into sound.
>
> Soon it is clear that the tones you hear are one and the same with the light that you see. All light is potential sound.
>
> The transdisciplinary composition of 'CineChine' treats elements of cinematography from the viewpoint of the projector. The perspective of time&rhythm and light&sound are based on projection, shutter speed and rhythm of the machine.
>
> For every exhibition a new location specific composition is made.
>
> (De Groot, 2020, para. 1)

For this analysis, I will consider the three documented versions of the work available on de Groot's website – the first taken from an installation at Film-huis den Haag (03:05) (described henceforth as Doc1), the second at Fort Ruigenhoek (03:05, Doc2) and the final version at De Hoge Rielen (16:18, Doc3). These documented forms of the work all offer a unique perspective on the installation and each subsequent, site-specific configuration, and will be considered both in isolation and in relation to one another and to the work as a whole.

Initial, intuitive response

Fundamentally, *Cinechine* consists of a series of rotating, apparently metallic discs, reminiscent of forms involved in film projection apparatus, through which beams of light are shone in dimly lit or dark spaces. These light/disc combinations, and the patterns of light and shadow they create, are synthesized into sound through light-sensitive speakers, creating a direct link between light and sound. For clarity in the ensuing discussion, I will describe these light-and-sound constructions here as 'audiovisual objects' (later, during our discussion, de Groot described them as 'instruments'). The position of the audiovisual objects, in relationship to each other and within the spaces they address, alters in each site-specific rendering or recomposition of the work.

Doc1 contains perhaps the most direct document of a likely audience experience of the work, with (apparently) fewer editing and design choices made about the structuring of the materials within the document; rather, the work seems to unfold more as one might expect in a visit to the work in situ (though of course in fixed, on-screen format) and one is aware of other installation goers in the document as one would be in an actual experience of the work.

Within this document, initially the central audiovisual materials are foregrounded primarily through one audiovisual object in what appears to be the 'primary' position in the room. This has the feeling of being the focal point, with other audiovisual objects arranged in support of this central protagonist. This is potentially due to the way the Doc1 is framed, as there is certainly an initial concentration on this central object, and as the document progresses, we become increasingly aware of other objects addressing other walls in the space, initially through a gradual fade in of another audiovisual object on the left wall of the space. From 01:15 onwards, there is a more gestural introduction of other objects, in sequence, which creates an evolving perspective on the spaces being presented and reduces the legibility of the objects, the space and the position of the observer within them. From 02:00 onwards, there is a perspective shift, as we become aware of other installation goers in the space; initially only in shadowy form, complementing the audiovisual materials created by the audiovisual objects, these figures become increasingly concrete as the document progresses, and one almost begins to consider more how they are responding to the work than how the work itself is unfolding. Interestingly, this is the only one of the three documents discussed that features the installation audience to any great extent, with the remaining two focusing primarily on the work itself and its behaviour within space; Doc3 features some audience members, but these are usually from a distance or from behind, and facial features in particular, unlike in Doc1, are difficult to decipher.

By contrast, Doc2 is both a very different form of documentation and a very different site-specific rendering of the work. Here, the audience is left with a number of unanswered questions about the nature of the space in which the work is presented, and indeed how the work is presented within that space. There are hints at smaller, more rounded, individual rooms, corridors and unusual architectural environments; yet there is limited legibility over both the spaces themselves, our position as observer within them and the position of the audiovisual objects within these unfamiliar and unusual spaces. Indeed, whilst it becomes clear at times what kind of space, or whereabouts in a space, an audiovisual object is presented – as an example, we see an audiovisual object clearly projecting into the corner of what appears to be a vaulted corridor ceiling at 00:16, after an initial, shadowy descent down the stairs – many of the spaces remain difficult to decipher throughout. Interestingly, though, while the spaces are difficult to decipher it is clear in this document that much of the contents of the space have been retained –

objects in rooms or on walls are projected onto or through, as part of the site-specific rendering, as opposed to being removed from view, altering the nature of the shapes and forms in the work and how we experience them. Indeed, Doc2 has perhaps the clearest feeling of being a *composed* document, with obvious design choices in how the materials are captured, edited and presented, and a more gestural and fragmentary audiovisual perspective on the work being addressed which will be discussed in more detail under the categories below.

Doc3 is the longest form document, and of the three works feels like the most complete rendering of *Cinechine* as a lived, linear experience. The full 16 minutes of the document can stand alone as a fixed audiovisual work, feeling the most like a complete 'piece' as opposed to a document of an installation experience. Whilst Doc1 captures a brief excursion into the work, and Doc2 affords a more composed perspective on the installation within a unique architectural space, Doc3 offers a really detailed exploration of the shapes, forms and structures developed in the work and perhaps provides the clearest picture of the work as a whole, as opposed to a document of it in a particular, site-specific environment. One of the most remarkable things about this particular document of the work is the interplay between light and shadow, specifically as this is enacted on the speakers on the floor as viewed from an elevated perspective; the way in which they appear to move in and out of light and shade creates the perception of their being layers of film, gradually cross-faded into one another both sonically and visually, even though the objects are never in fact becoming less concrete. This will be discussed in more detail below.

Shape

Individual elements	Compositional result
Shapes/gesture/motif/dynamics	Structure/form

Doc1 initially foregrounds the shapes and form of the primary audiovisual object, and indeed it is here that we see one of the clearest close-up perspectives on an individual audiovisual object in any of the three documents. The physical apparatus consists of a rotating object, composed of a series of concentric circles through which light is projected; these circles each appear to have a unique patternation, and indeed each version of this apparatus appears to feature variations on these patterns, with each of the concentric circles appearing to be capable of both moving with and independently from the rest of the circles in the array, though it is not always clear whether this is actually occurring or whether this is an illusory, stroboscopic (wagon wheel) effect. What is interesting about the initial presentation of this audiovisual object is that, although we are conscious of its being primarily circular in form, and indeed the sounds it synthesizes feeling timbrally similar, the visual

projection of this shape onto the central wall in the space is somewhat 'boxed off', by virtue of the shape of the space in which it is presented. Whilst the circles spin freely within their apparatus, the effect of that circular construction within the space is both circular and rectangular because of the nature of the projection, giving the impression of its almost being presented on-screen or in cinema form. The shadowy shapes of the speakers through which the sonic component of the work is both triggered and projected also bleed into the visual projection, reflecting the direct, causal nature of the audiovisual object both sonically and visually.

For the first minute of Doc1, this initial audiovisual object is the primary focus of the work, before we move to a more close-up perspective on both this and other objects in the space. Here, the elongated motifs in each of the objects gradually transition into more fragmentary gestures, as individual rhythmic stabs are passed from one audiovisual object to the next in space. This more gestural, dynamic section, a contrast to the more elongated first section, continues for around a minute, before all objects perform together and seem to gradually begin to unwind/slow down in unison, heralding the end of this section. Here, we become conscious of the presence of physical beings in the space alongside the audiovisual objects, and as the installation audience explores the shapes and forms within the work, so their shapes and forms become part of the visual document. Once again, this final section is roughly a minute in length, with all of the audiovisual objects playing together and against one another, developing beating relationships in both the light and sound materials.

Doc2, like Doc1, begins with a black screen and a gradual fade in of sonic materials, but here the parallel ends, with the high frequency sound materials, gradually increasing in pitch, against the descent down dark, shadowy stairs initially feeling more reminiscent of a horror film than a document of an audiovisual installation. Here, preoccupation with shape is manifest differently; though it is clear we are dealing with the same audiovisual objects as in Doc1, their rendering within this space is entirely different, as is the perspective offered on it. For the first c.45 seconds of this document, we are offered only hints of the audiovisuals object in situ, usually at a distance or from a moving perspective as opposed to be able to fully see or hear how they exist in space. At c.45 seconds, we are able to discern one of the objects and its subsequent audiovisual projection, but this is quickly disrupted in a series of semi-glitchy jump cuts and edits that consistently shift our perspective on the work. Indeed, this is a document in which POV is constantly shifting, with very few static shots or the opportunity to really figure out how shapes and gestures in the work are manifest in this space. One such opportunity is at c. two minutes, where we are able to see one of the audiovisual objects being projected up into the corner of a vaulted room; what is clear in this document is that the behaviours of the audiovisual objects have been shaped and formed directly by the space itself, as opposed to merely being projected within in. The visual, and I imagine acoustic (if in situ), consequences of this

are very intriguing, offering a warping and distortion of the sonic and visual forms that render them simultaneously both familiar and entirely different.

Doc3, in contrast to the first two, allows the viewer to really engage with the audiovisual objects and the shapes and structures they develop in detail, through presenting what feels like a long form, linear experience of the work 'in full' (I am unsure at this point whether this is 'in full', if indeed there is an 'in full' for this work, but it certainly feels like a more complete experience than that offered by Doc1 and Doc2). Interestingly, this version of the work had the audiovisual objects suspended from the ceiling and projecting onto speakers on the floor, which are clustered together in such a way as to be affected by more than one of the visual apparatuses at once. Consequently, the individual audiovisual shapes and forms, and the ways in which they interact with one another, are most visible and easily discernible in this version of the work.

One of the most interesting elements of the shapes and forms, and indeed movement of this work in this documented form (which will be discussed later), is that the visual apparatus of the work is suspended from the ceiling, as opposed to being freestanding as in the two previous documents. Consequently, as the apparatus spins it causes the objects to move on their individual, suspended arms, causing the circular forms to appear to both pulse and spin simultaneously, which creates corresponding pulsing sounds in the audio component of the work.

Structurally, this document has the clearest sense of form, as opposed to being split into equal sized sections, as in Doc1, or the more individual, gestural and fractured components in Doc2. The structure of Doc3 might be defined as follows, though these sections fluidly bleed into one another as opposed to being rigidly separated:

Section	1	2	3a	3b	3c	4
Timing	00:00–02:16	02:16–c.04:40	04:40–c.06:45	06:45–08:50	08:50–11:20	11:20–end
Total duration	02:16	02:24		06:40		05:00

Section 1 is an exploration of elongated form, involving most of the audiovisual objects. Section 2 offers a more detailed, close-up perspective on a single object for an extended duration, again exploring more elongated gesture with the continuous rise in speed and pitch in this section. Section 3 I have defined as existing in three parts; this whole section is more dynamic and gestural, affording fragments and snippets of activity from the audiovisual objects as opposed to the more continuous motifs in Section 2; it has been split into these three component parts as a broad reflection of the overall peaks and troughs in this section of the work. The final section develops a more rhythmic or fragmented exploration of the audiovisual objects, which will be explored more directly in the discussion of time below.

From the perspective of shape, this document allows us to most directly engage with the individual shapes comprising each of the audiovisual objects, both through the point of view (POV)/point of audition (POA) offered and the clarity and duration with which each of the objects is presented. In Section 2, as defined above, one of the audiovisual objects is foregrounded, almost to the point of feeling like a spotlight in the darkened space. As this document progresses, in Section 4 we're able to see and hear other constituent parts in each audiovisual object – there is a particular object composed of repeated lines and rectangles in its concentric circles, creating a fragmented, square-wave-like sound through its pattern of light and shadow. It is clear in this document the extent to which visual and sonic shapes are linked and, indeed, one and the same.

Colour

Individual elements	Compositional result
Pitch/tone	Timbre/texture

Colour and shape are inextricably linked in all documents of this work, and indeed in the construction of the work as a whole because of its physical components, perhaps more so than any of the others in this series of analyses. The individual visual shapes and forms developed through the audiovisual objects, alongside the speed at which the discs spin, fully define the pitch and tone of the sound materials, creating a fully audiovisual experience of shape and colour. In terms of actual colours in the work, because of the use of bright, white light in dark spaces the colour palette is composed of the continuum between black and white; this continuum creates some intriguing effects on the texture of the work within these documented forms. As an example, as discussed previously Doc3 presents quite a large amount of its material from an elevated position, looking down on the speakers from the ceiling, or near to the ceiling, of the space. The effects the overlapping and differently lit visual objects have, from this perspective, are to cause the concrete objects on the floor to appear to fade in and out, as though they were layers of film as opposed to the actual material object in space. The effect appears to alter the actual material texture of the room, alongside the timbre of the auditory spaces defined by the interaction of these layers of diffuse light on the speaker constructions in the work.

Time

Individual elements	Compositional result
Rhythm/movement	Momentum/direction

Time is considered and expressed – or perhaps presented and represented – differently in each of these documents, so they warrant some amount of individual discussion.

Doc1 is broadly split into three equal sections, which are experienced as being of equal length; there is nothing specific about how the materials are presented that develop a particular rhythm or momentum to the presentation of the work. Indeed, as previously discussed, this one feels most like a brief document of the work as opposed to a composed/intervention in the materials.

Doc2 is more rhythmically considered, presenting sections of materials that are almost pulsate – including the section from c. 01:35 – alongside other sections that offer a more slow-paced progression through the audiovisual space (the opening c.30 seconds is one such section).

Doc3, in presenting the most complete picture of a composed form of the work, has the clearest sense of rhythm and composed time. There appear to be defined sections to the work, suggested in my own formulation above, each of which presents a different rhythmic exploration of the audiovisual objects, and the juxtaposition of these sections with one another, and the contrasts this creates precipitate a sense of ongoing development, momentum and direction.

Space

Individual elements	Compositional result
Location/place	Spaces/site

Each of the documents presents a different, site-specific rendering of the work and, as de Groot acknowledges, each version is a new, site-specific composition, responding to the physical space of the installation. Consequently, there are some detailed and complex issues relating to space in this work, as developed in each subsequent document; and indeed, each document explores that space differently.

Doc1 and Doc3 provide quite an open and relatively legible perspective on the physical space of the work; it is relatively clear to see the detail of the space, or imagine what that space might appear like when fully lit or experienced in person. Doc2, by contrast, provides a continuously shifting perspective on the physical space of the installation, one which is often ambiguous in terms of viewer legibility of the space – as an audience member, I feel it would be difficult for me to suggest how this space is configured when fully lit.

Nonetheless, each of these documents presents a unique perspective on how the audiovisual objects comprising the work perform and act within the spaces in which they are present, and how they respond to each site-specific composition. Whilst it is not possible to be physically present in the spaces

explored and presented in these works, the documents here present some idea of what the spatial experience of these works might be.

With regard to POV and POA within these documents of the work, POV in each case is rarely static – even at points in Doc3 where perspective is largely similar for some duration, being largely from an elevated position in the space at a level with the spinning discs, the camera is in motion most of the time, moving amongst and between the audiovisual objects. By contrast, POA is relatively static throughout, as it is in the majority of the other documents of the work, and presents little suggestion of the broader sounds of the spatial environment present in this installation. I would be interested to discuss with the artist how the sound materials had been captured, and what the decision process behind present them as they have been actually was.

Finally, with regard to the broader contextual evocation of space, particularly in Doc3, much of the audiovisual material presented, particularly the low frequency, pulsating textures, were reminiscent (for me at least!) of the sound design in the opening scene of Ridley Scott's alien, in which we hear layers of distant, mechanical, rhythmically repetitive sounds on each subsequent deck of the ship as we move through it. This would perhaps be best considered under the personal contextual layer of engagement below, or indeed perhaps suggests the presence of an evocative layer in the reading of the work, but because of the importance of space in Ridley Scott's work and how this is depicted sonically, this felt like the appropriate location for its discussion.

Layers of engagement

Experiential layer

As with *For Tashi*, and indeed for all of the works in this analytical section, it has not been possible to attend an installation of this piece, which in the case of an installation of this kind is a real shame. Indeed it would not have been possible to have attended any of the installations that are examined in these documents in any case, as they all occurred in the past and are unlikely to be replicated in these specific forms.

For a work of this kind, being unable to engage with the experiential layer of the work in situ is a real limiting factor. For each of these documents, a specific architectural space is addressed, and it is clear that the work has been reconsidered and reimagined in each to accommodate, or rather, work with the specifics of the architectural spaces in each subsequent installation. Whilst it is possible to imagine some semblance of what, visually, these environments might have been like (though this is, of course, rather limited), acoustically a great deal is lost with regard to how the sounds of these audiovisual objects would behave in each of these subsequent spatial contexts. As an example, the vaulted ceilings and enclosed hallways and corridors of the fort provide

acoustically unique environments, and as sound within these environments is experienced in 360 degrees, without ambisonic field recordings of the works in space or the means to play them back, it is difficult to fully appreciate the audiovisual experience of this work. Indeed, beyond audiovisual perception, each of these unique spaces would provide additional sensory layers of engagement that cannot be replicated at home; an architectural space is not just experienced audiovisually, but also through taste, touch, smell – the fort, for example, I imagine would have a particular smell to it, the air in it would move in a particular way, be a particular temperature, you could move your fingers over the brickwork in the corridors and it would feel a particular way. Each of these sensory experiences might add another layer to the experience of the work which cannot be replicated here, and this is a shame. Nonetheless, each of the documents here is presented in quite an evocative way, even if slightly differently in turn, and as a consequence the audience is invited to think carefully about how their experience might have been mediated in that particular, site-specific rendering of the work.

In mediating my own experience of the work, I have again tried to watch each of these documents in a variety of different technological realisations in order to interrogate my experience of and perspective on the works. Once again, the visual material was best served by the highest resolution equipment possible, particularly when dealing with the really complex motion apparent in each of the concentric circles, though there was also something to be said about watching the work on my aged tablet, which seemed to struggle with some of the motion and had almost an aliasing effect on the circular patterns which felt complementary to the stroboscopic motion. From a listening perspective, I found listening to the work both on speakers and at a distance felt most appropriate in attempting to, in some part, replicate the lived experience of the work with a physical space or, at least, to try to do so. The perceived spaciousness that distance from the monitor speakers provided led to the feeling of being enveloped by the materials of the work and being able, in some form, to move through it, as one would be able to in installation form. This is also a work for which complete darkness in the room when viewing is definitely preferable (this can be difficult to achieve when so far north in the middle of a UK summer, when it is only dark for about four hours a night!).

Personal contextual layer

Once again, this work was chosen as although de Groot's name is one I have heard before I was not hugely familiar with her work prior to conducting this analysis and have not yet (sadly) had the opportunity to experience one of her pieces in installation format. Consequently, I felt that I was able to approach the work with limited preconceptions and a fresh pair of ears and eyes.

Much of the discussion regarding this layer of engagement might also fit within the consideration of the critical contextual layer; however, as the

critical context being discussed here is my own, I felt it most appropriate to situate this within the personal contextual layer.

Within de Groot's work I found, although our processes and outcomes are somewhat different in manifestation (and, indeed, Mariska's are significantly more impressive!) there was significant overlap and resonance between her approach to developing this work as a site-specific installation and my own ideas about working with Expanded Audiovisual Format (EAF) installations, specifically those related to the development of site-specific and site-adaptive works. In my recent book chapter for *Sound/Image: Aesthetics and Practices* (2020), I explore two of my works, Alocas and Visaurihelix, which I describe as being site-adaptive and site-specific, respectively. In this discussion, the term site-specific is reserved for works which are designed, and can only really function, within a specific space – which may be a physical, architectural space but may also have social, cultural or other contextual site-specificity. Site-adaptive works, in my own practice, are defined by being realised with an ideal space in mind (in my own work, this is often an imagined space as opposed to a real one) but are adaptable, and open to being adaptable and to the consequences of that adaptation, to a range of architectural spaces and renderings therein.

It is also worth here considering the definition of EAF works offered in this book chapter:

> Works for Expanded Audiovisual Format (EAF) are those that seek to explore the possibilities of expanded exhibition formats from both a sonic and visual perspective simultaneously. These might include, but are not limited to, multiscreen, fulldome or projection mapping in combination with multichannel, multidirectional or ambisonic sound. Expanded Audiovisual Format works might also involve site-specific reconfiguration of both sonic and visual materials based on available exhibition spaces, or the design of an expanded audiovisual work for a specific architectural space.
>
> (Harris, 2020, p. 282)

From my perspective, *Cinechine* is a site-adaptive, expanded audiovisual installation; I will not describe it as an expanded audiovisual *format* installation, as it is not the format that is expanded as such. Indeed, my definition speaks mostly to screen-based works as opposed to works which are realised through specifically constructed physical means, and one of the aspects of reflecting on this work might be that the conception of expanded works I offer is potentially a little narrow. I would describe the work as expanded as from this audience member's perspective it is concerned, in both intention and reception, with an expanding of the audiovisual space through, in this case, a site-adaptive reconsideration and recomposition of the work in each subsequent architectural environment. De Groot's work is one of the most successful and intriguing examples of site-adaptive installation work I have

seen to date, despite having not experienced it in person; the complete re-configuration of the work in each subsequent setting and the perspectives this reconfiguration offers are highly effective.

Critical contextual layer

Perhaps one of the clearest critical contexts surrounding this work (though I would be interested to discuss this further with the artist) is those that address the nature of audiovisual experience within the context of sound and light installations. Here, Adam Basanta's article on an application of and extension to both Chion's concept of synchresis and Coulter's notions of media pairing to works he describes as *Luminosonic* – referring to "light- and sound-emitting objects" (Basanta, 2012) – might be particularly instructive here. Basanta proposes a framework that specifically addresses the following, which appears to be a relatively apt description of de Groot's work:

> I will limit my analytical enquiry to light and sound media installation works utilizing physical objects that appear to emit both light and sound. A luminosonic object is in this regard an audiovisual object in which — by virtue of the localized production of sound and light — the two media are perceived as integrated, composite material. That is, sound and light are always in direct relation to one another, mutually constituting our perceptual understanding of the luminosonic object. In this sense, my object of analysis is neither light nor sound as separate media, but rather the compositional dynamics between the two, as well as the manner by which this dynamic affects our understanding of the luminosonic object.
>
> (Basanta, 2012, para. 4)

Going on to further categorise and define audiovisual relationships within a specifically constructed analytical framework, Basanta adds a third axis to the horizontal and vertical constructions of audiovisual harmonicity and audiovisual temporal relations proposed by Chion through the addition of a third axis – perceptual bond. Basanta proposes positioning each example in his discussion spatially within this three dimensional axis, with specific designations for typologies positioned within that space. Within this analytical framework, we might position de Groot's work as inhabiting the close intersection between a/v unison, unison and cross-modal pairing to define the work as being physically isomorphic, in which "shared formal features result from the physical coupling of media. In other words, the symmetry in audiovisual relations is a product of the underlying physical system that simultaneously produces both media" (ibid, para. 24). Basanta cites artificiel's *condemned_bulbes* (2002), Nam June Paik's *Exposition of Music-Electronic Television* (1963) and Robin Fox's *Laser Show* (2007) as other examples of physically isomorphic works.

One question that arises here, though, in applying this broader critical framework is how does this classification help us to understand the work

being analysed here. It's apparent that the work consists of audiovisual objects – what Basanta would describe as Luminosonic objects – in which sound and image are generated simultaneously by the action of the apparatus of the work; sound and image are perceptually linked as they are materially and medially linked. Yet what does this really tell us about the work? It cannot describe the way in which the work is recomposed for each subsequent setting, for example, or how it interacts with the architectural spaces in which it is installed. Categorising the work in this way doesn't really inform us about the content or context of the work any further than defining it as being audiovisual. This is not to render this kind of categorisation as redundant, but more to suggest that analytical categorisations of this type reveal only one, very specific thing about the work at hand, which needs to be understood within a broader reading of the work as a spatial, experiential and situated audiovisual construct. This will be considered in more detail through subsequent reflections on the analytical process in general, and in conversation with the artist, below.

Intentional layer

There is relatively limited discussion of this work available alongside the documentation, other than that which has already been cited. Consequently, this layer is largely informed through discussions with the artist herself, and my subsequent reflections on that discussion.

de Groot and I spoke at length about the work. This was very revealing, and in many ways, quite surprising. First, de Groot felt that I hadn't really talked about the work in my analysis, but rather about the documentation; this was, to some extent, inevitable as these were the only mechanisms by which I was able to engage with the work itself. She did talk about each of the documents I engaged with in similar terms to those explored above, specifically that Doc2 was a more conscious artistic intervention with the materials, while Doc3 represented a more complete 'composition' with the instruments. However, what became apparent through the discussion was that de Groot had expected me to talk more about the context surrounding the work, and indeed the conversation suggested that she had expected me to engage with notions of Expanded Cinema in more detail, as she considered the work to sit within that field.

This is intriguing, as I hadn't really related the work to Expanded Cinema in my own thinking about it, I suspect largely because it doesn't involve film, as such; instead, through working with specific physical objects it evokes shapes, forms, sounds and the apparatus of cinema without directly referencing the on-screen. de Groot herself talks about wanting to inhabit the mechanical means of cinema, and that this work is a manifestation of that desire and this is clear to see, but it would be useful here to perhaps explore some more contemporary notions of expanded cinema and how these might relate to *Cinechine*.

Discussion of expanded cinema usually begins with Gene Youngblood, and in this case we begin with the following from the preface to Expanded Cinema:

> When we say expanded cinema we actually mean expanded consciousness. Expanded cinema does not mean computer films, video phosphors, atomic light, or spherical projections. Expanded cinema isn't a movie at all: like if it's a process of becoming, man's ongoing historical drive to manifest his consciousness outside of his mind, in front of his eyes.
>
> (Youngblood, 1970, p. 41)

Certainly, it is very possible to consider *Cinechine* as a mechanism by which de Groot manifests her consciousness, specifically her desire to inhabit the mechanical processes of cinema, in front of her eyes. Further, following Youngblood we could argue that *Cinechine* creates "an emotionally real experience through the use of audiovisual technology" (ibid., p. 348).

Adeena Mey's exploration, and attempted definition, of Expanded Cinema in The Audiovisual Breakthrough evokes Jonathan Walley's (revived from Ken Jacobs) notion of paracinema as being

> an array of phenomena that are considered "cinematic" but that are not embodied in the materials of film as traditionally defined. That is, the film works... recognize cinematic properties outside the standard film apparatus, and therefore reject the medium-specific premise of most essentialist theory and practice that the art form defined by the specific medium of film. Instead, paracinema is based on a different version of essentialism, which locates cinema's essence elsewhere.
>
> (Walley, 2005, p. 18)

We might consider de Groot's work as embodying this notion of cinema, directly relating to and reflecting the cinematic without being bound within the filmic medium, locating its essence in – in this case – specifically built audiovisual instruments.

Here, it would be possible to disappear down a post-medium, or post-media-specific rabbit hole, as Walley himself then evokes Rosalind Krauss in suggesting that "For centuries it was only within and against the tradition encoded by a medium that innovation could be measured, just as it was in relation to its reservoir of meanings that new ranges of feeling could be tested" (Krauss, 1997, p. 5). Krauss herself, in this essay on the work of James Coleman, goes on to remark that

> inventing a medium is like inventing a language, since it is the business of a medium not only to have something like a grammar, a syntax and a rhetoric, but a way of deciding what counts as competence in its use. Not only does this parallel suggest the extreme difficulty involved in such an invention, but it also means that questions we might ask about such a language would apply a fortiori to a medium, just one of which

might be: would it be logically possible for someone to "speak" a language if her or she only eve uttered a single sentence in it?

(ibid, p. 6)

Might we position de Groot's work as a form of post-media cinema – paracinema as Walley would have it – through locating its cinematic essence in this particular manifestation? Equally, might we consider the media through which de Groot locates this essence as being a new medium – a new language – through which this essence is explored? Krauss's notion of the invention of a medium being akin to the invention of a language are key here if we explore de Groot's work further, specifically the use of these audiovisual instruments outside of *Cinechine*; her performance exploration of the technology through *Stirred Mandala*, for example, provides a strikingly different utterance in the language she has developed in mediating her work.

It might be useful here to refer to Pavle Levi's discussion of Vuco and Matic's work, *The Frenzied Marble*, in which the essence of cinema is realised through static, sculptural work comprising wood, metal, paper and other materials. As Levi remarks

> Crucial, here, is, of course, the fact that a discrepancy clearly manifests itself between the medium as a concept (as a nexus of different elements, understood and/or imagined as capable of generating specific effects), and the medium as an actual apparatus (as concrete technology embodying this nexus of relations).

(Levi, 2010, p. 27)

While within Levi's conceptualisation *The Frenzied Marble* remains a "forever inappropriate version of the cinematograph: it just is not capable of offering its viewers an actual flow of moving images" (ibid, p. 27) despite its ability to create film-like effects when considered through the framework of cinema, the temporal manifestation of de Groot work allows for a complete realisation of medium as both concept and actual apparatus.

Mey ultimately offers little in the way of a concrete definition of expanded cinema, instead suggesting that

> poetism might appear as a useful concept to think about expanded cinema as an expanded form of poetry, complicating the genealogies of the spectrum of audiovisual practices we are discussing. In fact, expanded cinema seems to suggest that categories are dynamic and that the dynamics of art practices themselves always create new relationships between ideas and materialities, creating the necessity for the critic or the historian to find other means.

(Mey, 2015, p. 61)

Certainly, this categorical dynamism is reflected in this book as a whole, and in micro-form in my discussion of *Cinechine* with de Groot; whilst I initially approached the work through one specific critical contextual lens, the artist

herself experienced it as something other and the attempt at reconciling these two approaches has necessitated the finding of other means of interpretation.

The process of encountering, and reencountering, this work is an important lesson in analysis and interpretation, and indeed on the value of discussion of intention with artists. Prior to discussing this work with de Groot I felt that this analysis was one of the most complete and compelling in this book, representing a really detailed and in-depth interrogation of these various forms of documentation and how they were manifest. Whilst I still feel this is the case – from my own engagement with the work at least – de Groot's response to my analysis raised questions about the value of approaching work in this way and the potential for either misinterpretation or misapprehension of intention. Whilst engaging with the work in the way I did informed *my* understanding of *my* response to it, it was through discussion with the artist that my engagement was fleshed out into a more complete picture of the work as a whole, the processes inherent in it and the contexts surrounding it. This perhaps argues for the importance of this kind of discussion and conversation with artists where possible, alongside detailed personal interrogation of a given piece of work, that each has an important role to play in situating our understanding within the broader picture of the work as a whole.

Case Study 3 – Audiovisual sculpture: *Pebbles* (2016-ongoing, permanent sculptural installation), Michele Spanghero

Pebbles is a site-specific audiovisual work, permanently installed in the former moat of the castle at San Vito al Tagliamento in the Provence of Pordenone, Italy.

Michel Spanghero describes *Pebbles* as follows:

> Pebbles is designed for San Vito's Castle (where it's permanently installed) and inspired by the water that no longer flows in the moat, but that has filled the riverbed with pebbles of the Tagliamento River.
>
> A group of rusty metal hemispheres of different sizes, surface from the moat's bed among the pebbles. The mimetic installation reveals its musical nature only when people interact with it: like bells, the metal pebbles give a unique voice to the moat of San Vito's Castle and may be used as musical instruments to play abstract melodies.
>
> (Spanghero, 2020, para. 1)

As *Pebbles* is a permanent, interactive sculptural work, this analysis will primarily consider the document of the work as presented on the artist's website. As an interactive work in permanent situ, always visual but only sonic when 'played' by the audience, this work presents a particular challenge from an analytical perspective, specifically relating to its temporal boundaries; whereas the three documented versions of *Cinechine* presented specific, temporal renderings of the work in specific spaces, *Pebbles* is always in its specific space and location, yet not always 'active' as an audiovisual installation.

Initial, intuitive response

One of the most interesting aspects of the work as presented in this documented form is that those interacting with the work have chosen to do so using the existing pebbles in the moat; the artist has obviously made the decision not to provide beaters or other apparatus with which to interact with the chiming bowls, and as a consequence visitors to the work are encouraged to really move down to the level of the objects and physically investigate them in order to create sound and engage with the shapes and forms in the work. This also speaks to the nature of the installation as a permanent and ongoing fixture in its physical location, whereas inserting additional apparatus such as beaters might slightly disrupt this.

The audiovisual forms present in this document are shaped not only by the objects themselves and their position in the moat but also by the figures interacting with the work and how they behave within the space. Interestingly, the audiovisual outcomes of this document of the work, I felt, had almost a religious or devotional connotation, creating the sense that the participants in the installation were almost in the role of worshippers

or devotees within the audiovisual space. In saying this, I should point out that I recognise that there is nothing specifically religious or spiritual about this document or the way it is presented, nor indeed (apparently) in the work itself as presented on the artist's website. However, the intermittent chiming of the hemispheric bowls feels almost reminiscent of church bells or chimes within a church environment, and the fact that those interacting with the work are constantly moving up and down from a crouched position further suggests a devotional aspect to the work. The medieval setting of the moat of the castle perhaps further shapes this experience and renders this meaning, and I have no doubt this would not be experienced universally.

As this is a permanent, interactive work, it exists quite differently to other examples in this chapter; it is both constantly there, not temporally bound as other pieces are – either to a particular site or duration of installation, or playback on a screen – and is only fully released through participation and interaction. There are numerous physical and other factors that will have an impact on its ongoing appearance and continuation, including the rusting and other degrading of the bowls, the position and erosion of the pebbles, the weather and the way in which participants interact with the work – piling pebbles under the bowls, for example, would prevent them from chiming. Consequently, it is a work in which the artist relinquishes a great deal of control, from the point of installation onwards, and this is a theme I would like to discuss with the artist in more detail.

Shape

Individual elements	Compositional result
Shapes/gesture/motif/dynamics	Structure/form

Shape within this document has been touched on to some extent above. The primary audiovisual shapes in the work are the series of hemispherical chiming bowls, arranged within the pebbles of the former moat of the castle of San Vito – these are complementary in shape to the pebbles but distinct in colour, because of the materials from which they are created, and appear almost like large mushrooms emerging from the floor of the moat. The dome-shaped protrusions produce sound according to the manner with which they are interacted, but more often than not, in this document at least, they are struck in isolation as opposed to in rhythmic pattern. The structure and form of the work, in this document at least, are a single, ongoing exploration of the piece in situ – much as the permanent installation of the work is an ongoing manifestation of its audiovisual outcome.

Colour

Individual elements	Compositional result
Pitch/tone	Timbre/texture

Each of the bowls has a specific pitch, and they sound as though they have been tuned to a particular scale, though again this is something that I would like to discuss in more detail with the artist. The way in which these pitches and tones ring out in the space is shaped by the pebbles within the moat, the shape and depth of the moat itself and the participants within the moat. One other key aspect of the audiovisual colour of the work is the sound of footsteps on the pebbles – a very specific, texture sound which when juxtaposed against the clear, often elongated tones of the bowls being struck provides an intriguing textural contrast. The bowls each have a particular timbral quality, reminiscent of hand-hammered Indonesian prayer bowls, and these shape the quality of the sound within the space and is complemented by the orange/brown patternation in the metal of each hemisphere.

Time

Individual elements	Compositional result
Rhythm/movement	Momentum/direction

I have touched on movement a little above, and it is indeed interesting how the rhythm with which installation participant interact with the objects in this work to some extent dictates their movement, which can be quite static or mediatory, but can equally be quite gestural and dynamic. The momentum and direction of the work would be shaped by individual experiences and interactions within the space, but the document encountered here suggested an initial reticence in encountering the objects, followed by an increased confidence and willingness to experiment.

Space

Individual elements	Compositional result
Location/place	Spaces/site

This is a site-specific installation, which is related to the physical location in which the installation is placed but also the social and cultural context of the

castle and the village as a whole. For residents of the village, there are layers of meaning here – a cultural and contextual site-specificity – associated with the building, the most and its history, which might not be apparent to an unfamiliar visitor. Nonetheless, to an external viewer, the medieval visual landscape against which these audiovisual objects are set seems to have a specific, implied cultural resonance and location, even if the specifics of that resonance are more imagined than concrete.

Layers of engagement

Experiential layer

Once again, it has not been possible to visit the work in situ due to COVID-19 travel restrictions – though I very much hope I would be able to visit this site once these restrictions are lifted and review my analysis in light of having actually experienced the work.

With respect to technological mediation, as with previous works in this section I attempted to experience the work through a range of playback media, both sonically and visually. Interestingly, though, in this case I found little difference in my responses to the work in each case – whilst it is always nice to be able to see and hear things clearly, the emotive and affective response of the work in each subsequent viewing was little shaped by the technology with which each viewing was mediated. Indeed, I found instead that, in each case, I focused on the actions of the participants and the audiovisual results of this as opposed to noting specific things about the sonic and visual materials of the work.

Personal contextual layer

I have a great love for Italy as a country – it is one of my favourite places – and a personal, developed interest in medieval history including within an Italian context, so the physical environment here is one that, though not specifically familiar, is resonant with a number of my likes, interests and preoccupations. This could account for my seeing the nature of the motion of the participants in the document of this work as reminiscent of devotional kneeling or somewhat related to religious worship. I have also personally encountered and visited very large numbers of site-specific installations, none specifically like this but enough to understand the usual modes of engagement with works of this kind. This will impact on my understanding of the work in this context and the action of the participants in the documentation within this framework.

As previously discussed, much of my own practice specifically considers notions of site as they relate to audiovisual installation work; this was explored in the analysis of de Groot's *Cinechine*, and I have previously described examples of my own work as both site-specific and site-adaptive

in how they address the spaces in which they are exhibited and the way in which they resonate with the sites in which they are situated. The work I have done in exploring these ideas through my own practice impacts on the way in which I view the documentation of this work and the way I might classify the work itself. This is, of course, a site-specific installation being permanently located in a specific place – indeed, it could be approached similarly to Richard Serra's idea that "To move the work is to destroy the work" (Serra, 1994, para. 2). Yet the layers of site-specificity here are somewhat opaque – the work has been added to the moat, and it is interacted with in that context; yet theoretically the hemispherical domes could be removed and placed in a similar, related context without fundamentally altering the work itself. These are ideas I will explore with the artist in more detail.

Critical contextual layer

There are a range of critical contextual considerations potentially relevant to this work, either concerned specifically with site-specific installation works in a sonic art or audiovisual context, or with the conceptual history of site-specific art in general.

One potentially valuable point of reference for this work is Nick Kaye's (2013) consideration of site-specific art through the related and complementary lenses of performance, place and documentation. In this volume, through a series of specific analyses and contributed chapters, site-specific art is considered and analysed across the thematic areas of space, materials, site and frames.

Perhaps most useful for this specific analysis of this specific work, as it has been done not through participation or interaction in the specific work but through exploration of the document of that work, is a consideration of Kaye's ideas on documentation, specifically the nature of a document of a work of this kind. As Kaye notes

> documentation, in declaring itself to be always other to the events and objects it recalls, finds a direct affinity with the tactics and processes underpinning site-specific practice… it is to this end that site-specific art so persistently works against its own final or definitive location, as, through this wide variety of forms and strategies, it speculates toward the performance of its places.
>
> (Kaye, 2013, p. 220)

In this specific case (again, this is something to be discussed in more detail with the artist) the document of the work (to this audience member at least) feels entirely 'other' to what a likely experience of the work itself might be, yet also resonant with the artistic strategies underpinning the construction of the work itself. By positioning the document in this way – attempting to capture one short interaction with the work in situ –

the artist is offering a brief, illusory snapshot of the potential of the work which speaks neither to the actual work or the actual experience of that work, yet also speaks to the conceptual and artistic concerns underpinning the work itself, particularly with regard to the relinquishing of control and the lack of ultimate agency the artist has over how the work will be encountered. It might be useful to recall Auslander here, on the performativity of documentation; Auslander contends that:

> [T]he act of documenting an event as a performance is what constitutes it as such. Documentation does not simply generate image/statements that describe an autonomous performance and state that it occurred: it produces an event as a performance and, as Frazer Ward suggests, the performer as "artist."
>
> (Auslander, 2006, p. 5)

This document does not present a 'performance' as such; yet there is a sense of this documentation providing a performed *version* of the work, or what an interaction with that work might look like, designating the actors within this context as artists (interestingly and circuitously, in this case, I believe the artist is indeed one of the performers within the document).

It is interesting to note within Kaye's book the separation of thematic elements into spaces, materials, site and frames. In this current volume, spaces and site are considered as part of the same fundamental element of audiovisual composition – Space; yet in Kaye's book these are treated as different thematic areas. It might be useful to briefly explore both of these in the context of Spanghero's work and my existing analysis of it.

For Kaye, concerns relating to spaces begin with the consideration of site-specificity within sculptural minimalism. Indeed, he notes:

> site-specificity is linked to the incursion of 'surrounding' space, 'literal' space or 'real' space into the viewer's experience of the artwork. In posing questions of the location or 'place' of the object, minimalism's interventions into the gallery engaged with the different orders of space in which the sculptural work is defined, undermining conventional oppositions between the virtual space of the artwork and the 'real spaces' of its contexts. Indeed, this address to interrelated orders of space, in which the viewer's privileged position as reader 'outside' the work is challenged, has played a key part not only in minimalism's site-specificity, but in the addresses to site and the performance of place in visual art, architecture and site-specific theatre. In this context, minimalism's exploration of the viewer's engagement with site in the 'White Cube' gallery (O'Docherty, 1986) provides a key point of departure from which to elaborate a range of site-specific interventions into the gallery, the city, and other 'found' sites, which, although operating through a variety of disciplines and means, each take their effect *in performance*.
>
> (Kaye, 2013, p. 25)

In my analysis of this work, numerous of these interrelated orders of space are addressed, as are notions of performance, though by virtue of my being only able to experience the work through documentation, these spaces and performances therein are manifest differently than they would be were I able to participate in the installation itself. The spaces articulated in the documentation of the world I know to be 'literal' or 'real'; yet as I have not engaged with them physically, they remain somewhat illusory and my perspective as the reader is still that of being 'outside', though not from the privileged, gallery-goer perspective outlined above. All of the spaces articulated in the documentation of the work – and, as we have seen, this documentation of a *performance* of the work – are intangible, despite to some extent presenting one aspect of a physical location and the behaviour of the performers and the work within that location. Perhaps more resonant to this specific experience of the work, in considering notions of *Site* Kaye describes that:

> Where minimalism's site-specificity is held within the gallery, the approaches to specific sites which emerged in its wake around land art, earth art, and conceptual art frequently played on the gallery as a vantage point from which the viewer might look out toward designated, mapped locations. Typically incorporating a mapping or documentation of places and events, these practices reflected upon and revised the impulse of earlier environmental art, happening performance, and Fluxus presentations, among others, to test the limits and discourses of the work of art by directing attention toward conventionally 'non-art' occurrences, locations, and acts... Reading the site in terms of its absences, and so focusing upon the elusiveness of the actual or 'real' site, this work articulated its specificity to site through means quite different from minimalism's engagement with 'the present tense of space' (Morris 1993c). In doing so, these strategies clarify relationships between the work and its site operating through a wide range of site-specific practices.
>
> (Kaye, 2013, p. 91)

Here, the elusiveness of the 'real' site is manifest in this documentation, through presenting a digital vantage point through which one might view the imagined ideal or 'real' site of the work. The location is designated and mapped by this documentation, but not experienced physically; indeed, as this work is available online in this format through the artist's website, it is in fact likely that the vast majority of audience members actually engaging with the work will do so in this format, rather than in its intended and permanent physical home. This raises interesting questions about the nature of the site-specificity of this work, and indeed about other works in this chapter; it has a specific, physical and permanent rendering that embodies its 'ideal' space and 'literal' site-specificity; yet the largest percentage of engagement with the work is likely to be through documentation, presenting

a site-specific rendering that is 'other' to the real or literal spaces presented by the work.

Intentional layer

I was fortunate enough to be able to discuss the work in detail with the artist, Michele Spanghero. Spanghero filled in a large number of contextual gaps in my knowledge of the work, and was also able to share with me some additional documentation of the work being engaged with in different contexts to those presented on his website, which was very illuminating.

Spanghero was interested in my identification of potentially religious or spiritual connotations in the work, specifically in the version I had engaged with in assembling this analysis. Whilst he agreed that this was apparent in the documentation, he positioned this as more meditative than spiritual, particularly as the hemispheres are reminiscent of Tibetan singing bowls.

What was most striking about our conversation, however, was the granularity of the site-specificity inherent in this work which goes far beyond what I described above. The complex meshwork of contexts, circumstances and situations that impacted on the final realisation of the work is extraordinarily nebulous and speaks to a level of site-specificity that steps far beyond physical, architectural or cultural considerations.

First, the work was initially being conceived during the centenary of the First World War, and Spanghero describes the area surrounding San Vito and his hometown as being somewhat permanently scarred by the battles that took place in that region during the war. Indeed, he discusses the impact the finding of a large unexploded bomb in a nearby field had on the original conception of the piece, and that although not specifically conceived as a memorial work, some of the spiritual or mediative connotations of *Pebbles* are reflective of his feelings about the conflict.

The nature of the prize that mediated the work also had a great deal of impact on the final manifestation of the piece – the prize is adjudicated largely by public visitors to a gallery space in the town, who vote on the works they would most like to see realised in the festival.

Spanghero also described a range of limitations on the work, some of which were self-imposed but many of which were inherent in the site occupied by the work, both architecturally and culturally. As this was a public sound work that should stand in perpetuity, it was important for Spanghero that there be no technological component to the work as this would require ongoing calibration, updating or repair. Interestingly though, the work is interacted with to such an extent in the town that Spanghero has already had to repair it once. It was also important to the artist that the work make sound only through the voluntary actions of the public and not as a result of natural processes such as an aeolian harp. Additionally, the moat in which the work is installed is surrounded by houses and businesses, so Spanghero

didn't want to make a work that would be too intrusive or disturbing, and the historic centre of the town is protected by the superintendent of cultural and historical heritage, so it would not have been possible to have made any interventions into historical structures such as walls. Consequently, the piece had to be self-contained within the moat. Finally, access to the moat is quite limited in size, so only small objects could easily be transported to the site.

It was fascinating to learn more about the context surrounding the work and how this impacted on the outcome of the piece – in this case, rather than in a work made entirely in ones studio for online exhibition, for example, the specific demands of the site and the local cultural context of the work completely shaped the direction in which the work was able to unfold and as a consequence it is as much a product of the site-specific contexts of its creation as it is a product of the artist.

Case Study 4 – Audiovisual performance: *Hitchcock Etudes* (2010), Nicole Lizee

Initial, intuitive response

Hitchcock Etudes (2010) is a 20-minute live performance work for 'piano, glitch and film', composed by Nicole Lizee. The work features an audiovisual reconsideration of the Hitchcock films *Psycho, The Man Who Knew Too Much, Rope* and *The Birds*. For the purposes of this analysis, I have explored both the full-length realisation by Megumi Masaki, and the 16-minute realisation by Zubin Kanga, which omits two of the etudes. I have done this as, while the Masaki version does not feature a visible performer, the Kanga version does and I would like to spend a little time considering the difference in the audiovisual experience between these two renderings.

The work itself begins with a fragmented reconsideration of the opening titles of psycho; indeed, it becomes immediately apparent why Lizee describes this work as being for 'piano, glitch and film' as the glitchy nature of the handling of the material is obvious from the outset. The way in which the film will be utilised to explore, elaborate on or reframe audiovisual gestures from the original footage is immediately apparent, as Saul Bass's opening titles are wound and rewound, fragmented and repositioned, both sonically and visually, to suggest a fragmented waveform heralding the beginning of the work and, indeed, the arrival of the piano.

The first etude addresses some of the earlier sections in *Psycho*, specifically focusing on and foregrounding Janet Leigh's face as she drives through the rain towards the Bates Motel. This gesture itself is heavily foregrounded in the Hitchcock original, but is given a new slant here through the repeated exploration of Leigh's face moving incrementally back and forth, proceeded by the slightly detuned original soundtrack against the tuned piano accompaniment. Indeed, the windscreen wipers moving back and forth, again an important audiovisual gesture in the Hitchcock original, seem to conduct the musical material in this etude and drive it forward (particularly at c. 01:29).

The sudden intrusion of a full colour Doris Day sat at the piano (in the beginning of our exploration of *The Man Who Knew Too Much*) is quite jarring, not only because of the change in colour palette from the stark black and white of *Psycho* but also because we are suddenly confronted with vocal material and indeed, for the first time, sound that spatially appears to be part of the on-screen world as opposed to the musical accompaniment. This exploration of Day's vocal utterances continues, takes on a peculiarly intimate first-person perspective – this is particularly apparent in the section with James Stewart at the church service, in which we feel almost part of her exposed and vulnerable psyche; this is highlighted further through the washing out and overexposure of the colour palette in certain sections. However, juxtaposed against the occasional reoccurrence of Janet Leigh's face, this feels

almost like it's part of a dream sequence, particularly as we return to the Bates Motel (and Norman Bates's speech patterns in particular) in the next section.

Vocal material having been restricted to fragments of Doris Day's singing up to this point, the sudden inclusion of complete words, almost to the point of complete sentences, in the next section is another quite dramatic point of departure. Here begins an exploration of and rhapsody in Bates's speech patterns, initially in isolation before gradually being joined by and significantly elaborated on by the piano – the fragmentary and stuttered nature of the way he speaks becoming increasingly apparent as the piano plays motifs to accompany his words. This section begins to breakdown into itself as the materials are layered and blurred into one another, and the juxtaposition of Bates's mother over the final looped statement of the scene, with the light and shadow moving in time with the loops, heralds the next film for consideration.

Rope is introduced initially through a close-up exploration of hands, which is also an important thematic area in the original film. Once again, we are suddenly jarred back into colour, though here the palette is quite muted and the close-up of Bates's mother occasionally intrudes as a reminder of the ever-present undercurrent of death, which is particularly resonant to this film. The piano here, as we saw with Doris Day's performance earlier in the work, takes on a peculiar dual aspect, begin part of both the fragmentary on-screen action and the external commentary on that action. The relationship between the two becomes increasingly difficult to unpick, particularly without being able to see the pianists performing the work, and this ambiguity over who is playing what is very intriguing in this section. The section moves to an almost glitchy electronica-type exploration of the musical material, which is an interesting contrast to the setting on screen, and the inclusion of and focus on the metronome and close-up of the protagonists at the piano almost give the feeling of our having briefly crossed over into a music video before being dragged back to the Hitchcock world through a sudden shift to the Bodega Bay School and the beginning of the exploration of *The Birds*.

This section was, for me, the most disturbing of all – potentially because of how genuinely terrified I was of *The Birds* when I first watched the film as a relatively young child (more on this later!). The complete recording of the children singing against the looped and reversed footage of their being conducted in class (which remains in time with the singing) feels quite horrifying, and an unsettling precursor to the horrors that are coming later in the film (as indeed this relatively tranquil scene is in the original film). This gradually transitions into an audiovisual exploration of the final two words of the song, looped and restated against an increasingly complex and beautiful piano part, before becoming increasingly distorted, pitch-shifted and elaborated as the children attempt to escape from the school. We also have an extended, elongated exploration of Tippi Hedren's face, which is very much reminiscent of the treatment of the footage of both Janet Leigh and Doris Day from earlier in the work.

This section is disrupted by the reappearance of footage from *The Man Who Knew Too Much*, and again there is a very sudden shift as we are immediately moved back into the on-screen world of that film, through a short section of directly quoted and unaltered footage. This doesn't persist for very long, however, and soon we are moved back into the more fragmented and disjointed world of the audiovisual, this time in exploring the open mouths of the choir as they perform the Storm Clouds Cantata, in a section that feels (in hindsight) like a foreshadowing of the exploration of the shower drain in the next section.

The final section of the work, perhaps unsurprisingly, is an in-depth and detailed reconsideration of the infamous shower scene from *Psycho*. Herrmann's original score and the original sound material from the film are reworked and reconsidered to such an extent as to barely be audible beyond occasional brief fragments and references, pitch-shifted in such a way as almost to sound like the refrain of an ice cream truck or a train whistle. The final elongated focus on the shower drain, this time apparently without the blood from the original film, is heavily reminiscent of the singing and open mouths of numerous women throughout the work as a whole and feels as though it is potentially asking questions about the role of women and women's voices within the original contexts of the films themselves, though this will be considered in more detail later in this analysis.

The work itself raises interesting questions about the role of the performer and their visibility, and indeed this is why I decided to watch a document of both the piece in full without a visible performer and the work in part with a visible pianist. I found the rendering without a visible performer to be significantly more satisfying than that with, though I suspect this was largely down to editing choices as opposed to the actual presence of the performer themselves; I will return to this in my consideration of the experiential layer later in this analysis. The editing choices made in the document of Kanga's performance were very much as you would expect from a standard concert performance documentation – close-ups of hands, the pianist viewed from a range of angles and often the accompanying film not shown at all for small chunks of time. This is quite disruptive and what it makes abundantly clear, when viewed side-by-side with the Masaki performance, is that the relationship between film, soundtrack and performance is essential and completely interlinked in such a way that breaking the perceptual experience by removing the film and focusing on the performer reduces the impact of the work. This is a complete audiovisual experience which cannot easily be disrupted in this way and remain intact. Indeed, the piano performer, though completely essential to the realisation of the work as an audiovisual experience, appears to take almost the role of a silent movie cinema pianist, through elaborating and commenting on the action on screen, but their actual bodily presence being relatively unimportant in the realisation of the work.

As an audience member, and a Hitchcock fanatic since my teens, this work feels like an exploration of and meditation on the shapes, colours, themes,

peculiarities and affordances of Hitchcock films in minute detail. It also has, for me, a sense of being an audiovisual representation of the internal feeling of when certain patterns, words, motifs or phrases from films or music get stuck in one's head. There are also reminiscences of the repeat watching of films through analogue means here which, from my own childhood experiences, often engendered slippages or strange patterns in the tape recordings, changes in colour or caused sections to skip and alter slightly with each subsequent viewing. The *Hitchcock Etudes* feels like a conscious digital intervention as a reference to this analogue process, though I would be interested to discuss with the artist whether this is indeed the case. Further, it also feels reminiscent of Douglas Gordan's work, *24-hour Hitchcock* (1993), in which *Psycho* was extended to two fps in order to last a full day, encouraging the audience to fully attend to the individual shapes, forms, patterns and, indeed, individual narrative streams inherent in the work.

Shape

Individual elements	Compositional result
Shapes/gesture/motif/dynamics	Structure/form

From the perspective of shape, gesture, motif and dynamics, each of the sections/etudes of the work explores these in different ways, so these could be considered on a section-by-section basis alongside a consideration of form and structure in the work as a whole. Rather than analyse each section individually, below is a consideration of shape as manifest in etude 1, as a possible precursor to analysis of the remainder of the etudes.

Etude 1

There are three key shape motifs or gestures in this section – the parallel bars of the opening titles, the exterior of the windscreen viewed through the windscreen wipers and the close-up of Janet Leigh's face. All of these are important visual devices in the original Hitchcock film, but take on different meanings here due to their treatment.

1. Opening titles – initially presented as they are in the opening of the film, these are quickly fragmented, dissected and begin to loop, reverse and repeat, disrupting the audience's expectations. Quickly joined by the piano in underscoring this repeated motion, this section immediately suggests a motif of tape gradually degrading or repeating.
2. The windscreen wipers/car exterior – significantly slowed down from their original form, the back-and-forth of the wiper against the oncoming headlights creates circles of light that are constantly being moved in and out of focus through the persistent rain being cleared and falling

again. This focus on the relationship between line and circle is even more apparent here through the slowing down of the material, in combination with the slowed musical material, causing a pitching down of the string parts which sounds detuned against the original pitch being played by the piano.

3. Janet Leigh's face: the motif of the blurry/raining light circles is continued here in the background but the main focus here is on the shapes of Leigh's face, occasionally layered and slightly defocused as the footage and musical material reverses and repeats against the onward motion of the piano. When watching this, my brain wanted to interpret the repeated musical motifs as falling at the same time as the blinking of Leigh's eyes, which does happen on occasion.

Etude 2

Motivically, this etude is primarily concerned with the shape of Doris Day's face, particularly as it explores the vowel sounds when singing – this is explored and developed throughout, in different contexts in the film.

Etude 3

This etude is concerned with fragments of shape and sound, as it explores the stuttering shapes of Norman Bates's speech and how this is manifest sonically and visually.

Etude 4

This etude is primarily concerned with the shape of the hands, as this is a primary focus and is implied through the playing of the piano, even when the close-up and slowed-down imagery of the hands is not on-screen.

Etude 5

The Birds etude has a more cluttered consideration and presentation of shape – the central section is a clear exploration of the shape, form and motion of Tippi Hedren within that specific scene, but the sections on either side of this deal primarily with the school children and, indeed, the school building, as their primarily material.

Etude 6

Once again, we return to the motif of open mouths singing (and later screaming) here, begun in etude 2 and continued in etude 7. The consideration of shape here begins with the circle of the phonograph and moves through to

the open mouths of the chorus, reflected in how the cantata material is utilised and transformed by both the soundtrack and the piano line.

Etude 7

The shower head, Bates's silhouette and water down the shower drain are the primary shape materials here; they are presented in isolation, in forward-and-backward motion, at normal speed and slowed down to allow detailed consideration of each of their forms individually, both sonically and visually, and as they relate to one another through juxtaposition and recontextualisation.

From my own reading of the work, although there is overlap it seems to consist of seven etudes as follows:

Section/ etude	1 - Psycho title sequence	2 - MWK TM Doris Day	3 - Psycho, Bates's speech	4 - Rope	5 - The Birds	6 - MWK TM concert	7 - Psycho shower scene
Timing	00:00– 02:33	02:33– 06:14	06:14– 09:12	09:12– 11:44	11:44– 15:45	15:45– 16:40	16:40– 20:48
Duration	02:33	03:41	02:58	02:32	04:01	00:55	04:08

Each of the etudes is structurally coherent, with a clear sense of formal design to the exploration of each aspect of material, as follows:

Etude	**1 - Psycho title sequence**		
Sub-section	1	2	3
Timing	00:00–01:00	01:00–01:39	01:39–02:33
Duration	01:00	00:39	00:57
Etude	**2 - MWKTM Doris Day**		
Sub-section	1	2	3
Timing	02:33–03:15	03:15–04:06	04:06–04:57
Duration	00:42	00:51	00:51
Etude	**3 - Psycho, Bates's speech**		
Sub-section	1	2	3
Timing	06:14–06:35	06:35–09:12	
Duration	00:21	02:37	
Etude	**4 - Rope**		
Sub-section	1	2	3
Timing	09:12–09:50	09:50–10:43	10:43–11:44
Duration	00:38	00:53	01:01
Etude	**5 - The Birds**		

Sub-section	1	2	3	
Timing	11:44–13:03	13:03–13:56	13:56–15:44	
Duration	01:19	00:53	01:48	
Etude	**6 - MWKTM concert**			
Sub-section	1	2		
Timing	15:44–16:10	16:10–16:40		
Duration	00:26	00:30		
Etude	**7 - Psycho shower scene**			
Sub-section	1	2	3	4
Timing	16:40–17:18	17:18–19:10	19:10–19:50	19:50–20:48
Duration	00:38	01:52	00:40	01:58

Interestingly, when presented like this there are 21 sections to the work, in a work that is roughly 21 minutes in length. Indeed, many of the sections are around a minute in length, though there are some clear and obvious departures from this; for example, the etude on Norman Bates's speech patterns is in two sections, an introduction and an elongated exploration, of 21 seconds and 2:37, respectively, while the second *Man Who Knew Too Much* etude could be seen as two short c.30 second sections. This also, of course, depends largely on how one reads and interprets the work; as an example, you might consider etude 6 to be one single one-minute long section, but the difference in audiovisual materials in the two halves argues for separate, though related, sections. Similarly, the Doris Day etude contains an ongoing motif of day sitting at the piano singer particular syllables (ah, be...) which persists through almost as a ground base against which the rest of the material is situated.

Colour

Individual elements	Compositional result
Pitch/tone	Timbre/texture

The colour palette is varied throughout the work, and the transitions between the stark black and white of *Psycho*, which is returned to throughout, against the specific palette of each of the other examples – the blues and greys of *The Man Who Knew Too Much*, the greens and whites of *The Birds* and the blues and beiges of *Rope* – creating striking contrasts that are reflected in the musical material of the work through explorations of key melodic motifs from both the score and the broader sound world of each of the films; as an example, the five-note motif that characterises much of the Doris Day etude is reflected in the striking colour palette of the scene we frequently return to (blue/red-pink/white/black/yellow) and the way in which the vocal material is taken and elaborated by the piano line.

Texturally, the three distinct but interrelated layers of material – piano, glitch and film – present what we might describe as an audiovisual heterophony, in which all three are effectively exploring a similar line/idea/motif/gesture in three related and complementary ways.

Time

Individual elements	Compositional result
Rhythm/movement	Momentum/direction

Each of the etudes deals with time, rhythm and movement in a specific way, and could be analysed individually in detail. However, looping and repetition are a very clear rhythmic motif that persists through but is manifest differently in each etude and, in many cases, in each sub-section. The clarity of the organisation of the work, with respect to the individual sections and their relatively short duration, provides an ongoing sense of momentum and direction that is in many ways reminiscent, in long form, of Herrmann's score for *Psycho* heard at the outset of the work.

Space

Individual elements	Compositional result
Location/place	Spaces/site

Space is an interesting concern in this work, and I imagine would feel as though it were manifest differently in the context of a live performance as compared to an online viewing. As we are presented with individual fragments of longer narrative feature films, we are constantly moving through new, implied locations and places, but never remaining in any of them for any extended duration. Indeed, these locations and the implied position of the audience within them are in constantly flux, adding to the ongoing feeling of underlying instability to the work. There are also interesting suggestions and negotiations of implied diegetic and non-diegetic space – at the beginning of etude 3, exploring Norman Bates's speech, we are suddenly launched directly into the on-screen audiovisual world of the film in a way we haven't been up until that point, and later during the Birds etude, we feel as though we are both in, and not in, the actual audiovisual environment of the school room.

The spaces and sites the work explores are presented almost from a hauntological perspective, with references to the preexisting works and the physical spaces and cultural sites they inhabit appearing almost as nostalgic reminiscences – ghostly and not quite fully formed.

Layers of engagement

Experiential layer

As described earlier, I approached this work initially through the full-length Masaki recording before then watching Kanga's recording which – to me – didn't represent the work as well due to editing choices over the presentation of the pianist. This does raise interesting questions, though, about the nature of the work as a 'performance' work – it has performance aspects, but it is one of very few 'concert' works I have engaged with where, to be honest, I feel I would rather not see the performer or to see them differently, as a part of the work as opposed to positioned in front of it (perhaps I would feel differently if I were able to experience the work live, but as with other works in this book this has not been possible under current global conditions).

The idea of presenting the performance almost as a silent movie with piano accompaniment – in which we would in the main not see the pianist – is an intriguing one and one which could work very well here, I feel. I also think this raises some interesting questions about the nature of our *expectations* from performance as audience members; one of the criticisms regularly levelled at laptop or computer music performers within a concert hall setting is the lack of legibility their mode of realising performance affords, and that the audience seeks more of a virtuosic display. A work of this level of complexity necessarily engenders a virtuosic performance but being presented in this format our ability to see that virtuosity reduces in importance against how that virtuosity is experienced within the audiovisual whole. It is interesting then, in a work which combines the kind of glitched/looping sound worlds often associated with computer music performance – an idiom often criticized for its lack of apparent virtuosity – is one in which the virtuosity and complexity of the performance are both very audible but also visibly subsumed into the overall audiovisual experience of the work.

As with other examples in this section, I have sought to experience the work through a range of technological mediations, and found it to be most successful and immersive through headphone listening with large HD screen visuals; the complexity of the sound materials, particularly the spaces between the glitch and piano lines, is easiest to decipher and really dig into in detail in this format, and it afforded an intimacy with the materials that felt a little more distant when presented through speakers.

Personal contextual layer

This is, again, an interesting consideration relating to this work, and indeed the personal experiential and contextual layer could have a very specific impact on the reception of this work.

As mentioned previously, I have been a Hitchcock fanatic since my teens, pouring over my VHS copies of all of these films and more through repeat viewing after repeat viewing (I must have watched each of the films explored

in this work in excess of 20 times each, and likely many more in the case of *Psycho* and *The Birds*). The way in which the materials in this work seem to glitch and degrade very much resonates with my personal experience of wearing out the films but continuing to watch them regardless, and the interesting effect this had on each of the films (in the case of Rope, for example, I recall that I had attempted to 'pause out' the advertisement breaks but neglected to un-pause at one point, so I was missing a crucial five-minute section in the middle of the film. Nonetheless, I watched it regardless).

Consequently, I view each of the layers of material explored in this work through the lens of a detailed and in-depth knowledge of each of the films; I know exactly what comes before and after each section and clip, and how the materials used fit into each film. I have also spent a lot of time dissecting and analysing the music in two of these films through formal study as part of my undergraduate degree at University. It isn't possible for me to remove these experiences or preconceptions and they undoubtedly colour my experience of engaging with the work. I think this was most apparent to me during the first viewing of the Birds etude, specifically the classroom scene. The complete recording of the children singing against the forward-and-backward looped conducting of their teacher I found genuinely very unsettling, I think not only because of the way in which the audiovisual materials had been assembled but also because I knew what was to come later in the film and so I read the scene through that knowledge.

Further, even the title of the work and the expectations this presents are coloured by my educational and personal background. As a classically trained musician, I understand the term *etude* to refer to a specific type of compositional/performance exercise and an immediately thinking about Chopin, Liszt, Debussy... This expectation of a series of complex studies undoubtedly coloured my initial experiences of the work, through my listening for this complexity and exploration in how I encountered the musical materials.

Critical contextual layer

As with all the other examples in this section, there are numerous fields of potential contextual consideration against which this work might be read. Most resonant, from my perspective, seem to be auteur theory, hauntology and glitch/post-digital aesthetics, though I would be interested to discuss with the composer whether these are the specific areas she is interested in exploring in this work.

References to hauntology – or rather a hauntological feeling – are very apparent in the work, and it is perhaps illustrative that it was written in 2010 at a time when hauntology was being much explored and discussed in critical theory and in musical composition, particularly through the electronic music distributed by labels such as Mordant Music and Ghost Box. At the time (though it seems peculiar to talk about 2010 as being a distinct past, when at only ten years distant) Mark Fisher was writing extensively about hauntology

as a potential cultural zeitgeist, and in a 2011 article positioned aspects of it as follows, specifically in reference to the Caretaker project:

> ...we should note that much hauntological music is as much about film and TV as it is about music. The Caretaker borrowed his name from the role that Jack Torrance (Jack Nicholson) takes on at the Overlook Hotel in Kubrick's 1980 film The Shining (about which more shortly). In fact, the whole Caretaker project was originally motivated by a simple conceit, the idea of making a whole album's worth of material that could have been heard in the Overlook. The Caretaker subjects 1930s tearoom pop to degradation (delay, distortion), rendering it as a series of sweet traces that are veiled by one of sonic hauntology's signature traits, the conspicuous use of crackle, which renders time as an audible materiality...
>
> To haunt does not mean to be present, and it is necessary to introduce haunting into the very construction of a concept," Jacques Derrida wrote in Specters of Marx... Hauntology was this concept. One of the repeated phrases in Specters of Marx is from Hamlet, "the time is out of joint," and in his recent *Radical Atheism: Derrida and the Time of Life*, Martin Hagglund argues that this broken sense of time is crucial, not only to hauntology but also to Derrida's whole deconstructive project. "Derrida's aim," Hagglund argues, is to formulate a general 'hauntology' (hantologie), in contrast to the traditional 'ontology' that thinks of being in terms of self-identical presence. What is important about the figure of the specter, then, is that it cannot be fully present: it has no being in itself but marks a relation to what is no longer or not yet. (Stanford University Press, 2008, p. 82). Provisionally, then, we can distinguish two directions in hauntology. The first refers to that which is (in actuality is) no longer, but which is still effective as a virtuality (the traumatic "compulsion to repeat," a structure that repeats, a fatal pattern). The second refers to that which (in actuality) has not yet happened, but which is already effective in the virtual (an attractor, an anticipation shaping current behavior)
>
> (Fisher, 2012, p. 18).

What is interesting here, specifically with respect to the *Hitchcock Etudes*, is the notion of the coherences and correspondences between hauntological artefacts that are musical and the filmic or televisual. Certainly here, there is a hauntological exploration of material from both a musical and filmic perspective, marking an audiovisual approach that feels fundamentally concerned with what is no longer – immediately Hitchcock as a director, making the films explored in the work, but beyond that the cultural and societal structures that supported that work and the technological mediation of that work through analogue means – but that is still 'effective as a virtuality', specifically in how it is explored in this work.

Viewed in hindsight, there is of course significant overlaps between some hauntological thinking and concepts and ideas relating to post-digital aesthetics – including discussion of glitch and aesthetics of failure – which

feel resonant to this work. Here, we might explore the work of Cramer, Andrews, Cascone or Berry, but I will instead draw attention to Caroline Bassett's (2015) work on feminism and technology in a post-digital context. As Bassett points out

> There are many postdigitals, but a characteristic they share – and a key way in which I am making the cut here – is that they claim to speak from, as well as about, the present, and, in doing so, to connect an aesthetic with an emergent popular sensibility.
>
> (Bassett, 2015, p. 138)

We might argue here that, through its exploration of the aesthetics of glitch, alongside its apparently (transparently? This is something, again, to discuss with the artist) hauntological agenda, *Hitchcock Etudes* both embraces an 'emergent popular sensibility' – in 2010, the emerging zeitgeist of hauntological practices – alongside speaking both from and about the present they inhabit and the past they refer to.

Finally, to briefly explore potential resonances and reconsiderations of auteur theory in this work, Hitchcock was, of course, one of Truffaut's most exemplary auteurs, epitomising the director as author of the artwork. This mysticism continues in contemporary criticism, with the following being taken from Marilyn Fabe's (2014) volume on close watching film.

Hitchcock summed up his motivation for making films in his interview with Truffaut:

> My main satisfaction is that the film had an effect on the audiences, and I consider that very important. I don't care about the subject matter; I don't care about the acting; but I do care about the pieces of film and the photography and the sound track and all of the technical ingredients that made the audience scream.

Elsewhere, Hitchcock has said,

> I aim to provide the public with beneficial shocks. Civilization has become so protective that we're no longer able to get our goose bumps instinctively. The only way to remove the numbness and revive our moral equilibrium is to use artificial means to bring about a shock. The best way to achieve that, it seems to me, is through a movie.

Whether or not we scream at a Hitchcock movie, the best ones put us through an experience that frightens us, shatters our complacency and brings us knowledge of parts of ourselves of which we may have been unaware. Hitchcock's genius is to create films that exploit the resources of the film medium to make us react, make us feel fear or make us experience not just the chaos that may erupt from without, but that which unfurls from within us. His movies fit Kafka's definition of a good book: "an axe for the frozen sea inside us." Hitchcock managed to be a superb entertainer whose films nonetheless have a very sharp edge (Fabe, 2014, p. 158).

It is precisely this sharp edge the *Hitchcock Etudes* plays so consciously with. As the audience, and I suspect even one unfamiliar with the films explored in this piece, we are familiar with Hitchcock and encounter the work with the expectation of shock or fear – the sharp edge. What this work delivers is the sharpening of the layers around that edge, continually exploring and re-configuring these layers of material that prefigure the more shocking events within the films but never actually seeing the events themselves – even the quotation from the Birds, in which the children flee from the school, never reveals the full horror of the scene. Here, Lizee is the auteur of a work that is both familiar and unfamiliar, nostalgic and unsettling, Hitchcock but not-Hitchcock, presenting a reconsideration of the original source material in a way that still evokes its character but places it under a different lens.

Intentional layer

I had very much hoped to discuss this work in more detail with the composer, Nicole Lizee, but unfortunately due to scheduling conflicts this was not possible. Instead, having explored the work a little through interviews with the composer elsewhere, the influence of glitch and auteur theory is clear, and I would have been intrigued to explore this in more depth with Lizee herself.

Case Study 5 – Music video: *Close to be Close to Me*, Echo Ladies (2016)

Close to be Close to Me is a 2016 song by Swedish self-described showgaze/dreamgaze band, Echo Ladies, taken from their self-titled EP. The video for the song will be analysed below.

Initial, intuitive response

There is much that is familiar in this video, but it is dealt with in such a way as to feel both nostalgic and slightly peculiar. There are nods here to the performance-style music videos that predominated in the 1960s and 1970s, but this is presented in a way that feels particularly appropriate and resonant to the musical material being presented – we are familiar with the general environment, but the specifics are slightly unusual or off-kilter. As an example, amps and a synth are wheeled/brought onto the performance space, but instruments aren't plugged in and there are no cables connecting anything – whilst we are invited to buy into what is happening as some form of performance, we are also made aware that things aren't quite right or as they need to be in order for that performance to be realised. There are references to numerous other music video tropes too; as an example, one of the band members wears a black polo neck jumper, which feels like a direct reference to some of the Beatles earlier promotional work, while the lead singer's wardrobe, make-up and, often, position on screen feels like a nod to the Cocteau Twins' *Carolyn's Finger*. Yet we are consistently drawn both into and out of the world of the music video as a performance document – the lip syncing and instrument playing are at times in line with what we're hearing, and at other times completely absent or not related to the musical materials. The overall effect is one of both familiarity and instability, as we both recognise and don't recognise the audiovisual artefact we are encountering – we are both oriented in tropes and traditions, and being encouraged to step outside of them.

Shape

Individual elements	Compositional result
Shapes/gesture/motif/dynamics	Structure/form

The arrangement of the central visual space is unusual – it could be a warehouse or a gallery space, in which what looks like a minimal white-walled sub-space has been constructed. This is lit in four corners by floodlights, which feel too large for the space, and there is the conscious sonic reference to these, and the fluorescent strip lights being turned on, slightly too loudly,

before the song begins; indeed, these lights seem almost to herald the beginning of the track.

The shape of the music track in terms of verse/chorus patterning is relatively formulaic; yet the structure of the visual component doesn't really tie into this to any great extent – there is a sense that we are watching initially an attempt at a performance and later more of a rehearsal with some short, performed elements or, indeed, just the band interacting with one another. Whilst the initial set-up of the video suggests that it will be a performance of the song, the remainder of the track isn't really presented in this way.

The visual shape of the lead singer is perhaps the most interesting and certainly, in many ways, the most reminiscent of her placing in the audio materials in the production of the work. Being dressed in a pale colour similar to that of the white room, and being presented often at a distance, at the side or in such a way that we are only able to see a small amount of her form, she is both central and not-central to what is happening on screen. This seems to directly correspond with what we are hearing, as the vocals in the song are both part of the main focus but are also mixed in such a way as to blend with the remainder of the musical materials – the vocals are not foregrounded to the extent that we might expect in a track of this kind. This simultaneously audiovisual foregrounding, and not-foregrounding, of the lead singer is intriguing and is one of the most direct correspondences in the work.

Colour

Individual elements	Compositional result
Pitch/tone	Timbre/texture

The visual colour palette of the majority of the work is somewhat subdued, which complements the musical materials which border on the pensive and slightly melancholic tonally, melodically and rhythmically. The exceptions to this are the bright pink of the band name at the opening of the video, which is further picked up in the eye-shadow of the lead singer and, later, the balloons that fall from the ceiling. It is not clear what the function of the balloons are, though they do seem to make a mid-point in the video and a point at which the band becomes less engaged with the idea of 'performance' – from here, we see fragments of performance against longer stretches of interaction, dancing or just playing with balloons, as though they have introduced play and distraction; it is perhaps interesting that when the band leave the space at the end, the instruments are left behind but they take a balloon with them. The musical texture of the work is quite heavily cluttered, as one might expect of a track in this genre and style, and this is, again, somewhat in opposition with the relatively clear, open environments we are seeing on screen.

Time

Individual elements	Compositional result
Rhythm/movement	Momentum/direction

Rhythm and momentum are maintained more consistently in the musical materials because this is a piece of rhythmically grounded and directed music – much more so than any of the other examples analysed in this chapter. In terms of how this is expressed audiovisually this is more complex; beyond some amount of lip-syncing, dancing or performance apparently 'in time' or at least consonant with what we are hearing, there is almost a sense of disconnection here between what is presented visually, rhythmically and what we are hearing; the nature of the track is such that it carries on in forward momentum almost regardless of what we are seeing on screen, whereas visually we are permitted moments of stasis, pause or, almost, reflection against this forward sonic momentum. This rhythmic disparity might feel like a disconnection, from the perspective of audiovisual pacing, but we might instead see the visual component of the work as a reflection of the content and emotive atmosphere of the musical world of the sonic materials as opposed to a direct reflection of the materials themselves – onwards temporal motion and rhythm don't necessarily speak to momentum in the audiovisual materials.

Space

Individual elements	Compositional result
Location/place	Spaces/site

As discussed above, a place and location is suggested in the video and, although this a coherent space – we understand the potential of what it might be – we are offered little about its specifics. The resonance of the site of the work speaks to the heritage and cultural context of the band themselves and their influences; for this particular audience member there is something undeniable Scandinavian about the sound they develop and how this is married with the minimal, clear visual environment this video inhabits, though this is quite difficult to describe in absolute terms.

Layers of engagement

Experiential layer

The experiential layer is particularly interesting when one considers music video specifically. Unlike the majority of the other works discussed in this section, music video was never really intended to be experienced within an 'ideal' context; initially developed for promotional purposes or as part of

longer form narrative films (The Beatles Hard Day's Night for example) or documentary forms (Pennebaker's work with Bob Dylan) later avenues to dissemination for music video were primarily televisual, through MTV, Top of the Pops and VH1. Now, they are predominantly experienced digitally via platforms such as YouTube, Vimeo and Vevo, so are often designed with mobile mediation specifically in mind.

For the purposes of this chapter, I watched the video on my laptop and tablet screen, on my studio screen, on our 65" 4K TV and on my phone, with a range of standalone speakers, headphones and device speakers. Audiovisually, whilst of course the detail was most apparent in the highest quality visual and sound technologies, the work itself didn't seem to suffer in reception whether experienced in high definition or through a mobile device. This may be indicative of a medium that, though its pedigree, has become perfectly suited to the mechanisms by which it is disseminated and mediated.

Personal contextual layer

It might be appropriate to describe my experience with music video to date as that of enthusiastic amateur; though I have flirted with the idea of publishing directly in the field of music video, I have not yet done so. I like to tell myself this is because I haven't yet had the time, but in reality I think it is more likely that I don't feel sufficiently authoritative in the field to yet offer an individual contribution. That being said, I have researched and taught on music video extensively, and have been something of a music video 'nerd' since I was a young child, so these are the layers of personal experience and context that I bring to my reading of this work. Specifically, I have a developed interest in the historical trajectory of music video, so am likely to read choices in framing, wardrobe or colour palette as direct nods to particular historical precedents, even if this was not a conscious choice by the artist – and there is certainly the risk of that in this specific case.

Critical contextual layer

Music video does not yet have a particularly extensive critical discourse, and that which it does tends to be predominantly from the musical side as opposed to offering a multimodal consideration of music video as audiovisual artefacts. Nonetheless, many of these critical constructs may be helpful in further understanding this individual example.

Carol Vernallis's (2013) work *Unruly Media: YouTube, Music Video, and the New Digital Cinema*, for example, might be particularly useful in encountering this particular work. In *Music Video's Second Aesthetic*, Vernallis argues that

> a broader picture of music video may require a new model. Since music
> videos place song and image in a relation of copresence, I suggest that we
> consider them as partners: we might see them on the couch and imagine

them in couples therapy... We can assume there are issues of dominance and subservience, passivity and aggression. In music–image relations one medium often seems to be pushing the other to do something, acting as the driver. Each suffers from not being able to show all it has... Asking what music and image are saying to one another, how they act as players and performers, can reveal a music video's persuasiveness or allure.

(Vernallis, 2013, para. 10)

The examples Vernallis offers for this perspective, particularly those of Sigur Ros and Lady Gaga, work well to illustrate her point here, but might be able to apply this approach to the Echo Ladies example discussed here? If we ask ourselves – what are music and image saying to one another – in this video, what do we discover?

As described above, there is both similarity and difference in how the audiovisual materials are constructed here. There is certainly what feels like an intuitive overlap between the slightly melancholic sound world, even if it is a relatively loud/noisy one, and the muted colour palette, and a clarity to the relationship of the voice with other sound materials and how this is manifest in the position of the lead singer on screen. Yet at other times, other than some timing simultaneities and the fact that we see the band on screen there seems to be very little relationship between what we are seeing and what we are hearing, beyond that they are happening together. This perhaps underscores one of the problems with interpreting a work of this kind, and indeed many of the others in this section, which has been explored earlier in this work, that audiovisual relationships are dynamic and fluid, not fixed around a series of temporal points. Whilst exploring this work from the perspective of Vernallis's ideas relating to narrative, temporality, teleological drive and harmony might reveal some aspects of our experience of the work, and the interpersonal interpretation offered above some other aspects, they are only really applicable in the moment.

Intentional layer

There is relatively little discussion of Echo Ladies online, beyond some information on the genesis of the band, their name and where it came from. Certainly, very little is offered about this song or its accompanying video. One interesting aspect of what can be found out about the band is contained in a brief summary on sound cathedral when discussing their influences "they claim their biggest influence to be effects pedals (they are now making their own to sell on tour) and "the feeling of nostalgia and hope for the future mixed with angst over defining who you are and what you will become" (Sonic Cathedral, 2020, para. 2). Certainly, the influence of effects pedals can be heard in how their music is produced and the sound palettes they choose to work with, but it is difficult to obtain much more information about the band and, specifically, this work is beyond what is offered above.

Case Study 6 – Narrative form: *A Love Story* (2019), dir. Anushka Naanayakkara

Initial, intuitive response

A Love Story is a c. six minute short stop-motion film exploring the relationship between the two central characters – puppets made of felt, string, wool, ribbons and other fabrics and materials. The world they inhabit is quite a closed one, and indeed the majority of the film is presented from the perspective of the main character – for ease, and as they don't have names (as such) within the film itself I will refer to them as *Beige* (main) and *Multi* (secondary, named for their predominant visual colour element).

The basic narrative arc of the work is that Beige is initially alone in a relatively beige world and seems quite content – we begin by seeing them contentedly munching away almost cow-like on some nearby fluff/foliage. There is little audiovisual colour at this point, and everything on screen and sonically is quite self-contained and tidy, almost isolated. We see our first glimpse of Multi at the left of the screen, and a single red line of thread, accompanied by an isolated sonic bell-like gesture, moves through the space and embeds itself in Beige, going in through their back, appearing on their face and eventually threading onto their lips. This gesture heralds the arrival of Multi, initially hiding behind some nearby foliage before emerging into the main visual space. In contrast to Beige, Multi is multicoloured, made up of many textures and layers, and seems to branch out in all directions as opposed to being self-contained; sonically, this is suggested by the manipulated vocal and Kalimba material that seems to characterise Multi throughout.

The two characters exchange coloured audiovisual material, in the form of coloured threads and cries, each impacting on the other until they are tied together by coloured lines, each one seeming altered in texture and colour by the process. The settle to a point of equilibrium, and Beige resumes their initial character gesture of contentedly munching absent-mindedly on some fluff, though now whilst entangled with Multi.

At this point, a fracture begins, initially through a close-up of Multi's eye from which some black thread begins to emerge. This black material begins break out and envelope Multi, making them withdrawn and seemingly unhappy and unwell; Beige attempts to break through the black material, but their threads simply bounce off, and when they try to pull at and remove the black material Multi becomes angry and some of the black thread moves across Beige's lips (this feels like an exploration of the nature of mental illness, and though I am sure it certainly refers to an illness of some kind I am not sure of the type). The two characters move away from each other, straining at the threads that bind them as the blackness begins to infest the whole environment, ultimately plunging them into darkness. Beige seems to try one last attempt to get through to Multi, through sending all the coloured

threads to them (which feels as though it is an attempt to remind Multi of what they are missing – the coloured threads representing memories of happier times) but the darkness remains, and Beige becomes washed out and is left dishevelled and untidy by the process, breaking the threads that tie them to Multi and allow the darkness to drift away.

The broken coloured threads are left hanging in the air, as Beige sits alone in their original environment, unsure of what to do. Eventually the memory threads are incorporated back into Beige, and both they and their environment return to some semblance of the shape and form of the beginning of the piece, though this time altered by the coloured threads.

Once again, a single red thread travels through space, heralding the reemergence of Multi, apparently cured of the darkness. But the damage has been done, and Beige turns their back on Multi, unable to return to the relationship they once had. Multi leaves one more red strand, which embeds itself above Beige's right eye, and leaves, as Beige looks wistfully after them, with a return to the initial sonic repeated gesture from the opening of the film, this time coloured by deep, visceral vocal materials.

A Love Story feels like a story about the turmoil of relationships, potentially coloured by mental illness or illness of some kind, and the way in which individuals within those relationships are shaped, formed and coloured by their experiences as an entangled pair. It also raises questions about the amount of one's self one is able to give to another, before the sacrifice becomes too great.

Shape

Individual elements	Compositional result
Shapes/gesture/motif/dynamics	Structure/form

Although the materials of the work suggest almost a lack of definition (through the use of fuzz, fluff, materials and with a real 'softness' suggested in the visual environment) shape is nonetheless an important component in this work, with the shape of Beige in particular being open to audiovisual disruption. When we initially see Beige they are on their own – a neat, tidy, almost potato-shaped object with no rough or frayed edges and nothing that disrupts the clean outline of their form, either sonically or visually; indeed, whilst visually the shape of Beige has relatively little to distinguish it from the rest of the environment, sonically the same is true, as outside of the sounds of Beige chewing and the repeated rhythmic gesture in the musical underscore Beige makes little noise.

Multi, by contrast, is much messier and more indistinct; from the outset, both sonically and visually Multi is a 'disruptive' presence, bringing more obvious audiovisual gestures, such as the red thread and the Kalimba musical materials, continuing through subsequent shapes and motions of threads that move through the space and encounter Beige. As the two become more

entangled, and indeed as the work progresses to the central climatic section, the isolated audiovisual gestures become more difficult to separate amongst the general cacophony of the work, until Beige breaks away in the third section. Here, as Beige's visual self has been altered by the experience – incorporating coloured threads both into their now very messily edged shape and the environment as a whole – so the sound palettes move from the detached and uncluttered rhythmic gesture in Section 1 to materials inflected with the vocal and Kalimba motifs associated with Multi.

Structurally, we might consider or define the work as follows:

Section	Introduction	1	2	3
Duration	00:00–00:47	00:48–02:24	02:25–04:39	04:40–06:05

Indeed, the film could easily be read as a three act structure, and there are certainly elements of exposition, confrontation and resolution. However, there is something more musically paced about the work as a whole and although there are key pivot points in the action, the piece feels more like the continuous evolution of a perspective than a compartmentalised plot exposition. Indeed, I have separated the introductory section out above as, although within a three act structure it might be considered as part of the exposition, the clarity of the audiovisual gestures at this point provides a sense of scene-setting that warrants its being considered as a separate entity

Colour

Individual elements	Compositional result
Shapes/gesture/motif/dynamics	Structure/form

Pitch/tone/colour relationships in this work are particularly illustrative of both plot and character, with much of Multi's actions and behaviours underpinned by audiovisual gestures in colour and tone such as the initial red thread gesture and subsequent similar gestures that point to moments of crisis or resolution in the work.

The texture and timbre of the piece are in flux throughout, and are very much coloured by the behaviours of the characters and what feels like their mental state. One of the interesting aspects of this work is that we are presented with a small, self-contained, highly textured environment that we both understand as logical and representative; we are familiar with the audiovisual materials we are confronted with and the shapes, characters and environments they are being used to describe. Yet, we are also forced to confront the illogical qualities of the world we are invited into; it appears both bound by and outside of natural laws such as gravity, and there is no real sense of the scale or size of the world, other than the small snapshot we are afforded. It is

a work in which texture and timbre play an essential role not just in defining the characters on-screen but also the character of the environment as a whole.

Time

Individual elements	Compositional result
Rhythm/movement	Momentum/direction

The way in which the two characters both exist individually and encounter one another is heavily rhythmic. Beige is initially characterised by a repeated rhythmic gesture in a neat, self-contained visual world, but this is disrupted by Multi's more fragmented and gestural, more heavily pitch-inflected and coloured audiovisual world. The combination of the two and the return to Beige's rhythmic motif at the end of the work suggest an evolution of character and environment that is underscored audiovisually through relationships between pitch/colour and tone/rhythm. Momentum is driven through the evolution of the narrative, but the narrative itself is driven by relationships between audiovisual colour, shape, form and motion, which dictate the direction of the work.

Space

Individual elements	Compositional result
Location/place	Spaces/site

As described above, space in this work is inextricably linked with texture and timbre, and indeed with colour and shape in defining the environment in which we are situated, which itself feels like a third character within the narrative of the work. Location-wise, though perspectives on it may change, we are fundamentally bound to a particular place throughout the film, with little sense of what exists outside or around that space; indeed, it isn't clear where Multi has come from or returns to, as we are only provided with perspective on one particular location. Sonically, the same is true, though presented slightly differently. There is no dialogue in the work, with points of apparent 'verbal' communication (the characters don't speak a verbal language, but have mouths and make utterances) between characters provided instead by the exchange of pitched/coloured threads. These visual threads are tied to particular sonic gestures, but while sounds specifically associated with the movement and action of the characters, such as Beige moving against the environment and eating fluff, are assembled in such a way as to sound as though they are happening in the actual physical location on screen, the musical gestures associated with communication appear, spatially, to be part

of the underscore. There is, consequently, an interesting relationship between diegetic and non-diegetic sound here, one which raises questions about the usefulness of those terms in describing sound's function on- and off-screen in this particular example. The audiovisual environment, delimited by the visual screen, is spatially interesting, with the sounds of the communication threads potentially not only being indicative of that communication happening on screen but also the effects of that communication for the internal mental state of the central character. We might consider here, then, that much as the primary visual space is that of Beige and their visual environment, the primary sonic space is that of Beige's internal mental spaces, and as such the audiovisual perspective throughout is unique to Beige as opposed to presenting a dialogue between the two characters.

Layers of engagement

Experiential layer

The most usual screening 'mode' for a work of this type would be a cinema, and while I was unable to visit one of these under the current circumstances, I was nonetheless able to quite closely replicate at least the technological if not the audiovisual experiential environs of a cinema within my own living room. I therefore watched the work initially in this context, before repeat viewing in my studio, on both monitor speakers and headphones, and on two different mobile devices. Certainly, the work was most immersive in as close to its intended form as possible, though the quality of the speakers did show up some slight untidiness to some of the sound editing in the work and that some additional mixing and balancing work might be needed in a very few areas in the piece (a couple of the peaks in volume are a little distracting and don't quite work in the overall montage).

Interesting, unlike any of the other works encountered in this section, my initial intuitive response to the work left me slightly underwhelmed with the auditory component of the work – there seemed to be something of an imbalance between the audio and video materials, with the two not seeming to work as well together as I might have hoped (indeed, this was the only example in this section of the book where I considered that alternative options for the sound materials and their incorporation might have worked a little better with the visuals on-screen). Consequently, I also watched the work without any sound at all, to try to clarify my perspective on this. I think what I can boil this down to is that the visual environment of the work is very direct and striking, with a clear sense of colour, form, shape and rhythm, but that the sound materials don't really imply this with the same clarity – I do wonder whether the slight messiness in some of the editing and mixing might precipitate this, and that as a consequence I am not as immersed in the audiovisual experience as I might be. The work is undoubtedly not as

effective without the sound materials, but I do wonder if it might be even more effective if the sound worlds were slightly differently conceived.

Personal contextual layer

There is a relatively little within my personal contextual layer to bring to bear on the experience of this work, beyond a developed interest in narrative film in general and particularly in short form and slightly more experimental modes. It is certainly a work I can imagine experiencing at a short film festival and responding to quite strongly. The other layer of personal contextual consideration is my specific interest in stop motion and animation in an experimental context, and in puppetry, as a child whose favourite television programmes were *Fraggle Rock* and Jim Henson's *The Storyteller* and who grew up watching *The Muppets* and *Labyrinth* on an almost weekly basis. This long-held interest in and predisposition towards both stop-motion animation and puppetry would certainly inflect on my initial intuitive encounter of a work of this type, and lead to my responding differently to how I would were I not interested in either field to any great extent.

The personal contextual layer, from a critical perspective however, is quite different in approaching this film; unlike encountering de Groot or Spanghero's work, which feels fundamentally in some way akin to my own, or Ru and Xu's *For Tashi*, which speaks to visual music and electroacoustic traditions with which I am very familiar, I am not as familiar with film studies, film theory or film analysis, so my personal critical engagement here feels less directly involved and more distant than that with which I am able to approach some of these examples.

Critical contextual layer

There are an almost inexhaustible source of potentially relevant film theories and models of textual film analysis which might be relevant to a reading of this short film. In this case, I have chosen to consider how this work adheres to Richard Raskin's schematic overview of story design in the short fiction film (2014), as a potential gateway to a broader conceptual consideration of the film in the context of short film theory. Raskin's scheme also specifically emphasise relationships between sound and image, so are potentially quite pertinent here.

Raskin's schematic overview of story design falls into seven categories (building on a model of five parameters developed approximately a decade earlier (2006)). They will be presented here in isolation, cited directly from Raskin, with a brief discursive consideration of how each relates to the audio-visual experience of this work:

1. **character-focus ↔ character-interaction**

 letting the viewer know whose story is being told, yet keeping the main character interacting with others; unless we know whose story it is, we have no "home base" within the film; at the same time, interaction can provide the vitality needed to capture and hold our interest.

 (Raskin, 2014, p. 31)

 Within this work, it is clear that Beige is the central character, but that the action is driven through Beige's interaction with Multi. As apparent as this is, as a narrative construct, it is echoed in the relationships between pitch/tone, colour/shape and texture/timbre in the construction of the audiovisual materials.

2. **causality ↔ choice**

 making cause and effect relationships central to the story, but having the causality flow from the main character's deliberate choices; main characters who make things happen, driving the story forward, are more interesting to the viewer than are characters things happen to.

 (Raskin, 2014, p. 32)

 Interestingly, within *A Love Story*, the Beige's choices don't necessarily feel deliberate; rather, they seem inescapable and to some extent out of Beige's control until the final decision to reject Multi. This could still tie in Raskin's conception, however, as there is a shift between a sense that things happen to Beige towards a sense that, in the final section, they make things happen.

3. **consistency ↔ surprise**

 keeping behavior consistent with each character's definition, yet utterly unpredictable; unlike longer narratives, the short fiction film is not good at depicting A character's transformation; while the situation at the end of the film differs from that at the start, the characters remain essentially the same.

 (Raskin, 2014, p. 32)

 This isn't something that *A Love Story* displays to any great extent; perhaps the lack of dialogue in this case allows for a more concrete statement of the evolution of the characters, in this case reinforced by the behaviour of the audiovisual materials within the audiovisual space of the work through the emphasis on relationships between shape, colour, pitch, tone, timbre and texture. Certainly, the central theme and focus here is the change that the central character undergoes, and indeed both the situation and the character are quite different by the end of the film.

4. **image ↔ sound**

 designing the action in such a way that it is as interesting to the ear as to the eye; sound, in particular, should be an integral part of the action

rather than simply an auditory backdrop for the action; characters can produce sounds and react to sounds; sounds can trigger events or can in themselves constitute events.

(Raskin, 2014, p. 32)

Within this work, sound is certainly an integral part of the action in how it depicts both the visible environment on screen and the characters and their relationships with one another. As discussed above, the role of sound in reflecting the change in Beige in particular is significant in this work, as it is in reflecting the relationships between internal and external spaces.

5. **character ↔ object and décor**

having characters interact with meaningful objects and with their physical setting; in this way the inner lives of characters can be connected to the physical world; subjectivity and interiority are balanced by external, material things.

(Raskin, 2014, p. 32)

What is interesting about *A Love Story* is that there isn't a hugely clear delineation between interiority and material things. The physical space and place of the film are very much a reflection of Beige's mental state and feel completely tied to that character; as a consequence, the characters meaningfully interact with one another, and it is that interaction that engenders a response and reflection within the implied physical world.

6. **simplicity ↔ depth**

keeping the story simple enough to be habitable by the viewer; stories that are too complex or detailed hold the viewer at a distance, in the role of an observer rather than a participant; simplicity can best enable the viewer to enter the story and to explore and construct its meanings from within

(Raskin, 2014, p. 32)

The story is not only simple enough to be habitable but, I would argue, is likely to be quite deeply resonant for a large percentage of the audience. There are parallels to be sought here between the way one's personal relationships have shaped ones development, and the audience is likely to be very much able to construct and reflect the work and its meanings from within.

7. **economy ↔ wholeness**

balancing the trimming away of all superfluous moments and detail so that the film is a concentrated distillation, with the viewer's need to experience the film as a whole that is richly textured and teeming with life; only dwelling on characters' faces (eyes) takes precedence over cutting to

the bone; closural strategies can play a major role in leaving the viewer feeling that the film is complete and inexhaustible.

(Raskin, 2014, p. 32)

Certainly *A Love Story* has a very clear narrative arc that is dealt with fully yet economically. At c. six minutes in length, the work presents quite a complex story in emotive detail yet allows it to reach its conclusion at a pace that is neither drawn out nor rushed. Its sense of proportion is maintained throughout, with nothing feeling overly superfluous nor excessively trimmed.

The duration of the work is certainly what Raskin would argue is optimal for a short film arguing that anything above 15 minutes falls more within the bounds of what the French would describe as a moyen métrage, lying somewhere between a short and feature film. Indeed, as Raskin himself argues:

> The true short film on the other hand – the poetry of filmmaking – is typically only six or seven minutes long, and in my view has a maximum length of 15 minutes… producing a film that has the kind of density and concentration found in poetry, and in this connection I would like to quote a Chinese master, Wu Qiao, who wrote:
> "The [writer's] message is like rice. When you write in prose, you cook the rice. When you write poetry, you turn rice into rice wine."
> The mediocre short – dilute and tediously belabouring a story that seems to go on forever – is like cooked rice, while the best short films – holding back while teeming with substance – are pure rice wine.
>
> (Raskin, 2006, p. 160)

Intentional layer

The film's director, Anushka Naanayakkara, and I were able to speak at some length about the work and its constituent parts, and reflect a little on the process of filmmaking and the position of sound as a mechanism for characterisation, particularly in this work.

Much of the narrative and thematic material I perceived as being present in the work very much resonated with Naanayakkara's approach and the things she had sought to weave into the piece as a whole. However, the role of the voice within the soundtrack of the piece was an area in which we diverged. The intention in the making of the work was that the vocal material be characteristic of the Beige character, but I didn't pick up on this in viewing the work – as we discussed together, this may be because it was a little too subtle, or because of the positioning of the voice within the montage – the first time we hear it, for example, it appears to be emanating from the multicoloured character, and as such I saw it as indicative of the

relationship between the two main characters as opposed to belonging to one of them in particular.

Naanayakkara seemed to be very interested in such a close reading of the work and what it could tell her about the process of making, and equally I found discussing the processes undertaken in developing the work, in particular our shared experiences of personal relationships involving the kind of mental health issues the film explores, to be very illuminating.

Case Study 7 – Longer form fixed-media audiovisual work/hybrid form: *Open Air* **(2018), 01:08:00, The Necks (music, 2013) Grayson Cooke (media artist), Emma Walker (painter)**

As part of both the analytical process in this volume, and through conversations with artists in the process of assembling this analysis, I have decided to attempt a reading of a slightly longer form work. This was done in order to consider how to tackle a much longer piece of work, but also to engage with a work that was developed through a process of non-simultaneous collaboration between three different artists, and which has been described by one of those artists as both visual music and music video, whilst also not really being either.

Open Air is just over an hour long, being a complete audiovisual realisation of The Necks album *Open* (2013). In it, Grayson Cooke uses Landsat imagery in combination with very intimate and intricate filming of painting and materials, to provide a visual rendering of the Neck album *Open*. The Necks themselves are one of the most successful experimental improvising groups in Australia, and indeed internationally, and their work typically involves detailed and lengthy improvisational exploration of musical motifs and gestures over extended durations – in the case of *Open*, a single track over an hour in length.

Initial, intuitive response:

My initial intuitive response to the work can be summed up in one word:
 Expansive
 ...
 However! This analysis isn't about single word descriptions, but detailed consideration of individual works and how they unfold over time. This is one of the only works I encountered during this process of analysis, though, that I feel can be aptly summarised in a single word, and I'll begin by exploring what that word means as applied to this work as I encountered it.
 First the initial musical material itself. Released before this specific audiovisual realisation, *Open* is an hour-long exploration of and mediation on motifs and gestures that seem to borrow from jazz, free improvisation, ambience, minimalism and sound art without really settling into any of these 'genres' (if it's appropriate to call them that) as such. The band seem to know the conventions of each of the traditions from which they, on the surface, draw but are never fully compartmentalised within any of them; the sound is both familiar and not familiar, and the way in which the band improvise and work with the material is constantly surprising as it moves between the restrained to the heavily dynamic via everything in between. Ideas are stated, restated, reworked, revisited and moved on from in a way that feels not really bound by time; indeed, even the pauses and silences in the work feel like they invite

reflection on the musical material that has come before and consideration of what may come after. Here, the term *expansive* refers to the scale of the endeavour – an hour-long, continuous improvisation that moves through a range of timbral, textural and motivic palettes that are simultaneously distinct from and coherent with one another. But *expansive* also refers to the individual musical elements and how they relate to one another – each of the performers being in complete command of what they are doing, provoking response from their fellow musicians, continually expanding on the gestures they communicate and express with and between one another and expanding on the techniques and ways in which they explore ideas.

Then, the visual realisation of the work. Here expansive refers to the way in which musical materials are reflected and articulated visually, often in quite surprising and unexpected ways. As an example, in the second section of the work (I will discuss the structure in more detail below), the audiovisual relationship moves to a more direct, rhythmic or synchronised exploration. However, whilst there are times where sonic and visual gestures occur simultaneously, the musical material contains a number of pauses and, rather than pause at the same points, the visual material subverts our expectations by pausing still, but pausing out-of-sync or out of step with what is happening musically, often still rhythmically or just after/before a musical pause, encouraging the audience to pay attention not only to what the absences in the music reveal but also to how the absences in the visual material behave likewise.

Expansive also refers to the nature of the visual materials themselves, and how they are utilised and situated in this work. A combination of Landsat imagery with very close-up footage of paintings and materials in motion, the visual landscape presents a hugely expansive yet simultaneously intimate exploration of the materials involved in painting as though they were aerial photography of the earth itself, whilst also provoking the viewer to consider the intricate detail of the satellite imagery. The shapes and motions implied through the qualities and properties of these materials and how they interact with one another resonate very strongly with the Landsat photography, making it never quite clear whether one is looking at paint and water interacting or an aerial view of a dessert during rainfall, some graphite shavings or stars in the night sky. In both cases there is a familiarity and tangibility that does not quite engender legibility – we are conscious that we are looking at 'real' things we understand in some form, but are never fully sure of what that form is; this is an interesting correspondence with the musical material as it unfolds, containing rhythmically, melodically, harmonically and texturally familiar materials that we can never quite fully reconcile into one particular style or 'thing'.

The use of the term expansive here to qualify my initial intuitive response is perhaps suggested, not so subliminally, by the title of both the initial album (*Open*) and the subsequent audiovisual realisation of it (*Open Air*). However, whilst I use the term here to imply the size, scale and scope of the work, both

in its formal proportions and the way in which it presents its materials (in both audio-only and audiovisual form) I also use it here as one might refer to a person's mood as expansive – frank, relaxed, genial, communicative. There is a direct quality to the way this work is presented that invites interpretation but is also very specific about what it is; a tangibility without specific legibility, as highlighted previously. Expansive, for me therefore, feels like the most appropriate term to describe the overall experience of the work.

Shape

Individual elements	Compositional result
Shapes/gesture/motif/dynamics	Structure/form

Audiovisually, the work is built around repeated gestures and motifs that are restated and, in many cases, elaborated with each subsequent restatement. As an example of how this is specifically manifest audiovisually, in the final section of the work from c. 56:58 onwards, we hear initially a cymbal roll followed by a snare drum roll, the rhythmic motion of which is taken on and developed by other instruments in the work; similarly, this motion is initially reflected in the movement of what appears to be graphite powder as it is blown across a surface, before being taken on by coloured water moving around a central point, fire travelling across a page and clouds of powder seeming to erupt in channels of water. The perceptual correspondences here are quite direct; we see and hear a similar motion in the audiovisual materials being reflected subsequently by different instruments or voices in the palette. At other times, however, audiovisual reflections are less immediate and synchronous, being left to the viewer to infer; as described above, Section 2 contains a number of places where sonic pauses and visual pauses both occur regularly but are not synced with one another – there is an audiovisual coherence without a direct synchronicity.

Structurally, the work seems to broadly sit in six sections (see below) though there is significant motivic overlap between the sections such that exact timings are difficult to pinpoint; the below is more indicative of the general proportions and layout of the work rather than a specific indication of exactly when a section begins/ends.

Section	1	2	3	4	5	6
Timing	00:00:00– 00:09:30	00:09:30– 00:18:14	00:18:14– 00:33:15	00:33:15– 00:46:00	00:46:00– 00:56:58	00:56:58– 01:08:13
Duration	09:30	08:44	15:01	12:45	10:58	11:15

Colour

Individual elements	Compositional result
Pitch/tone	Timbre/texture

From the perspective of colour, pitch and tone, each of the sections defined above has a particular palette associated with it, though they are specifically a palette – a combination and amalgamation – as opposed to an exploration of one particular colour scheme or tonal centre. There is perhaps an intuitive sense of a central point and focus or concentration; as an example, Section 1 feels, to me, to explore a palette that is heavily red with a focus on A flat, while Section 2 feels more blue/green, but continues to explore A flat as one of its primary pitch-based motifs, alongside F and D flat (though much more rhythmically than in Section 1). Though these centres might provide a basis or pivot point around which the palette is clustered, each palette is nonetheless extremely varied – one Landsat photograph, for example, might have a predominant focus in the deep green of a particular landscape; there will nonetheless be reds, oranges, blues, yellows, blacks, whites and variations of all of these contained within the single image. The colours utilised act almost as fundamentals and partials of harmonics within the instrumental material they explore and reflect.

Texturally, there is a spatial quality to the work as a whole that is reflected in the often somewhat minimal musical materials (here meaning literally minimal, as opposed to stylistically Minimal) in combination with complex yet slowly moving or even static imagery. Throughout the work, there is a textural and timbral coherence between the audiovisual materials, such that the character of each subsequent section is distinct yet inextricably linked with what both precedes and proceeds it. There is also a timbral clarity to how each of the instruments and sound components is utilised, both in isolation and in relation to the other sound materials, which is reflected in the layering and foreground of particular shapes, colours or forms in the visual landscape.

Time

Individual elements	Compositional result
Rhythm/movement	Momentum/direction

As the work is of significant duration, and often explores gestures, motifs or ideas for extended periods of time within that duration, time itself as manifest

through rhythm and movement is explored or appears to behave differently in each subsequent section of the work. Interestingly, although this is not the case for the *whole* of each of these sections, Sections 1, 3 and 5 are often more spacious or elongated in their explorations, allowing more time for motifs to develop or, often, just sit for a while before progressing onwards, whereas Sections 2, 4 and 6 are more actively and persistently rhythmic and, as a consequence, seem to more actively precipitate forward motion. Momentum in the work seems to go in peaks and troughs, with areas in which much seems to happen to propel the work forward balanced against those that are more meditative or contemplative; yet there is a persistent sense of direction throughout, even when the work seems to pause for extended durations or dwell on one idea for what might almost be slightly too long.

Space

Individual elements	Compositional result
Location/place	Spaces/site

Location/place and spaces/site are interesting when considered in the context of this work, sonically, visually and audiovisually.

Sonically, we are relatively familiar with at least some of the instruments we are hearing – certainly piano, double bass and drums should be familiar to anyone encountering the work, and afford a certain amount of cultural situation, through our preconceptions and cultural expectations or associations with the sound of those instruments, if not necessarily within this direct musical context. However, there are also some more unfamiliar or less immediately legible sounds here; those of us familiar with technologically mediated music-making may be able to quite readily identify the likely sound sources and the ways in which they have been transformed for use in this work, whereas audience members less familiar with those traditions might struggle to recognise these sounds nor specifically equate them with particular sources or cultural expectations. Spatially, the overall effect of the musical material is consistent with what we expect of an album of this type; it exists in its stereo form suggesting both live interaction and performance alongside studio recording and configuration. What is less clear is the configuration of the work as a spatial entity and the musicians within that space; the polished stereo production removes all artefacts associated with the live performance beyond the actual sounds of the instruments themselves, leaving the musical material disembodied from the artists who mediate it which feels a little odd in a recording of a band who are so much about process and communication, and whose musical material suggests this so directly.

Visually, we are presented with a range of materials and environments that are familiar, broadly recognisable and that we understand to be tangible or real, but which we might find difficult to identify as belonging to a specific

thing or a specific location. The satellite imagery allows us to identify coast lines, cloud formations, agriculture, human intervention in the environment and prior knowledge of the artists involved in the work might afford the relatively safe assumption that the landscapes being explored belong to various different locations in Australia. However, whilst the general shapes, form and syntax in the landscape might make them recognisable as being physical locations, the specific places they belong or refer to remain opaque, except perhaps to those very familiar with the environment. Similarly, the close-up footage of paintings and materials is similarly ambiguous; we are broadly familiar with the materials we are seeing and how they interact, but are unable to see the broader composition they refer to or attach them to one specific visual construct.

Audiovisually, this combination of implied legibility with simultaneous ambiguity in the layers of audiovisual material and how they are combined creates a feeling of audiovisual coherence that persists throughout the work, almost irrespective of the nature of the moment-to-moment relationships between the sonic and visual materials. The work is both located in, and somehow outside of, the aesthetic, spatial and cultural associations that each of its constituent materials points to, and the ambiguity this creates facilitates the creation of a third audiovisual space that is somehow 'other', neither specific to nor a departure from the context of any of its component parts - an effective audiovisual synergy.

Layers of engagement

Experiential layer

As with the other works in this section, I have sought to experience this piece in a range of technologically mediated contexts, being unable to engage with it in any 'live' experiential context. Perhaps unsurprisingly, the visual materials in the work were best experienced as large as possible in as high a quality as possible, as there is so much detail in the imagery used here. The musical material seemed to lend itself equally well to playback on speakers and monitoring headphones, though was (again, unsurprisingly) less detailed through lower quality earbuds. A large HD screen and monitor speakers in combination seemed to be the most appropriate mediation for the work, allowing the spatial aspects of the musical material to be most directly presented and explored, and creating more of a sense of the music happening within that space and time as opposed to being played back by a recording.

Personal contextual layer

This is a slightly complex, multifaceted layer in this case. I have been familiar with the work of the Necks for many years, and have seen them perform live in the UK. I was also familiar with *Open* prior to encountering *Open*

Air, though prior experience or familiarity with the audiovisual artefacts was something which I specifically sought to avoid in encountering these works. Nonetheless, although *Open Air* presents an entirely different encounter with the work, my previous experience of the auditory component of the work will no doubt have coloured my expectations of how the audiovisual materials would interrelate.

I have also spent some time in conversation with Grayson Cooke, who I did not know prior to beginning work on this volume but with whom I have discussed the results of the questionnaire in Section 2 and issues relating to audiovisual composition more broadly. My, albeit relatively limited, knowledge of his process and practice will no doubt have impacted on my expectations of the work and, potentially, the way in which I might have expected the audiovisual realisation of the piece to unfold.

Critical contextual layer

The critical contextual layer in this case could draw from the extensive reception history of the Necks as a band, the media art practices of Cooke himself or the context surrounding the work of painter Emma Walker. Indeed, engagement with all of these contexts might provide the most complete picture of the work as a collaborative effort involving these particular artists. However, one of the more interesting aspects of this work, I feel, is that prior to engaging with the work myself in full, having discussed aspects of it with Cooke he described it as being both 'visual music' and 'music video' yet also not really being either. Indeed, it would be easy to see how this designation might be apt. There are certainly moments here that speak to our broad understanding of the historical preoccupations and ethos of visual music in expressing musical structures in visual terms; this is evident in a number of specific areas in the work, many of which are discussed earlier in this analysis. Consequently, we might attempt a consideration of the work as a form of visual music, and assess it against our frameworks for encountering works of that kind. Equally, being an audiovisual representation and reflection of a commercially released album speaks towards the artefact being considered a form of music video, though typically music video is concerned with rendering individual tracks as opposed to full albums (though the Necks have often eschewed traditional forms) and indeed the majority of the scholarship on music video, including Vernallis's *Experiencing Music Video* (2004), deals with short form music video, typically involving lyrics, and bases its analysis on the interplay between music, image and text. This work is without lyrics, and indeed is without the traditional structures associated with popular song (verse, chorus, bridge, middle 8, etc.), so becomes quite difficult to encounter in the critical context of music video. It is also over an hour long, and consequently quite a departure from the majority of music videos one might expect to encounter and deal with utilising Vernallis's framework.

Earlier in this volume, I talk briefly about Matthias Weisse's article on the (in)differentiability of music video and visual music, and this might seem like a useful touchstone here; however, although the ethos of that chapter might be apt to encountering this particular work, the analytical examples it cites equate visual music specifically to a history of VJ-ing as opposed to the historical precedents suggested by this work. Perhaps also potentially resonant here is Holly Rogers's discussion of the unification of the senses in 20th-century video art, in which she states:

> although video art–music appears to lack a history, this is illusion; rather, it harbours **a double past, an excess of history**. Arrival at the 'new' genre was achieved neither by progressing in any one direction, nor by developing a particular form, but by **merging a musical and an artistic past, two strands that fully come together** only during video art–music's 'constitution'. Rather than a type of music developing into a musico-visual experiment, or a traceable art-history lineage evolving into video work, the genre is better considered as the child of performance space experimentation; the result of an increased interest in the interaction of media with its spectators.
>
> But once **context is taken into account, music and art in the 20th century cannot coherently be discussed as individual disciplines, but rather encourage a more lateral history or spatial sensibility that moves fluidly through the space between them**. A detailed interdisciplinary account in turn establishes video art–music as an audiovisual form with a rich and complex history, despite its appearance of 'newness'. With this in mind, it is possible to rephrase Bartlett's enthusiastic exclamation that a 'whole new story was about to be told thanks to the new techniques'. By relocating his emphasis from the tale to the telling, it can be suggested that during the 1960s there developed a whole new way of recounting two well-known stories" (Rogers, 2011, p. 427, emphasis mine).

Whilst Rogers is speaking here specifically to the development of what she describes as video art–music, and indeed to some specific examples from the middle part of the 20th century, there is certainly a resonance here if we consider this particular cultural artefact not as emerging from a lack of history – or indeed a lack of precedent – but from an excess or combination of it. The work could be positioned as both visual music and music video, whilst simultaneously being neither. It draws from both musical traditions (The Quietus suggest, for example, that The Necks 'lie somewhere in the fluctuating limbo between minimalism, jazz, and Krautrock' (Southall, 2013, para. 1), though I might suggest other genres that feel more apt to my own experience of their music) and visual/media art traditions, through the context and history of the two visual/media artists who developed the visual component of the work. It both suggests live performance, through the recordings of the musicians playing together, yet also suggests more opaque and disembodied studio

practice. It implies a particular space and site, whilst also not specifically referring to any particular one. In almost all of its aspects – other than that we can define it as containing sounds and visual materials, that it is audiovisual – it defies any coherent or stable categorisation based on the critical contexts we currently possess within which to situate it.

To encounter *Open Air* is to encounter an audiovisual work that exemplifies much of the ethos of this book and of audiovisual practices more broadly. It is open to interpretation, to characterisation, to context, to situation. It sits between critical, personal, experiential and perceptual contexts, speaking to a number of them, yet never firmly being rooted within any specific one. Consequently, it embodies the ethos of audiovisual composition as understood by this book and its author – that, regardless of the artists, materials, means, histories and contexts surrounding the work itself, the work speaks both sonically and visually, and in so doing speaks to the spaces between the histories and contexts of both its sonic and visual materials whilst never being fully definable within either one of them. It is a transperceptual experience.

Intentional layer

Having completed the analysis above, I spent some time discussing *Open Air* and my responses to it with Grayson Cooke, the media artist behind the audiovisualisation of the work. Cooke had read my analysis beforehand, so we were able to discuss not only his experiences in putting the work together, and the intentions and designs underpinning the audiovisual outcome, but also my analytical interpretation of the work.

Broadly, Cooke felt that the analytical work I had done was intuitive and insightful, and identified and explored many of the structural, aesthetic and conceptual considerations underpinning his approach to the work, for example, the structure of the work as broadly falling into the six sections above, alongside the relationship between sonic and visual pauses and the Landsat/ painting imagery resonated with his intuitive understandings of putting the work together.

So many interesting things emerged through the discussion with Cooke, which significantly enhanced my own understanding of the work. Perhaps one of the most interesting was that the painter Emma Walker, the exploration of whose work formed one of the main visual materials for this realisation, paints whilst listening to the Necks and is good friends with the band. This raises interesting questions about whether we might see a somewhat recursive audiovisual relationship developing here; visual materials that are developed whilst listening to specific music are themselves then enacted to create a visual rendering of those musical materials. Indeed, *Open Air* as an artefact initially evolved through Cooke and Walker working with these combinations of visual materials, attempting to find something to edit their materials to and settling on the Necks – the synergy between audio and visual

material this facilitated then leading them to approach the Necks to create an audiovisual rendering of Open. It is interesting to consider, though impossible to quantify, the extent to which Walker's paintings embody aspects of the Neck's music, and whether this intuitive relationship forms an aspect of what makes *Open Air* a successful audiovisual artefact.

Cooke and I also talked a little about the 'ideal' environment in which to present the work, and he felt that the expansive nature of the materials would lend itself best to very large projection, in a darkened, comfortable space with excellent quality sound. That being said, many of the manifestations of the work in gallery spaces have been on much smaller screens, often with headphones; whilst this is far from ideal, it does open the work up to other audiences, which in an environmentally situated work of this kind is important.

Reflections

In constructing the analyses in this section, a pivotal moment was encountered when interrogating Mariska de Groot's *Cinechine*, specifically when considering the work in light of Adam Basanta's analytical framework for encountering Luminosonic works (Basanta, 2012). I will preface this section of my discussion by stating that I hold Basanta's work, and indeed the analytical models of Chion and Coulter that he draws from, in high esteem and feel that there is much to be learned from these discursive frameworks in terms of how we encounter and categorise audiovisual works. However, having designated de Groot's work as 'physically isomorphic' according to Basanta's three-dimensional categorisation, I realised that although this described and, according to the framework, defined the work with respect to certain components of its physical and perceptual qualities, it actually revealed almost nothing about the work itself. To further illustrate my point here, I will use a rather rudimentary but, I hope, an illustrative example.

I say to you "there is a chair over there". You are unable to see the chair, but perhaps your mind conjures up an image of a particular chair or a general idea of what said chair might look like; for me, when thinking of a chair, I see a simple, wooden framed example such as one might sit at a school desk (this perhaps reveals a great deal about my childhood experiences, and experiences with chairs, but that is for a later discussion!).

By saying "there is a chair over there", I am letting you know that an object exists with a particular function; we know what a chair is, we understand that it is a thing that can be sat on, we broadly appreciate the context of 'chair'. Insofar as defining the function of the thing, saying 'a chair' is sufficient – it tells us something about the essentials of the thing, enough that we would need to know in order to encounter it in a particular way.

However, what it does not tell us is:

Where is the chair?
What is the chair made of?
How is it shaped?
How does it smell?
What does it feel like?

Is it cushioned?
What colour is it?
How old is it?
Is it in good condition?
Are there things around the chair?
Are there things on the chair?
Can the chair be sat on – is it upright? Is there something on it? Is it still in one piece?
Who made the chair?
What did that maker intend?

There is a huge network of conceptual, contextual and perceptual affordances attached to any one particular chair – the chair in question might be an arm-chair, a Bauhaus Wassily, an Eames Classic, this or a plastic stool from Ikea. It might have cushions on it, be intended for a child, or even be a piece of dolls house furniture. It could be contained within a well-lit, white-walled minimal loft, in a small rural cottage, within a museum, in a derelict castle, on a carpet, on linoleum tiling, or on parquet flooring. Each of these layers or affordances tells us something about the chair – provides more detail, allowing us to understand something about this *particular* chair. Analysing the works above as I have done allows me to interrogate multiple aspects of the works in question and my responses to them, without reducing them to specific categories or potential redundancies that tell us little about the works as creative artefacts. It could be argued that identifying particular features within the work, such as considering the works through the lens of the elements of audiovisual composition, could itself be somewhat reductive or redundant; and indeed, if that were as far as the analysis went that may be true. But through looking at other layers of engagement around that, and considering and interrogating my personal responses to the work, this affords a more multifaceted level of engagement that situates those elements within my broader, individual context.

To return to de Groot's work, I believe the comparison was drawn at this point because not only was I engaging with a particular work but also I was exploring three different manifestations of that work, each in many ways radically different than the last, as a recomposition but also as a site-specific rendering. Whilst all of them were fundamentally audiovisual installations – consisting of what Basanta would describe as Luminosonic objects – and could be defined as being *physically isomorphic* (2012), the designation of phys-ical isomorphism revealed very little about the work itself and, crucially in this particular case, how it responded to the space in which it was situated. It told me nothing about the compositional processes involved, what the com-poser intended in approaching the work each time, how I responded to it, what my personal arts practice and experience allowed me to bring to the ex-perience of the work and how that affected my reading of it. Viewed through the lens of a consideration of existing analytical frameworks, in attempting to

develop ways to encounter audiovisual work from an analytical perspective we have potentially lost one of the key components of engaging with a work of art – the broad network of affordances of a creative artefact and the range of contexts in which it is situated and which we bring to it.

I am reminded here of an editorial by Professor Tony Myatt for a 2008 edition of Organised Sound on *New aesthetics and practice in experimental electronic music*, an editorial which has long struck a chord with me and which presents a perspective which is resonant with my own, both in the contexts of this volume and that in which the editorial was originally offered. Rather than paraphrase, I will allow Myatt's words to speak for themselves:

> I regularly read extended metaphors coined to describe and analyse electronic music and continue to see myths, which have been perpetuated for as long as I can remember, as the foundation of many discussions (I paraphrase): 'any sound imaginable can be created by computers, there are an infinite number of possibilities', 'the computer is a sonic-prosthetic', 'it is important that the microstructure of the work is reflected in the macrostructure' and many other similar statements with which I could fill an issue of the journal.
>
> What do these statements mean? What and moreover who are they for? Should we question traditional rhetorics or accept them as unassailable musical truths? Are we representing the body of research and practical experiences amassed in the field over sixty years or re- visiting the same territories? A careful analysis of the logical construction of many descriptions unfortunately reveals little about music per se. Additionally, the endless discussion of the implications of Schaeffer's work, spectromorphology, and rather circuitous discussions of new terminologies for surround sound, musical gesture, ever more complex categorisations of sound accompanied by correspondingly complex diagrammatic representations of (and I open an issue of the journal at a random page, then seek the nearest categorisation) 'sustained, impulse, iterated, composite and accumulated sound'. Are we lacking definitions of these terms? (No) Once again, many discussions appear to reveal more about their authors than their subject...
>
> I would like to end this editorial comment with a simple call for a future discourse on electronic music that can provide accurate and factual descriptions of sounds and music in the context of contemporary cultures, economies and philosophies, particularly in relation to the function of music and of musical research within the societies and communities who support it.
>
> (Myatt, 2008, p. 6)

Myatt's point here reflects my own approach in attempting the analyses of these works; there are an increasingly complex array of terminologies and models within which we might attempt to situate, for example, de Groot's

work or any of the works in this section – indeed, as we have seen this can be done quite convincingly, suggesting that the models developed are in many ways appropriate and effective insofar as they approach definition or categorisation. What that doesn't tell us is anything about the work itself, the experience of it, the intentions behind it or its broader context, either from an individual or situated perspective. Whilst we might be able to glean some fundamental, specific information about a given work through categorising it in absolute or functional terms – as I have in defining the works in this section as 'fixed media', 'performance', 'installation', etc. – that tells us very little about the work itself. By categorising a work in specific terminology, or referring to the audiovisual relationships developed in it as, for example, physically isomorphic, we don't learn anything about the work beyond its specifics – to return to the analogy of the chair, we force the thing to remain a 'chair' in the abstract, as opposed to a concrete instance of a chair within its own specific context – we don't acknowledge or interrogate the 'chairness' of the chair.

I use the term affordances above, a term which we now intuitively understand and successfully apply in a range of contexts, but it is worth here exploring the genesis of this term and the man who proposed it as the psychological principles it defines might be usefully applied here. Proposed by J.J. Gibson, initially in his 1966 book *The Senses Considered as Perceptual Systems* but significantly expanded in his seminal work *The Ecological Approach to Visual Perception* (1979), affordances refer to the things offered by an environment to an animal and vice versa in a complementary relationship, usually now boiled down to the fundamental properties an object or thing has which suggest how it can be used. However, potentially most interesting here is a sidebar to the discussion of affordance within Gibson's 1979 text, which states:

To perceive an affordance is not to classify an object

> The fact that a stone is a missile does not imply that it cannot be other things as well. It can be a paperweight, a bookend, a hammer, or a pendulum bob. It can be piled on another rock to make a cairn or a stone wall. These affordances are all consistent with one another. The differences between them are not clear-cut, and the arbitrary names by which they are called do not count for perception. If you know what can be done with a graspable detached object, what it can be used for, you can call it whatever you please. The theory of affordances rescues us from the philosophical muddle of assuming fixed classes of objects, each defined by its common features and then given a name. As Ludwig Wittgenstein knew, you cannot specify the necessary and sufficient features of the class of things to which a name is given. They have only a "family resemblance." But this does not mean you cannot learn how to use things and perceive their uses. You do not have to classify and label things in order to perceive what they afford.
>
> (Gibson, 2019, p. 134)

Gibson is speaking specifically to our visual perception of objects, but there is nonetheless something tempting here about applying this thinking to the analytical consideration of the works approached in this chapter and, indeed, in potentially considering Wittgensteinian concepts of language and language games as a metaphor or allegory for the analytical discussions being attempted above. Wittgenstein suggests that language is effectively meaningless outside of context; using the example of the term 'game', defining something as a game without consideration of the broader context of that game – board, video, Olympic – reveals very little about the meaning or construct of the game or what the term 'game' actually means (Burbules, 2006, p. 38). Similarly, Gibson's affordances, in isolation, do not classify a thing as being only a specific thing, and the arbitrary names by which things are termed do not qualify our perception of them.

The analyses attempted in this section proceed from the recognition that there is a family resemblance between all of these works – they are all audiovisual. But defining them as such or indeed attempting to categorise them as a single 'thing' within that family resemblance tells us relatively little about the work in its broader context, and reveals little about the individual networks of contexts and meanings associated with each of the works, either the ones it holds or the ones we bring to it. The kind of personal, interpretive analysis being proposed in this section might, ultimately, prove not to be a useful framework within which to explore creative artefacts, but I would argue that an attempt to take a more holistic view of a work and our responses to it cannot help but extend our knowledge of it as a thing, and our knowledge of ourselves in response to it, and indeed, it in response to us.

Here, I must once again return to the writings of Salome Voegelin but seek to apply them audiovisually and transperceptually. Voegelin writes:

> My room transcribes not the heard in isolation but composes its sociality: the hearing of myself in the social context of a room, my soundscape, a position and its consequence, which these words are trying to reflect on and share. My writing might not achieve this sociality but the impetus of its practice lays in that aim: its motivation comes from the desire to share the heard without reducing it to the description of its source or the structure of a pre-given register. Instead, I use words to grant you access to sound's present unfolding, for you not to hear the same, but to hear its possibilities.
>
> (Voegelin, 2014, pp. 1–2)

This sociality is what is intended in these analyses, not reducing the works to a description of their source or technology, or the parametric audiovisual mappings they might exhibit, but opening up the possibilities of the work through my personal and situated experience – to allow inroads to exploring transperceptual experience.

Epilogue – final reflections

Attempting this book has been a labour of love and has prompted me to ask a lot of questions about the work I do, the context(s) it sits in, the field as a whole (if there is such a thing) and my place within it. It has also brought with it a recognition: that I know relatively little.

I say this not to be flippant or self-effacing, but because I think it is an important thing to acknowledge. That one of the things writing this book has forced me to do is to consider, interrogate and evaluate what I *do* know, and find the gaps, omissions and areas of my knowledge that are less well developed. Specifically, it has made me confront the limits of the disciplinary bubble in which I usually operate, and pushed on the membrane of that bubble to allow the inclusion of perspectives and ideas from well outside of its usual remit.

This book is a treatise on how I compose, and although I suspect this will be of limited practical use to many people it affords the opportunity to explore how an audiovisual composer in 2020 approaches their work. It is a discussion of audiovisual pedagogy, which I hope will find some practical application. It is a collection of views, ideas and perspectives from a large number of contributors, many of which have considerable overlap and, I hope, account for at least *some* contemporary perspectives on what 'audiovisual composition' might be. It attempts analysis of a number of audiovisual artefacts, most of which would not typically be encountered within the same volume as they draw from and are related to very different arts traditions. The analyses it attempts are both personal and situated, and involve intuitive, structural and critical consideration of the artefacts they encounter. It tries to find ways to describe audiovisual experience, and to suggest processes for engaging with audiovisual modes. It advocates transperceptual attention as a means to encountering audiovisual works regardless of their mode, genre, style or function, and in so doing I hope can facilitate the ongoing development of a discourse around thinking, composing and analysing audiovisually.

However, it is only one relatively short book, and it has become abundantly clear in attempting this volume that the extent of the detailed knowledge and experience necessary to account for audiovisual composition as a collection of transdisciplinary practices is far more than one single scholar can offer. It is

possible to relate the practices, art works and artists in this book to an almost unlimited array of research areas, such that for each thing I read in preparing this work at least ten more research sources suggested themselves – to the point where I eventually had to draw a line and say 'no more'! But acknowledging the gaps in our knowledge and processes should be an essential part of transdisciplinary discourse and dialogue, and being open to potential ways in which that dialogue might be shaped in future – rather than setting out a concrete and immovable set of positions and principles – should be fundamentally inherent to the ethos of that discourse. This book is not exhaustive, and nor should it be – it is a starting point. An offering. A possible way to proceed in our thinking, composing, analysing and teaching practices related to the audiovisual, which is open to interpretation and, indeed, contradiction in the pursuit of advancing the discourse.

Nonetheless, this section *is* the conclusion – the final reflection on what has come before – and as such it is the place in which I, ultimately, set out my store. So, these are the central things this book argues:

• **That composing audiovisually describes the act of creating with sound and visual materials in such a way as to consider them as being of equal importance in the conception, development, realisation and outcome of the work.**

This does not apply to or imply particular types/genres/styles/modes of working with sounds and images but is instead a guiding principle – an ethos in working in the transdisciplinary audiovisual medium. It also does not imply that the act must be an individual one – audiovisual composition can absolutely be a collaborative act. Nor does it suggest that it should all happen at the same time – as can be seen with the recomposition or setting of works such as Walter Ruttmann's Opus 1, or with the distance between the composition of the album and the subsequent visual realisation of *Open Air* (2016), effective audiovisual composition can absolutely involve working at a temporal distance.

• **That we can think about how to approach audiovisual composition through considering how elements of audiovisual composition are developed, both individually and together, and the results of combining these elements.**

As described in Section 2 of this book, and building on the descriptions of elements of composition taken from a range of different disciplinary perspectives, the following categories and subdivisions might provide an initial starting point in thinking about how to compose with sounds and images. This framework considers both individual elements and the compositional effect of those elements within the work, utilising terms that are both well

understood but whose meanings have sufficient dynamism and fluidity to allow them to speak to transperceptual works and processes.

Category	Individual elements	Compositional result
Shape	Shapes/gesture/motif/dynamics	Structure/form
Colour	Pitch/tone	Timbre/texture
Time	Rhythm/movement	Momentum/direction
Space	Location/place	Spaces/site

• **That experiencing audiovisual works necessitates transperceptual attention and that, in turn, composing, thinking and analysing audiovisually are transperceptual acts.**

This is the recognition that the act of engaging with audiovisual works necessitates attention to the sonic and visual components of the work both in isolation and as they relate to, and affect, one another. It also necessitates attention to our bodily and embodied experience of the work within its broader situated context, the other perceptual modes it engages, and the complex meshwork of personal and cultural experiences, expectations and preoccupations we bring to it and experience with and through it. The term transperceptual here means to attend to the work using multiple different perceptual modes, whilst also considering the spaces between and across perceptual and contextual experiences.

Transperceptual attention is an apperceptive act in which I specifically attend to sight and sound and their interaction, and encounter other perceptual and contextual modes in light of that interaction.

• **That we can begin to encounter audiovisual works using the following four steps/processes:**

1. Hear/look – *Sentire* (to sense)
 Begin by intuitively experiencing and sensing the work, on almost a passive level, without trying to think about the work, the media, what they are individually, what they are together, how they were made. Just experience, sense, hear and look.
2. Listen/see – *Audire* (to hear, to review)
 Begin to think more critically and in detail about what you are seeing/listening to and consider how to apply meaning. This might be specific/intrinsic meaning, or might be more intuitive – how does the combination of sound and image construct meaning *for you*? Are there specific things the work is trying to say or speak to, or things it is attempting to address? Within this particular component of engaging with the work, we might begin to consider some of the elements of audiovisual composition suggested above.

3. Think/engage – ***Cogitare*** (to ponder, to think)
 Consider what you know about the work, the artist, the broader
 contexts, the way in which it might be described. What kind of
 work is this? How can this or does this contextual awareness shape
 how you experience the work?
4. Understand/reflect – ***Intelligere*** (to understand)
 Combine these layers of perceptual experience with contextual ones;
 bring them together, ask how they relate to one another and how
 they shape one another. How does (or simply *does*) this help to codify
 your experience of and response to the work?This should also be a
 recursive process, constantly open to reconsideration and reinterpre-
 tation, in light of new experiences, new ideas and changes in per-
 spective. Much as with the listening modes described above, or the
 suggestions for ways to encounter visual work, this is in reality not
 necessarily a compartmentalised process.

• **That attempting to analyse and interrogate our encounters with
 audiovisual work should be both personal and situated.**

That in encountering audiovisual work, or indeed in encountering artworks
of any kind, we should not only be interrogating the work but also our re-
sponses to it and the things we bring with us into experiencing the work;
further, this should be a recursive and reflective process. That there is no such
thing as an objective encounter with a piece of art, or its encounter with us.
Much as Voegelin describes of sonic possible worlds

> there is also my reciprocity: my being in the sonic environment and it
> being through my being part of it. This aspect allows me to reflect on
> myself as a sonic subject: I create my sense of the work, and my sense of
> self, through the experience of inhabiting this work as world
>
> (Voegelin, 2013)

So we can apply this process to our construction of individual, situated audio-
visual experience.

• **That individual, disciplinary perspectives can reveal useful
 things about a piece of work, but not everything.**

That each work, in turn, can be read through a range of disciplinary perspec-
tives, traditions and histories, and that these readings can fill in contextual
gaps in our understanding of the work, but that they should not be seen as
the only way to encounter a piece of work. Indeed, that our own critical con-
textual understanding of a piece of work can be radically different to that of
another audience member, or the artist(s) themselves, and that this recursive

process of encounter and reencounter can enrich our own understanding of how we act with a work, and how it acts with us.

- **That it is possible to apply a transdisciplinary, transperceptual approach to audiovisual practices to encounter works from across a range of disciplinary and contextual backgrounds from a level footing.**

And related:

- **That this transdisciplinary, transperceptual approach marks the beginning of a potential discourse, but that much more needs to be done.**

The above is a reflection of the key things I have learned in the construction of this volume, but as I have made clear from the outset this is a beginning – a set of potential starting points and avenues for further discussion and possibilities for future conversations. In acknowledging that this is a vast and transdisciplinary field that this book serves merely to scratch the surface of, I invite other artists and theorists from across all relevant disciplines to discuss this with me, to push back, to disagree, to counter, to point out gaps, to enrich – and ultimately to shape, sculpt and assemble a discourse that we can take forward to our encounters with, and our making of, audiovisual works.

Bibliography

Alves, B., 2005. Digital harmony of sound and light. *Computer Music Journal*, 29(4), pp. 45–54.

Alves, B., 2012. Consonance and dissonance in visual music. *Organised Sound*, 17(2), pp. 14–19. https://doi.org/10.1017/S1355771812000039.

Andrews, I., 2013. Post-digital aesthetics and the function of process. In Cleland, K., Fisher, L. & Harley, R. Proceedings of the 19th International Symposium on Electronic Art, ISEA2013, Sydney

Auslander, P., 2006. The performativity of performance documentation. *PAJ: A Journal of Performance and Art*, 28(3), pp. 1–10.

Azevedo, I. and Sandford-Richardson, E. 2017. Sonorous images through digital holographic images. *Practical Holography XXXI: Materials and Applications*, 10127, pp. 1012707. https://doi.org/10.1117/12.2250508.

Barad, K., 2012. On touching – the inhuman that therefore I am. *Differences*, 23(3), pp. 206–223.

Barnes, R., 2007. Barton Fink: atmospheric sounds of the creative mind. *Scope: An Online Journal of Film Studies*, 9. https://offscreen.com/view/barnes_bartonfink

Basanta, A., 2012. Shades of synchresis: a proposed framework for the classification of audiovisual relations in sound-and-light media installations. In *Proceedings from Electroacoustic Music Studies Conference*, Stockholm.

Bassett, C., 2015. Not now? Feminism, technology, postdigital. In Berry, D. and Dieter, M. eds., *Postdigital Aesthetics: Art, Computation And Design* (pp. 136–150) Springer.

Battey, B., 2015. Towards a fluid audiovisual counterpoint. *Ideas Sónicas*, 17(4), pp. 26–32. http:// http://www.sonicideas.org/

Battey, B. and Fischman Steremberg, R.A., 2016. Convergence of time and space: the practice of visual music from an electroacoustic music perspective. In Kaduri, Y. ed., *The Oxford handbook of music, sound, and image in western art*. Oxford University Press.

Biesenbach, K., Ross, A., Dibben, N., Morton, T., 2015. *Björk: archives*. Museum of Modern Art.

Bjork. 1993. *Human behaviour*. https://www.youtube.com/watch?v=p0mRIhK9seg. Accessed 27th October 2020.

Black, M., 1979. Wittgenstein's language-games. *Dialectica*, pp. 337–353.

Bloch, M., Lave, J. and Wenger, E., 1994. Situated learning: legitimate peripheral participation. *Man*. https://doi.org/10.2307/2804509.

Blum, S., 2012. Composition. *Grove Music Online.* https://www.oxfordmusiconline. com/grovemusic/view/10.1093/gmo/9781561592630.001.0001/omo-9781561592630-e-0000006216?rskey=tiF5iW&result=1

Born, G., 2017. After relational aesthetics: improvised music, the social, and (re) theorizing the aesthetic. In Born, G., Lewis, E. and Straw, W. eds., *Improvisation and Social Aesthetics* (pp. 33–58). Duke University Press.

Bourriaud, N., [1998]2002. *Relational aesthetics*, trans. Simon Pleasance and Fronza Woods with the participation of Mathieu Copeland. Les Presses du réel.

Brougher, K. and Zilczerm, J., 2005. *Visual music: synaesthesia in art and music since 1900.* Museum of Contemporary Art, Thames and Hudson.

Bryant, L., Srnicek, N. and Harman, G. eds., 2011. *The speculative turn: continental materialism and realism.* re.press.

Burbules, N.C., 2006. Lyotard on Wittgenstein: the different, language games, and education. In Dhillon, P. and Standish, P. eds., *Lyotard: just education* (pp. 36–53). Taylor and Francis.

Cambridge Online, 2020. *Cohesion.* https://dictionary.cambridge.org/dictionary/english/cohesion. Accessed 24th August 2020.

Candy, L., 2006. Practice based research: a guide. *CCS Report*, 1, pp. 1–19.

Carvalho, A. and Lund, C., 2015. *The audiovisual breakthrough.* Collin & Maierski Print GbR.

Cavanagh, P., 2013. The artist as. *Nature.* http://www.jstor.org/stable/2930183. Accessed 1st November 2020.

Centre for Visual Music, 2020. *Home.* http://www.centerforvisualmusic.org. Accessed 23rd November 2020.

Ceraso, S., 2018. *Sounding composition: multimodal pedagogies for embodied listening.* University of Pittsburgh Press.

Chion, M., 1994. *Audio-vision: Sound on Screen.* Columbia University Press.

Chion, M., 2012. The three listening modes. *The Sound Studies Reader*, pp. 48–53.

Chion, M., 2013. The audio-logo-visual and the sound of languages in recent film. *The Oxford handbook of new audiovisual aesthetics*, p. 77.

Chion, M. and Gorbman, C., 2019. *Audio-vision: sound on screen.* https://doi.org/10.7312/chio18588.

Cook, N., 2002. *Analysing musical multimedia.* Oxford University Press.

Cooke, G., 2015. Performing archival remix in outback and beyond. *International Journal of Performance Arts and Digital Media*, 11(1), pp. 100–115. https://doi.org/10.1080/14794713.2014.960673.

Cooke, G., 2017. Start making sense: live audio-visual media performance start making sense: live audio-visual media. 4713 (February). https://doi.org/10.1386/padm.6.2.193.

Coulter, J., 2010. Electroacoustic music with moving images: the art of media pairing. *Organised Sound*, 15(1), pp. 26–34.

Curtis, R., 2016. Immersion and abstraction as measures of materiality. In Liptay, F. and Dogramaci, B. eds. *Immersion in the visual arts and media* (pp. 40–64). Brill Rodopi.

Daniels, D., and Naumann, S. eds., 2010. *Audiovisuology: an interdisciplinary survey of audiovisual culture.* Compendium, Walther König.

de Groot, M., 2020. *Cinechine.* http://www.mariskadegroot.com/projects/cinechine/. Accessed 27th October.Dibben, N., 2006. Subjectivity and the construction of emotion in the music of Björk. *Music Analysis*, 25(1–2), pp. 171–197.

Dibben, N., 2009. *Björk*. Indiana University Press.

Dohmen, R., 2013. Towards a cosmopolitan criticality: relational aesthetics, Rirkrit Tiravanija and transnational encounters with pad Thai. *Open Arts Journal*, (1), pp. 35–46.

Domingues, D., and Reategui, E., 2005. Collaborative and transdisciplinary practices in cyberart: from multimedia to software art installations. *Media Art History*. http://www.mediaarthistory.org/wp-content/uploads/2017/12/DDomingues.pdf. Accessed 30th October 2020.

Dunaway, J., 2020. The forgotten 1979 MoMA sound art exhibition. *Resonance: The Journal of Sound and Culture*, 1(1), pp. 25–46.

Edmonds, E. and Candy, L., 2016. Relating theory, practice and evaluation in practitioner research. *Leonardo*, 43(5), pp. 470–476.

Edmonds, E.A., Weakley, A., Candy, L., Fell, M., Knott, R. and Pauletto, S., 2005. The studio as laboratory: combining creative practice and digital technology research. *International Journal of Human-Computer Studies*, 63(4–5), pp. 452–481.

Eisenstein, S., 1957. *Film form [and]: the film sense; two complete and unabridged works*. Meridian Books.

Fabe, M., 2014. *Closely watched films: an introduction to the art of narrative film technique*. University of California Press.

Fisher, M., 2012. What is hauntology? *Film Quarterly*, 66(1), pp. 16–24.

Fox-Gieg, N., Keefer, C. and Schedel, M., 2012. Editorial. *Organised Sound*, 17(2), pp. 7–102. https://doi.org/10.1017/S1355771812000015.

Frodeman, R. and Mitcham, C., 2007. New directions in interdisciplinarity: broad, deep, and critical. *Bulletin of Science, Technology & Society*, 27(6), pp. 506–514.

Fuxjäger, A., 2012. Translation, emphasis, synthesis, disturbance: on the function of music in visual music. *Organised Sound*, 17(2), pp. 20–27. https://doi.org/10.1017/S1355771812000040.

Garro, D., 2005. A glow on Pythagoras' curtain: a composer's perspective on electroacoustic music with video. *Electroacoustic Music Studies*. http://www.ems-network.org/spip.php?rubrique34.

Garro, D., 2020. Connected media and connected idioms. In Knight-Hill, A. ed., *Sound and image: aesthetics and practices* (pp. 1–12). Focal Press.

Garro, D., 2012. From sonic art to visual music: divergences, convergences, intersections. *Organised Sound*, 17(2), pp. 3–13. https://doi.org/10.1017/S1355771812000027.

Gavin, F., 2013. *Pearl vision*. https://fourthree.boilerroom.tv/film/pearl-visions. Accessed 27th October 2020.

Germer, M., 2001. The new grove dictionary of music and musicians, 2nd ed. (Review). *Notes*. https://doi.org/10.1353/not.2001.0195.

Gibson, J.J., 1966. *The senses considered as perceptual systems* (Vol. 2, No. 1, pp. 44–73). Boston: Houghton Mifflin.

Gibson, J.J., 2014. *The ecological approach to visual perception: classic edition*. Psychology Press.

Gjerdingen, R.O., 1994. Apparent motion in music? *Music Perception*, 11(4), pp. 335–370.

Gorbman, C., 1987. *Unheard melodies: narrative film music*. Indiana University Press.

Gorea, A., 1991. Thoughts on the specific nerve energy. *Representation of vision. Trends and tacit assumptions in vision research* (pp. 219–229). Cambridge University Press.

Grierson, M., 2018. The CodeCircle platform. *The Routledge research companion to electronic music: reaching out with technology* (p. 312). Routledge.

Haddon, M., 2019. Warp's music videos: affective communities, genre and gender in electronic/dance music's visual aesthetic. *Journal of British Cinema and Television*, 16(4), pp. 571–590.

Hadorn, G.H., Hoffmann-Riem, H., Biber-Klemm, S., Grossenbacher-Mansuy, W., Joye, D., Pohl, C., Wiesmann, U. and Zemp, E. eds., 2008. *Handbook of transdisciplinary research* (Vol. 10, pp. 978–981). Springer.

Harris, L., 2016a. Audiovisual coherence and physical presence: I am there, therefore I am [?]. *eContact!*, 18(2). Vancouver. https://econtact.ca/18_2/harris_audiovisualcoherence.html

Harris, L., 2016b. Thinking, making, doing: perspectives on practice-based, research-led teaching in higher music education. In Haddon, E. and Burnard, P. eds., *Creative teaching for creative learning in higher music education* (pp. 65–78). Routledge.

Harris, L., 2020. Exploring expanded audiovisual formats (EAFs) – a practitioner's perspective. In Knight-Hill, A., ed., *Sound and image: aesthetics and practices*. Focal Press. https://doi.org/10.4324/9780429295102-19.

Harris, L. and McGuinness, D., 2017. The teaching of creative practice within higher music education: guerrilla learning objectives (GLOs) and the importance of negotiation. In Heile, B., Rodriguez, E.M. and Stanley, J. eds., *Higher education in music in the twenty-first century* (pp. 167–181). Routledge.

Hayler, M. and Moriarty, J. eds., 2017. *Self-narrative and pedagogy: stories of experience within teaching and learning*. Springer.

Hediger, V. and De Rosa, M., 2017. *Post-what? Post-when? Thinking moving images beyond the post-medium/post-cinema Condition*. Mimesis International.

Higgins, D., 1966. Statement on intermedia. *Dé-coll/age (décollage)*, 6.

Higgins, D., 2001. Intermedia. *Leonardo*, 34(1), pp. 49–54.

Hugill, A., 2012. *The Digital Musician*. Routledge.

Hunter, L., 2009. Situated knowledge. In Riley, S.R. and Hunter, L. eds., *Mapping landscapes for performance as research* (pp. 151–153). Palgrave Macmillan.

Hyde, J., 2012. Musique concréte thinking in visual music practice: audiovisual silence and noise, reduced listening and visual suspension. *Organised Sound*, 17(2), pp. 70–78. https://doi.org/10.1017/S1355771812000106.

Ikeshiro, R., 2012. Audiovisual harmony: the realtime audiovisualisation of a single data source in construction in Zhuangzi. *Organised Sound*, 17(2), pp. 48–55. https://doi.org/10.1017/S1355771812000076.

Ingold, T., 2007a. Against soundscape. *Autumn leaves: sound and the environment in artistic practice*, pp. 10–13.

Ingold, T., 2007b. Materials against materiality. *Archaeological Dialogues*, 14(1), pp. 1–16.

Jihoon, K., 2016. Materialism and beyond: Lee Hangjun's expanded cinema. *Millennium Film Journal*, (63), p. 24.

Kaduri, Y. ed., 2016. *The Oxford handbook of sound and image in Western art*. Oxford University Press.

Kahn, D., 1992. Eisenstein and cartoon sound. *Essays in Sound*, 1. http://tmckosky.asp.radford.edu/thea180/SergieCarSound.htmKahn, D., 2013. *Earth sound earth signal: energies and earth magnitude in the arts*. University of California Press.

Kane, B., 2012. Acousmate: history and de-visualised sound in the Schaefferian tradition. *Organised Sound*, 17(2), pp. 79–88. https://doi.org/10.1017/S1355771812000118.

Kane, B., 2014. Pierre Schaeffer, the sound object, and the acousmatic reduction. In Kane, B. ed., *Sound Unseen: Acousmatic Sound in Theory and Practice*, pp. 15–41.

Kapuscinski, J., 1997. Basic theory of intermedia-composing with sounds and images. *Monochord, De musica acta, studia et commentariti*, pp. 43–50.

Kapuscinski, J., 1999. *McLaren: synergist*. WRO99 Media Art Biennale Catalog.

Kassabian, A., 2013. *Ubiquitous listening: affect, attention, and distributed subjectivity*. University of California Press.

Kaye, N., 2013. *Site-specific art: performance, place and documentation*. Routledge.

Keestra, M. and Menken, S. eds., 2016. *An introduction to interdisciplinary research: theory and practice*. Amsterdam University Press.

Khan, D. and Macauley, W., 2015. *On the aelectrosonic and transperception*. https://www.researchcatalogue.net/view/108900/108901. Accessed 27th October 2020.

Kim, J., 2016. *Between film, video, and the digital: hybrid moving images in the post-media age*. Bloomsbury Publishing.

Kitnick, A., 2013. *Mark Leckey – essay*. https://hammer.ucla.edu/exhibitions/2013/mark-leckey-on-pleasure-bent. Accessed 27th October 2020.

Kitto, H.D.F., 2017. *The Greeks* (Vol. 220). Transaction Publishers.

Knight-Hill, A., 2020a. Audiovisual spaces. In Knight-Hill, A. ed., 2020b. *Sound and image: aesthetics and practices*. Focal Press.

Knight-Hill, A. ed., 2020b. *Sound and image: aesthetics and practices*. Focal Press.

Kopytko, R., 2007. Philosophy and pragmatics: a language-game with Ludwig Wittgenstein. *Journal of Pragmatics*, 39(5), pp. 792–812.

Krauss, R., 1979. Sculpture in the expanded field. *October*, 8, pp. 31–44.

Krauss, R., 1997. "… And then turn away?" An essay on James Coleman. *October*, 81, pp. 5–33.

Kwastek, K., 2011. Audiovisuology. Essays. Histories and theories of audiovisual media and art. In Daniels, D, Naumann, S. and Thoben, J. eds., *See this sound: audiovisuology 2. Essays. Histories and theories of audiovisual media and art*.

LaBelle, B., 2012. On listening. *Kuntsjournalen B-Post*, 6(1), available online https://b-post.no/en/12/labelle.html. Accessed 9th March 2021.

Lave, J. and Wenger, E., 1991. *Situated learning: legitimate peripheral participation*. Cambridge University Press.

Leckey, M., 2012. *Pearl vision*. https://www.fact.co.uk/artwork/pearl-vision-2012. Accessed 27th October 2020.

Leon-Carlyle, M.R., 2014. Merleau-Ponty and McLuhan on the modalities and mechanization of perception. *Tooth & Claw*, 11, pp. 27–37.

Levi, P., 2010. Cinema by other means. *October*, 131(5), pp. 1–68. https://doi.org/10.1162/octo.2010.131.1.51.

Levý, J., 2011. *The art of translation* (Vol. 97). John Benjamins Publishing.

Lewis, J.W., 2010. Audio-visual perception of everyday natural objects–Hemodynamic studies in humans. In *Multisensory object perception in the primate brain* (pp. 155–190). Springer.

Lipps, T., 1902. *Vom Fuehlen, Wollen und Denken*. Leipzig, Verlag von Johann Ambrosius Barth.

Lund, H. ed., 2009. *Audio. Visual: on visual music and related media*. Arnoldsche Art Pub.

Manning, P., 2012. The oramics machine: from vision to reality. *Organised Sound*, 17(2), pp. 37–47. https://doi.org/10.1017/S1355771812000064.

Marks, L.U., 2002. *Touch: sensuous theory and multisensory media*. University of Minnesota Press.

Massachusetts College of Art and Design, 2020. *Elements of art and design*. https://massart.edu/sites/default/files/Principles%20and%20Elements.pdf. Accessed 27th October 2020.

Mayo, A., 2019. *Rules of shot composition in film: a definitive guide.* https://www. studiobinder.com/blog/rules-of-shot-composition-in-film/. Accessed 27th October 2020.

McDonnell, M., 2010. A composition of the 'things themselves': visual music in practice. In *CEC.* Canadian Electroacoustic Community. https://econtact.ca/15_4/ mcdonnell_visualcomposition.html. Accessed 9 March 2021.

McDonnell, M., 2020. *Finding visual music in its 20th century history.* Dissertation. Trinity College.

McLuhan, M., 1975. McLuhan's laws of the media. *Technology and Culture,* 16(1), pp. 74–78.

McLuhan, M. and Fiore, Q., 1967. The medium is the message. *New York,* 123, pp. 126–128.

Merleau-Ponty, M., 1982. *Phenomenology of perception.* Routledge.

Merriam-Webster, 2020. *Cohesion.* https://www.merriam-webster.com/dictionary/ cohesion. Accessed 27th October 2020.

Messham-Muir, K., 2014. Three questions not to ask about art-and four to ask instead. In *A year in the life of Australia/The conversation* (pp. 276–280). Future Leaders. https://theconversation.com/three-questions-not-to-ask-about-art-and-four-to-ask-instead-29830. Accessed 9th March 2021.

Mey, A., 2015. Expanded cinema. In Carvalho, A. and Lund, C. eds., *The audiovisual breakthrough* (pp. 43–61). Collin & Maierski Print GbR.

Mihalik, A. and Noppeney, U., 2020. Causal inference in audiovisual perception. *Journal of Neuroscience,* 40(34), pp. 6600–6612

Moholy-Nagy, L., 1947. *Vision in motion.* Theobald.

Mollaghan, A., 2015. *The visual music film.* Palgrave Macmillan.

Myatt, T., 2008. New aesthetics and practice in experimental electronic music. *Organised Sound,* 13(1), pp. 1–3.

Newell, W.H. 2013. The state of the field: interdisciplinary theory. *Issues in Interdisciplinary Studies,* 31, pp. 22–43.

Nissani, M., 1995. Fruits, salads, and smoothies: a working definition of interdisciplinarity. *Journal of Educational Thought,* 29(2), pp. 121–128.

Noë, A., 2004. *Action in perception.* MIT Press.

Noë, A., 2008. Précis of action in perception. *Philosophy and Phenomenological Research,* 76(3), pp. 660–665.

OED, 2020. audio-visual, adj. and n. *OED online.* September. Oxford University Press. https://www.oed.com/view/Entry/322543?redirectedFrom=audio-visual. Accessed 15th August 2020.

Ok Go, 2010. *End love official video.* https://okgo.net/2010/06/14/end-love-official-video/ Accessed 26th October 2020.

Oliveros, P., 1974. *Sonic meditations.* Smith publications.

Oliveros, P., 2005. *Deep listening: a composer's sound practice.* IUniverse.

Oram, D., 1972. *An individual note: of music, sound and electronics.* Galliard Limited.

Ox, J., 2001. Intersenses/intermedia: a theoretical perspective. *Leonardo,* 34(1), pp. 47–48.

Ox, J. and Keefer, C., 2006. On curating recent digital abstract visual music. *Center for Visual Music.* http://www.centerforvisualmusic.org/Ox_Keefer_VM.htm

Panofsky, E., Dürer, A., and Vasari, G., 1955. *Meaning in the visual arts: Papers in and on art history.* Doubleday.

Payling, D., 2014. *Visual music composition with electronic sound and video*. Doctoral dissertation, Staffordshire University.

Petrini, K., Russell, M. and Pollick, F., 2009. When knowing can replace seeing in audiovisual integration of actions. *Cognition*, 110(3), pp. 432–439.

Raskin, R., 2006. On pacing in the short fiction film. *Journal of Media Practice*, 7(2), pp. 159–160.

Raskin, R., 2014. On short film storytelling. *Journal of Scandinavian Cinema*, 4(1), pp. 29–34.

Reckitt, H., 2013. Forgotten relations: feminist artists and relational aesthetics. In Dimitrakaki, A. and Perry, L. eds., *Politics in a Glass: Case Feminism, Exhibition Cultures and Curatorial Transgressions* (pp. 131–156). Liverpool: Liverpool University Press.

Redhead, L., 2011. Relational aesthetics and the western canon of increasingly historical works. *British Postgraduate Musicology*, 11, pp. 1–9.

Richardson, J., Gorbman, C. and Vernallis, C. eds., 2013. *The Oxford handbook of new audiovisual aesthetics*. Oxford University Press.

Roads, C., 2004. *Microsound*. MIT press.

Robertson, R., 2011. *Eisenstein on the audiovisual: the montage of music, image and sound in cinema* (Vol. 5). IB Tauris.

Rogers, D.A., 2013. *A case for transdisciplinary practice in the art, science and technology research environment: Michael Naimark's practice in the creation of See Banff! and be now here*. Doctoral dissertation, University of the Witwatersrand, Johannesburg, South Africa.

Rogers, H., 2011. The unification of the senses: intermediality in video art-music. *Journal of the Royal Musical Association*, 136(2), pp. 399–428.

Rogers, H., 2013a. "Betwixt and between" worlds: spatial and temporal liminality in video art-music. In Richardson, J., Gorbman, C., & Vernallis, C., eds., *The Oxford handbook of new audiovisual aesthetics* (p. 525).

Rogers, H., 2013b. *Sounding the gallery: video and the rise of art-music*. Oxford University Press.

Rogers, H., 2014. The musical script: Norman Mclaren, animated sound, and audio-visuality. *Animation Journal*, 22, pp. 68–84.

Sa, A., Caramieux, B. and Tanaka, A., 2014. The fungible audio-visual mapping and its experience. *Journal of Science and Technology of the Arts*, 6(1), pp. 5. https://doi.org/10.7559/citarj.v6i1.131.

Salter, C., 2010. The question of thresholds: immersion, absorption, and dissolution in the environments of audio-vision. In Daniels, D. and Naumann, S., eds., *Audiovisuology: an interdisciplinary survey of audiovisual culture* (pp. 634–654). Compendium. Walther König.

Schaeffer, P., 1966. *Traité des objets musicaux*. Paris: Éditions du Seuil.

Schaeffer, P., 1967a. *La musique concrète*. Paris: Presses Universitaires de France.

Schaeffer, P., 1967b. *Booklet accompanying Solfège de l'objet sonore*, trans. L. Bellagamba. INA-GRM, INA C 2010–2012, 1998.

Schaeffer, P., 1970. *Machines à Communiquer*. Éditions du Seuil.

Schafer, R.M., 1992. *A sound education: 100 exercises in listening and sound-making*. Arcana Editions.

Serra, R. (1994 [1969]) *'Tilted arc destroyed'* in *Richard Serra Writings* (pp. 193–214). Chicago University Press.

Shams, L. and Beierholm, U.R., 2010. Causal inference in perception. *Trends in Cognitive Sciences*, 14(9), pp. 425–432.

Shrivastava, P. and Ivanaj, S., 2011. Transdisciplinary art, technology, and management for sustainable enterprise. *Transdisciplinary Journal of Engineering & Science* 2, pp. 81–92.

Skains, R.L., 2018. Creative practice as research: discourse on methodology. *Media Practice and Education*, 19(1), pp. 2–97. https://doi.org/10.1080/14682753.2017.136 2175.

Smith-Autard, J.M., 2000. *Dance composition*. Psychology Press.

Smith, T., 2005. *Four ways of looking at art*. https://vimeo.com/3563987. Accessed 15th September 2020.

Smith, V. and Hamlyn, N., 2018. *Experimental & expanded animation: New perspectives and practices*. Springer.

Sonic Cathedral, 2020. *Echo ladies*. https://www.soniccathedral.co.uk/2018/01/24/echoladies/. Accessed 27th October 2020.

Southall, N., 2013. *Review – the necks: open*. https://thequietus.com/articles/13902-the-necks-open-review. Accessed 27th October 2020.

Spanghero, M., 2020. *Pebbles*. http://www.michelespanghero.com/works/pebbles/. Accessed 27th October 2020.

Stark, W., 2016. *New materialism*. https://newmaterialism.eu/almanac/i/intra-action. html. Accessed 27th October 2020.

Stickney, J., 2008. Wittgenstein's 'relativity': training in language-games and agreement in forms of life. *Educational Philosophy and Theory*, 40(5), pp. 621–637.

Tate Online, 2020. *Composition*. https://www.tate.org.uk/art/art-terms/c/composition. Accessed 1st August 2020.

Trębacz, E., 2012. Depth modulation: composing motion in immersive audiovisual spaces. *Organised Sound*, 17(2), pp. 56–62. https://doi.org/10.1017/S1355771812000088.

Uroskie, A., 2012. Visual music after cage: Robert Breer, expanded cinema and Stockhausen's originals (1964). *Organised Sound*, 17(2), pp. 63–69. https://doi.org/10.1017/S135577181200009X.

Van Looy, J., 2005. Virtual recentering: computer games and possible worlds theory. *Image & Narrative*, 12, pp. 45–67.

Vernallis, C., 2004. *Experiencing music video: aesthetics and cultural context*. Columbia University Press.

Vernallis, C., 2013. *Unruly media: YouTube, music video, and the new digital cinema*. Oxford University Press.

Vernallis, C., Herzog, A. and Richardson, J. eds., 2013. *The Oxford handbook of sound and image in digital media*. Oxford University Press.

Vernallis, C., Rogers, H. and Perrott, L. eds., 2019. *Transmedia directors: artistry, industry and new audiovisual aesthetics*. Bloomsbury Publishing.

Vickery, L., 2012. The evolution of notational innovations from the mobile score to the screen score. *Organised Sound*, 17(2), pp. 28–36. https://doi.org/10.1017/S1355771812000052.

Voegelin, S., 2010. *Listening to noise and silence: towards a philosophy of sound art*. Bloomsbury Publishing.

Voegelin, S., 2013. Sonic possible worlds. *Leonardo Music Journal* (special issue on Sound Art), 23, pp. 89–98.

Voegelin, S., 2014. *Sonic possible worlds: hearing the continuum of sound*. Bloomsbury Publishing.

Walley, J., 2003. The material of film and the idea of cinema: contrasting practices in sixties and seventies avant-garde film. *October*, pp. 15–30.

Walley, J., 2005. *Paracinema: challenging medium-specificity and re-defining cinema in avant-garde film*. The University of Wisconsin-Madison.

Ward, J. et al., 2008. The aesthetic appeal of auditory-visual synaesthetic perceptions in people without synaesthesia. *Perception*, 37(8), pp. 285–296. https://doi.org/10.1068/p5815.

Weber, W., 1999. The history of musical canon. *Rethinking Music*, pp. 336–355.

Weiss, M., 2008. Images of performance – images as performances. On the (in-) differentiability of music video and visual music. In Lund, H., ed., *Audio visual: on visual music and related media* (pp. 88–103). Arnoldsche Art Pub.

Wenger, E., 2009. Communities of practice. *Communities*, 22(5), pp. 57–80.

Westerkamp, H., 1974. Soundwalking. *Sound Heritage*, 3(4), pp. 18–27.

Whitney, J., 1980. *Digital harmony* (p. 97). Byte Books.

Whitney, J., 1994. To paint on water: the audiovisual duet of complementarity. *Computer Music Journal*, 18(3), pp. 45–52. Vancouver.

Wilson, E.O., 1999. *Consilience: the unity of knowledge* (Vol. 31). Vintage.

Winters, B., 2014. The Oxford handbook of new audiovisual aesthetics ed. by John Richardson, Claudia Gorbman, and Carol Vernallis. *Music, Sound, and the Moving Image*, 8(2), pp. 229–235.

Wittgenstein, L., 1984. *Culture and value*. University of Chicago Press.

Wittgenstein, L., 2009. *Philosophical investigations*. John Wiley & Sons.

Wysocki, A.F., 2012a. Drawn together: possibilities for bodies in words and pictures. In Arola, K.L. and Wysocki, A., eds., *Composing (Media) = Composing (Embodiment)* (pp. 25–43). University Press of Colorado.

Wysocki, A.F., 2012b. Introduction: into between – on composition in mediation. In Arola, K.L. and Wysocki, A., eds., *Composing (Media) = Composing (Embodiment)* (pp. 1–22). University Press of Colorado.

Xu, R., 2020. *Artist's statement*. http://rebeccaxu.com/about.html. Accessed 27th October 2020.

Xu, R. and Wu, C., 2019. *For Tashi*. https://vimeo.com/402035599/d193ed5e78. Accessed 27th October 2020.

Youngblood, G., 1970. *Expanded cinema*. Fordham University Press.

Zielinski, S., 1999. *Audiovisions: cinema and television as entr'actes in history*. Amsterdam University Press.

Zinman, G., 2014. Between canvas and celluloid: painted films and filmed paintings. *The Moving Image Review & Art Journal (MIRAJ)*, 3(2), pp. 162–176.

Index

Locators in *italics* refer to figures and those in **bold** to tables.

Printed in the United States
by Baker & Taylor Publisher Services